Benedikt Huber

Die Stadt des Neuen Bauens
Projekte und Theorien von Hans Schmidt

Benedikt Huber

DIE STADT DES NEUEN BAUENS

Projekte und Theorien von Hans Schmidt

ORL-Schriften 45/1993

Springer Fachmedien Wiesbaden GmbH

**Schriften des
Instituts für Orts-, Regional-
und Landesplanung
ETH Hönggerberg**

**Institutsleitung:
Prof. B. Huber
Prof. Dr. J. Maurer
Prof. Dr. A. Rossi
Prof. Dr. W. A. Schmid**

**Umschlagbild:
Perspektivzeichnung der Stadt Orsk
aus: "Can our cities survive?", 1944**

Quellensammlung: Ute Lehrer, lic. phil. I

**Dokumentation und Lektorat:
Raoul Rosenmund, dipl. arch. ETH**

**Grafisches Konzept: Benedikt Huber
Grafische Gestaltung: Oswald Roth**

ISBN 978-3-519-05036-0

**Der vdf dankt dem
Schweizerischen Bankverein
für die Unterstützung zur
Verwirklichung seiner
Verlagsziele**

Die Deutsche Bibliothek – CIP-Einheitsaufnahme

Huber Benedikt:
Die Stadt des Neuen Bauens: Projekte und Theorien von Hans Schmidt/Benedikt Huber. –
Zürich: vdf, Verl. der Fachvereine;
(ORL-Schriften zur Orts-, Regional- und Landesplanung; Bd. 45)
ISBN 978-3-519-05036-0 ISBN 978-3-663-12052-0 (eBook)
DOI 10.1007/978-3-663-12052-0
NE: GT

Inhaltsverzeichnis

Vorwort

Hans Schmidt wurde am 10. Dezember 1893 in Basel geboren und starb am 18. Juni 1972 während einer Tagung des BSA in Soglio. Zum Anlass seines 100. Geburtstages im Jahre 1993 wird das Werk von Hans Schmidt von den verschiedensten Seiten her bearbeitet und gewürdigt.

Dass sich die vorliegende Untersuchung auf die städtebaulichen Theorien von Hans Schmidt konzentriert, ist einmal aus meinem eigenen Lehrgebiet des Städtebaus erklärlich. Vor allem aber ist Hans Schmidt für mich derjenige unter den Architekten der Moderne, der sich am konsequentesten mit den städtebaulichen Theorien auseinandergesetzt und zeit seines Lebens mit einer unbeirrbaren Überzeugung nach den wesentlichen Grundlagen des Städtebaus geforscht hat. Für ihn gab es keine Trennung zwischen seiner politischen, philosophischen Auffassung und seiner Tätigkeit als Stadtplaner, eines bedingte unmittelbar das andere.

Mit Hans Schmidt verbinden mich mehrere persönliche und fachliche Begebenheiten. Da er ein Freund meines Vaters Fritz Huber war, bin ich Hans Schmidt und seiner Familie schon als Kind öfters begegnet und seine Zeichnungen von Räubergeschichten schmückten mein Kinderzimmer. Als Architekt unseres Vaterhauses in Riehen hat Hans Schmidt die Architektur- und Raumerfahrungen meiner Kindheit massgebend geprägt. In meiner Studienzeit wurde eine Renovation an unserem Hause notwendig; Hans Schmidt hat mich bei der Durchführung dieser Arbeiten hilfreich beraten und dabei mit mir allgemeine Fragen der Architektur diskutiert. Als ich 1955 die Redaktion des WERK übernahm, sprach ich mit ihm über mögliche Beiträge von seiner Seite, die sich nach seinem Wegzug aber nicht realisieren liessen. Während seiner Arbeit in der DDR beschränkten sich unsere Kontakte auf wenige Briefe, hingegen konnten wir an der BSA Tagung 1972 ein ausgesprochen fröhliches Wiedersehen feiern, das dann mit seinem plötzlichen Tod ein unerwartetes Ende fand.

Dass heute im Jahre 1993 die Stadtplanungen seiner letzten Lebensphase in der ehemaligen DDR ein unrühmliches Ende gefunden haben und härteste politische und fachliche Kritiken erfahren müssen, hat die Untersuchung über seine städtebaulichen Theorien nicht einfach gestaltet. Auch wenn die Bauwirtschaft und der Städtebau der neuen deutschen Bundesländer, die er seinerzeit mitgeprägt hat, heute nach neuen Grundsätzen wieder

aufgebaut werden, erfordert der Respekt vor der Persönlichkeit Hans Schmidt umsomehr eine sorgfältige und dokumentierte Darstellung auch seiner letzten Arbeiten.

Das Werk und die theoretischen Arbeiten von Hans Schmidt sind stark bestimmt durch sein auch äusserlich bewegtes Leben: das Studium in Zürich und in Holland, die selbständige Tätigkeit bis 1930, der Aufenthalt in der Sowjetunion bis 1938, die Phase als Architekt und Politiker in Basel bis 1955 und die Tätigkeit in Ostberlin bis 1969. Es liegt daher nahe, auch die Untersuchung über seine städtebaulichen Theorien und deren Entwicklung in diese vier Phasen zu gliedern.

Die vorliegende Untersuchung stützt sich neben meinen persönlichen Erfahrungen auf die umfangreichen Veröffentlichungen von Hans Schmidt und auf seinen Nachlass am Institut GTA der ETH Zürich. Ich danke meinem Kollegen Prof. Werner Oechslin für den Zugang zum Archiv und Ursula Suter, die den Nachlass betreut. Vor allem aber danke ich meiner Mitarbeiterin Ute Lehrer, welche das erste Material zusammenstellte und meinem Mitarbeiter Raoul Rosenmund, der die umfangreiche Dokumentation und das Lektorat besorgt hat.

Zürich, im Januar 1993
Benedikt Huber

Buchwidmung für Fritz Huber
von Hans Schmidt 1913

Fritz Huber dem Gottesgelehrten
Zürich 1913 Hans Schmidt

Willst Du den Perlentau der edlen Gottheit fangen
So musst Du unverrückt an seiner Menschheit hangen
Angelus Silesius

Hans Schmidt, der Städtebau und der Sozialismus

Städtebau als Gesellschaftsreform

In der Geschichte der modernen Architektur erscheint Hans Schmidt heute vor allem als der Architekt des Neuen Bauens, der mit seinen kompromisslosen Bauten der 20er Jahre und mit der Zeitschrift ABC der schweizerischen Architektur den neuen Weg gewiesen hat. Seine weiteren und späteren Tätigkeiten, seine Planungen in der Sowjetunion, seine städtebaulichen Forschungen und Projekte und seine Funktionen in der ehemaligen DDR werden im allgemeinen weniger hervorgehoben, nicht zuletzt deswegen, weil diese Seite seines Werkes eng und direkt mit seiner politischen Überzeugung, dem Sozialismus verbunden ist und aus der architektonischen Sicht allein nicht interpretiert und eingeordnet werden kann.

Hans Schmidt um 1929

Hans Schmidt war jedoch seit seinen ersten beruflichen Erlebnissen in Holland 1921–22 ein politischer Mensch und hat seine Aufgabe als Architekt und Städtebauer immer als einen politischen Auftrag verstanden. Politik umfasste für ihn dabei die Aufgabe, eine neue bessere Gesellschaft zu erkämpfen und für diese Gesellschaft eine bessere Stadt und Behausung zu gestalten. Architektur und insbesondere der Städtebau waren für ihn die Mittel, mit denen diese bessere und rational gestaltete Welt erreicht werden konnten.

In einem Manuskript aus dem Jahre 1957 definiert er in "Meine Auffassung von den Aufgaben der Architektur") [1] seine persönliche Haltung folgendermassen.

"Ich bin durch gewisse Umstände schon frühzeitig dazu geführt worden, das Wesentliche der Architekten in ihrer gesellschaftlichen, kulturellen Bedeutung zu sehen.

Auf der einen Seite sind meine Anlagen weniger nach der naturwissenschaftlich-technischen als nach der geisteswissenschaftlich-historischen Seite hin entwickelt. Dem entsprach auch meine Ausbildung an einem humanistischen Gymnasium.

Auf der anderen Seite fielen in die Zeit meines Werdens als Architekt Ereignisse wie der 1. Weltkrieg und die russische Revolution, die mich entscheidend beeindruckten und mich zur Erkenntnis kommen liessen, dass ein neues, dem Sozialismus gehörendes Zeitalter begonnen habe. Damals be-

gannen Aufgaben wie der Massenwohnungsbau, der Städtebau, die Industrialisierung in Form der Standardisierung und Typisierung die Architekten zu beschäftigen. Architektur musste etwas anderes sein als nur individuelle, künstlerische Schöpfung eines Einzelnen, sie musste das Werk einer ganzen Gesellschaft sein.

Seit jener Zeit hat mein Interesse in erster Linie dem Wohnungsbau und Städtebau gegolten. Unter dem Einfluss meines Lehrers Hans Bernoulli aufgewachsen, der die Anschauungen Ostendorfs vertrat, stiess ich bald mit dem Funktionalismus zusammen und wurde eines der Gründungsmitglieder der CIAM (Congrès d'Architecture Moderne). Ich habe aber die funktionalistische Periode der Architektur der 20er Jahre nicht so sehr als künstlerische Entwicklung, sondern in erster Linie als Ausdruck einer notwendigen technischen und ökonomischen Umwälzung im Bauen aufgefasst und in meinen Arbeiten und Schriften vertreten."

Für Hans Schmidt wurde die sozialistische Ideologie und der Sozialismus in seinen verschiedenen Erscheinungsformen zur einzigen Möglichkeit, die Gesellschaft zu erneuern. In diesen Dienst stellte er ganz bewusst seine Kräfte als begabter Architekt, und als ebenso begabter Theoretiker, Schreiber und Lehrer. Den Städtebau hat er früh schon als diejenige Disziplin erkannt, welche die ökonomischen, gesellschaftlichen und technischen Bedingungen erfassen und in die Realisierung einer besseren Umwelt, in die sozialistische Stadt umsetzen kann. Aus dieser Überzeugung heraus hat Hans Schmidt mit allen ihm gegebenen Mitteln, in allen Situationen und in allen Funktionen gekämpft und gewirkt, als Architekt, als Planer, als Schriftsteller, als Parteipolitiker und als wissenschaftlicher Forscher. Architektur als Baukunst war ihm für längere Zeit zu einem fraglichen Begriff geworden. Er wollte allein auf rationalen, nicht auf künstlerischen Faktoren seine Theorien der Architektur und des Städtebaus aufbauen. Er verstand sich dabei stets als Generalist und hat sich in seinen Schriften nicht nur zu architektonischen Fragen geäussert, sondern auch zur Ökonomie, zur bildnerischen Kunst, zur Innenarchitektur, zum Produktdesign, zur Modularkoordination und sogar zur Sprachanwendung. Sein erstes Anliegen und der zentrale Punkt all seiner inneren und äusseren Auseinandersetzungen war jedoch die Erscheinung und Gestaltung der Stadt als dem physischen, sozialen und kulturellen Ort einer neuen Gesellschaft.

Von diesem zentralen Punkt seines Denkens und Handelns aus ergibt sich auch die Begründung, diese Untersuchung und Dokumentation allein auf die städtebaulichen Theorien von Hans Schmidt zu konzentrieren. Er selbst hat die Trennung von Architektur, Städtebau und Politik nie explizit vorgenommen. Für ihn war Städtebau ein Mittel der Politik und Architektur ein Mittel des Städtebaus. Auch wir bemühen uns heute wieder Architektur,

1 Maturaklasse Humanistisches Gymnasium Basel 1912
Unten: 5. von rechts Hans Schmidt, 4. von links Fritz Lieb, dahinter Fritz Huber

2 Teilnehmer am CIAM-Gründungskongress von La Sarraz 1928.
Oberste Reihe: 2. von links Max Ernst Haefeli, 3. v. l. Rudolf Steiger, 4. v. l. Hans Schmidt, 5. v. l. Paul Artaria, 2. v. r. Werner M. Moser, 3. v. r. S. Gideon.
Quelle: Aus CIAM, Dokumente 1928–1939, hrsg. von Martin Steinmann, 1979. GTA, ETH Zürich

Städtebau und Planung als eine Einheit in verschiedenen Massstabsbereichen zu sehen und nicht als unterschiedliche Disziplinen. Die vorliegende Untersuchung versucht, Hans Schmidt als Städtebauer zu verstehen und seine städtebaulichen Theorien in ihrer inhaltlichen und chronologischen Entwicklung aufzuzeichnen.

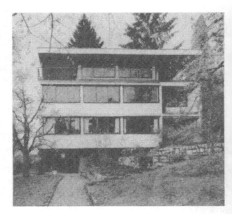

3

Den Städtebau als Schwerpunkt im Lebenswerk von Hans Schmidt zu behandeln, ergibt sich aus einem weiteren Gesichtspunkt. Hat er doch mit seinen Theorien und Postulaten im städtebaulichen Bereich die internationale Bewegung des Neuen Bauens massgeblich mitgeprägt.

Bei der Gründung der CIAM 1928 in La Sarraz hat sich Hans Schmidt zusammen mit Mart Stam für eine Erörterung der städtebaulichen Frage an Stelle architektur-ästhetischer Deklarationen eingesetzt. Von diesem Zeitpunkt an wurde er in der Schweiz wie im Ausland zu einem markanten Exponenten des Städtebaus innerhalb des Neuen Bauens. Er äusserte sich zu städtebaulichen Fragen im ABC, in der Schweizerischen Bauzeitung und im WERK, er entwarf städtebauliche Konzepte für Basel und Genf, er lieferte die städtebaulichen Grundlagen für das Neubühl und die WOBA-Siedlung und er wurde von Ernst May wegen seiner Siedlungstypologien als einziger Schweizer in das Russlandteam aufgenommen.

Man darf deshalb für Hans Schmidt in Anspruch nehmen, dass er in der Zeit des Neuen Bauens und auch noch in den Kriegsjahren in städtebaulichen Fragen bei allen Kollegen im In- und Ausland als kompetente Instanz anerkannt und mit seinem Urteil massgebend war. Hans Bernoulli, sein Lehrer hatte sich in der Zwischenkriegszeit vor allem auf seine Freiwirtschaftslehre konzentriert und kann nicht unbedingt zu den Vertretern des Neuen Bauens gezählt werden. Ernst May war als der grosse Macher von Frankfurt hervorgetreten, ohne über eine eigentliche Städtebautheorie zu verfügen, Mart Stam, der einen wesentlichen Einfluss auf Hans Schmidt ausübte, wurde zu einem Wanderer innerhalb der modernen Architektur. Le Corbusier prägte mit seinem Plan Voisin und seiner Ville Radieuse eine eigene künstlerische Auffassung von Städtebau, die von Schmidt abgelehnt wurde. In dieser bewegten und aufbrechenden Periode der 20er und 30er Jahre erarbeitete sich Hans Schmidt seine, auf dem Sozialismus fundierende Theorie eines neuen Städtebaus, und er hielt an seinen Theorien fest über alle Entwicklungen der Zeit und der Architektur hinweg bis zu seinem Tode.

Anmerkung

[1] Hans Schmidt, "Meine Auffassung von den Aufgaben der Architektur", Typoskript, Berlin 1957; GTA Archiv, ETH Zürich, Nachlass Hans Schmidt

3 Haus Huber, Riehen; Baujahr 1928

4 Generalplan der Stadt Orsk von Süden.
Quelle: Archiv GTA, ETH Zürich, Nachlass Hans Schmidt

5 Perspektivskizze zum Wettbewerbsprojekt Neugestaltung Zentrum Ost-Berlin, Marx-Engels-Platz 1959.
Quelle: Archiv GTA, ETH Zürich, Nachlass Hans Schmidt

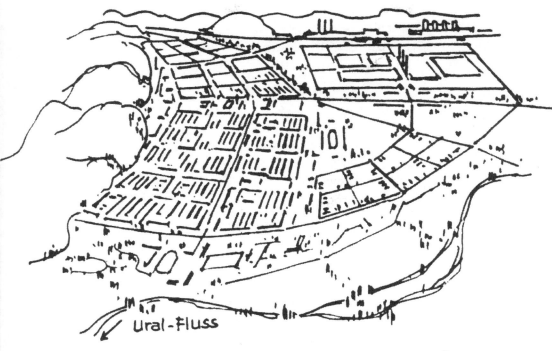

Ural-Fluss

ORSK VON SÜDEN

4

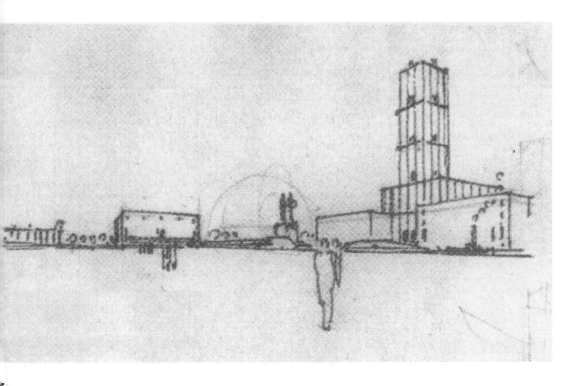

1 Anlage eines neuen Marktes in Basel,
Semesterarbeit an der ETH Zürich bei Prof.
Karl Moser, WS 1917/1918.
Situation und Perspektive.
Quelle: Archiv GTA, ETH Zürich, Nachlass
Hans Schmidt

Basel 1924 bis 1930
Vom sozialen zum wissenschaftlichen Städtebau

Studium und Lehrjahre im Städtebau

Sein Architekturstudium beginnt Hans Schmidt in München, er wechselt in den Kriegsjahren an die ETH nach Zürich und diplomiert 1918 bei Prof. Karl Moser mit einem Projekt über ein Bibliotheks- und Vortragsgebäude in Zürich. Der Städtebau wird an der ETH von Prof. Hans Bernoulli vermittelt, der zu dieser Zeit stark von Ostendorf beeinflusst ist. Die historisch klassizistische Lehre Ostendorfs bildet für Hans Schmidt eine Alternative zur expressionistischen Baukunst des Jugendstils, sie wird für ihn zum Einstieg und Übergang in eine neue Architekturauffassung und auch in einen gesetzmässigen Städtebau.

PERSPECTIVE VON A. XXX

MASSTAB 1:500

1

Nach dem Diplom betätigt sich Hans Schmidt am Wettbewerb der Automobilindustriellen Piccard, Pictet & Cie für eine Gartenstadt in Genf und gewinnt gleich den zweiten Preis für sein von der Lehre Bernoullis und Ostendorf geprägtes Siedlungsprojekt. In den Jahren 1920 bis 1922 arbeitet er in Rotterdam beim holländischen Architekten Michiel Brinkmann [1] als Bauführer im Wohnungsbau der "Spangeschen Polder". Er wird dabei mit der sozialen Frage des Wohnungsbaus und den bautechnischen Fragen konfrontiert. Bei dieser Gelegenheit lernt er über Werner Moser Mart Stam kennen, der ihm den Zugang zu den fortschrittlichen Architekten Hollands vermittelt.

Nach einem Aufenthalt 1923 in Paris, wo er an einer Gartenstadtplanung mitarbeitet, kehrt Hans Schmidt nach Basel zurück und beteiligt sich im gleichen Jahr am Wettbewerb für den Basler Zentralfriedhof "am Hörnli". Mit diesem grossflächigen Projekt wechselt Hans Schmidt von der klassizistischen Haltung Bernoullis und Ostendorfs zu einer freien, von der Topographie bestimmten Planung und Gestaltung. Unter dem Motto "Totenacker" projektiert er den Friedhof als grosse Landschaftsanlage, in welcher die Bauten informell eingebettet sind. Das Projekt steht damit im Gegensatz zu den monumentalen Anlagen der Mitbewerber und gelangt nicht in die Reihe der prämierten Arbeiten.

Es ist sein ehemaliger Lehrer Hans Bernoulli, der in einer ausführlichen Publikation der Wettbewerbsergebnisse [2] das unkonventionelle Projekt von Hans Schmidt den prämierten Entwürfen vorzieht und die neue städte-

bauliche Öffnung, die sich im Entwurf von Schmidt ankündigt, hervorhebt. Bernoulli ist bekannt für seine harte und oft ironisierende Kritik. Bei der Beurteilung des Friedhofprojektes seines Schülers findet er jedoch ein ungewohnt gefühlvolles und poetisch formuliertes Lob:

"Wie ganz anders tritt uns Hans Schmidt in seiner Arbeit entgegen. Wohl finden wir auch hier das unmutige Sichabwenden von jeder ausgesprochenen Stilform, dies fast schadenfrohe Bestreben, dem freundlich herantretenden Beschauer, der das Neue am Bekannten, Vertrauten messen möchte, in Verlegenheit zu bringen, in Bestürzung zu versetzen. Hier wird nun aber jede symmetrische Gebundenheit aufgelöst.

Die grossen Bauten zerspalten, verteilen sich, verschieben sich gegeneinander; unerwartete, unerklärliche Abstufungen treten auf, begonnene Rhythmen brechen schnell ab, im Einzelnen gesehen glaubt man nur Fragmente vor sich zu haben.

Deutlich erkennbar verfolgt der Entwurf das Bestreben einer unbedingten, harmlosen Einkleidung des gegebenen Programmatischen in das anspruchslose Gewand, das die Zweckbestimmung vorschreibt, prosaisch durch und durch. Aber die Prosa ist gut, sie hat etwas von der Poesie, die sich nur in ungebundener Rede einstellt. Und leise beginnen Gefühle mitzuklingen, die uns allen eigen sind. Nicht Gefühle, die gelöst werden vor grossartigen architektonischen Schöpfungen; es sind Gefühle, die wach werden mögen, vor einer zartgestimmten Landschaftsmalerei, vor einer Vedute im Stil der Meister um 1820, 1830 römisch geschult, mit der Poesie des am deutschen Herd Aufgewachsenen vorgetragen. Schmidt hat die Aufgabe hinübergespielt in das Gebiet der Landschaftsschöpfung. Er hat die im Programm geforderten Räume und Baukörper zerschlagen und verkleinert, bis sie sich dem Bild fügten, das er sich von der idealen Landschaft macht.

Die offizielle Architektur, die der Gesetzmässigkeit, der Gebundenheit bedarf, ist ihm ärgerlich, erscheint ihm fad, abgestanden. Er löst das heroische Programm auf in eine Idylle, in ein träumendes, spielendes Wesen, das mit Architektur nur noch die Eignung zu gleicher Zweckbestimmung gemein hat."

Auf der Suche nach Lösungen in der Wohnungsfrage

Im Jahre 1924 gründet Hans Schmidt sein eigenes Büro und verassoziiert sich ein Jahr später mit seinem Kollegen Paul Artaria. Im gleichen Jahr erscheint das erste Heft von ABC, das er zusammen mit Emil Roth und Mart Stam herausgibt. Der Schwerpunkt seiner Projekte und seiner theoretischen

2 Vogelperspektive aus dem Wettbewerbsprojekt Zentralfriedhof am Hörnli Basel, 1922.
Quelle: Archiv GTA, ETH Zürich, Nachlass Hans Schmidt

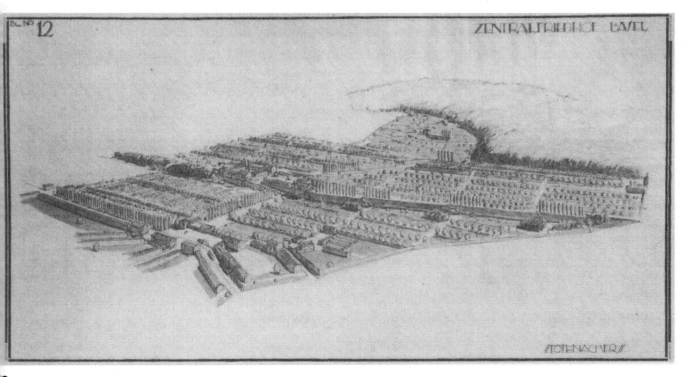

2

Arbeiten liegt jetzt in der Suche nach neuen Lösungen für den Wohnungs-
bau. Städtebau und Architektur werden für ihn zu einer Frage der neuen
und richtigen Wohnkonzepte.

Die Lösung des Wohnungsbaus sieht Hans Schmidt zu dieser Zeit primär
in der Zeilenbauweise von Kleinhäusern. Das grosse Mietshaus für Arbeiter
bezeichnet er als "Wohnausbeutung", solange die Bewohner nicht am Ka-
pital beteiligt sind. Entsprechend dieser Beurteilung sind denn auch die mei-
sten Siedlungsprojekte der Jahre 1924 bis 1930 in der Zeilenbauweise
konzipiert, so der erste und zweite Entwurf für die Siedlung Schorenmatten
(1927), die Häuser der WOBA-Siedlung Eglisee (1930) und später die
Siedlung Neubühl (1930/32). Nur wenn die baugesetzlichen Bestimmun-
gen einer langen Zeile entgegenstehen, wie beim Projekt Spitzwaldstrasse
in Allschwil (1926), werden die Reihenhäuser auf Doppelhäuser verkürzt.

Auch bei den gesamtstädtischen Planungen dieser Jahre versucht Hans
Schmidt die Zeilenbauweise, in Form von Reihenhäusern oder Stockwerks-
wohnungen, als Grundlage seiner Siedlungsmuster durchzusetzten. Dies
zeigt sich im Gegenprojekt für das Basler Westplateau (1923), im Wettbe-
werbsprojekt für die Planung von "Genf – rechtes Ufer" (1930) und teil-
weise im Bebauungsplan für Lutry (1930). Die Orientierung der Zeilen Ost -
West oder Süd, scheint vorerst nicht von Bedeutung zu sein, da in den
Entwürfen beide Typen vorkommen.

Hingegen bezeichnet es Hans Schmidt als wesentlich, dass die Zeilen
quer zur Strasse gelegt werden und in ihrer Länge nur durch Fussgänger-
wege erschlossen werden. Mit diesem Prinzip stellt sich Schmidt in bewus-
sten Gegensatz zur städtebaulichen Lehre von Hans Bernoulli und von Frie-
drich Ostendorf und damit zur herkömmlichen Stadtbaukunst. Denn bisher
galt es als Aufgabe der Hausfassaden, den Strassenraum zu begleiten und
räumlich zu fassen. Bei den verschiedenen Siedlungen Bernoullis wie auch
im Freidorf von Hannes Meyer sind die Eingangsfronten der Wohnhäuser –
mehr oder weniger repräsentativ – der Erschliessungsstrasse zugewandt.
Hans Schmidt wendet jedoch der Strasse nur noch die meist geschlossene
Stirnseite seiner Zeilen zu. Dieses Bebauungsprinzip ist weniger in der da-
mals noch schwachen Lärmbelastung durch die Strasse begründet, sondern
bedeutet eine bewusste Abkehr von der bisherigen städtebaulichen Reprä-
sentanz.

Der Schwerpunkt seiner Siedlungsprojekte liegt in der Typisierung von
Siedlungsmustern und Haustypen für die Wohnbevölkerung. Der Begriff des
Bauens für das Existenzminimum, wie er von Ernst May in Frankfurt verwen-
det wird, kommt bei Hans Schmidt nicht vor. Vielmehr erachtet er die Re-
duktion des räumlichen und baulichen Aufwandes im Wohnungsbau als ge-
nerelles ökonomisches Diktat, das alle Bewohnerschichten betrifft. Er

3 Übersichtsplan der Wohnkolonien be
den Langen Erlen, Basel 1929.
Westlicher Teil: Wohnkolonie der WOBA
Schweizerische Wohnausstellung 1930,
Häuserzeile 13: Artaria und Schmidt.
Östlicher Teil: Siedlung Schorenmatten
(Wohngenossenschaften Lange Erlen und
Rüttibrunnen) 1929.
Artaria und Schmidt zusammen mit
A. Künzel.
Quelle: Werk 1929/8

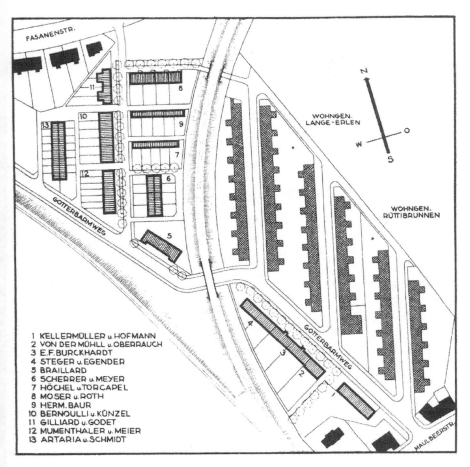

FASANENSTR.

11

13 10

GOTTERBARMWEG

12

8

9

7

6

5

N

WOHNGEN.
LANGE-ERLEN

O

W

S

WOHNGEN.
RÜTTIBRUNNEN

4

3

2

GOTTERBARMWEG

MAULBEERSTR.

1 KELLERMÜLLER u. HOFMANN
2 VON DER MÜHLL u. OBERRAUCH
3 E.F.BURCKHARDT
4 STEGER u.EGENDER
5 BRAILLARD
6 SCHERRER u. MEYER
7 HÖCHEL u TORCAPEL
8 MOSER u. ROTH
9 HERM. BAUR
10 BERNOULLI u. KÜNZEL
11 GILLIARD u. GODET
12 MUMENTHALER u. MEIER
13 ARTARIA u. SCHMIDT

3

postuliert eine "Minimal- oder Standardwohnung" und verlangt, dass auch das "Villenbauterrain" in den Vororten und Aussenquartieren der Stadt Basel jetzt für diese Art von Wohnsiedlungen bereit gestellt werden muss.

Dass das Büro Artaria und Schmidt in dieser Zeit vor allem mit der Erstellung von Einfamilienhäusern für den Mittelstand seine Beschäftigung findet, mag widersprüchlich erscheinen. Dabei ist jedoch zu berücksichtigen, dass in der Krisenzeit der öffentliche und private Wohnungsbau weitgehend zum Erliegen gekommen ist und der Einfamilienhausbau eine der wenigen Beschäftigungsmöglichkeiten für Architekten darstellt. Andererseits versuchen Artaria und Schmidt auch bei den Einfamilienhausbauten eine grösstmögliche Rationalisierung im räumlichen Aufwand und in der Bauausführung zu erzielen. Meinem Vater, als Bauherrn des Hauses Huber, hat Schmidt in der Projektierungszeit erklärt [3], dass unser Haus bei einer konventionellen Massivbauweise bedeutend höhere Baukosten verursachen würde und dass allein das moderne Bauen dieses Bauprogramm zu reduzierten Kosten ermögliche.

Vom künstlerischen Städtebau zum wissenschaftlichen Stadtbau

In der ersten Ausgabe von "ABC – Beiträge zum Bauen" vom April 1924 verkünden die drei Herausgeber Emil Roth, Hans Schmidt und Mart Stam auf der Titelseite die Programmatik der neuen Zeitschrift:

"Diese Zeitschrift wird Artikel veröffentlichen, die Klarheit bringen wollen in die Aufgaben und den Prozess der Gestaltung, der Gestaltung der Städte in ihrem technischen, ökonomischen und sozialen Wesen, der Gestaltung des Wohnungsbaues, der Arbeitsstätten und des Verkehrs, der Gestaltung in Malerei und Theaterkunst, der Gestaltung in Technik und Erfindung. "

"Diese Zeitschrift soll der Sammlung aller jungen Kräfte dienen, die in künstlerischen und wirtschaftlichen Aufgaben unserer Zeit reine und klare Resultate erstreben. Das Ziel für die neue Generation ist, auf jedem Gebiet durch eigenes Nachdenken zu einer selbständigen und künstlerisch weiteren Auffassung zu gelangen. Dieser Generation der schöpferisch Arbeitenden soll unsere Zeitschrift gehören."

In der gleichen Ausgabe von ABC veröffentlicht Hans Schmidt 1924 seinen Text "Das Chaos im Städtebau". Er begründet darin seine These einer "architektonischen Stadt als Ausdruck höchster Gesetzmässigkeit, Einheit und Ökonomie" und illustriert diese mit seiner Planung für die Bebauung

4 Ideenwettbewerb Gartenstadt Aïre bei Genf für die Firma Piccard, Pictet & Cie ("Pic-Pic"), 1918.
Quelle: Archiv GTA, ETH Zürich, Nachlass Hans Schmidt

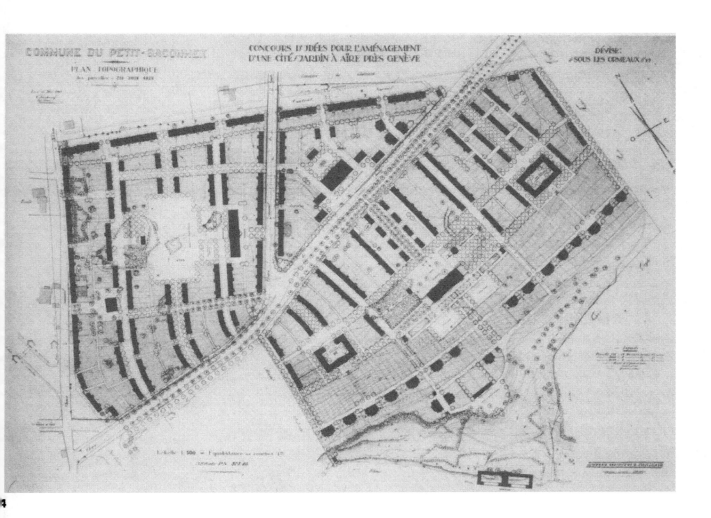

des äusseren Westplateaus von Basel. Der Text "Das Chaos im Städtebau" wird für Hans Schmidt zum ersten Beitrag einer langen Reihe von Stellungnahmen zur Städtebaudiskussion.

Im Programmtitel des ABC wie in seinem "Chaos im Städtebau" verwendet Hans Schmidt noch die Begriffe "Baukunst", "künstlerisch", "Architektur" und "Städtebau", Begriffe, die an die Tradition mit Hans Bernoulli, Friedrich Ostendorf und Camillo Sitté anknüpfen. Vor allem in seinen Äusserungen zum Städtebau wechselt Hans Schmidt bald die verwendeten Begriffe. Es geht ihm jetzt um die soziale und ökonomische Ausrichtung der Planung und schlussendlich um eine politische Lösung der Aufgabe Stadt. *"Das Bauen ist nicht Architektur"* überschreibt er einen Artikel im WERK 1927 und er stellt sich vehement und dezidiert gegen die Begriffe *"Kunst"* und *"Baukunst""* als *"Relikte einer überkommenen Architektenschulung"*.

"Das Bauen hat aufgehört eine Sache der Kunst zu sein."

"Das Bauen hat begonnen, seine besten Kräfte aus der produktiven Arbeit der Technik und der sie unterstützenden Wissenschaften zu ziehen."

Mit diesen apodiktischen Maximen setzt Hans Schmidt die Architektur und den Städtebau auf eine technisch wissenschaftliche Ebene. Begriffe wie "Stadtbaukunst" und "malerische Stadt" lehnt er als falsche Ideale ab. Auch die städtebauliche Ordnung der Weissenhofsiedlung beurteilt er als falsch, weil sie *"noch auf Grund der gefühlsmässigen Modellskizze eines Architekten"* entstanden sei. (Gemeint ist das Tonmodell von Mies van der Rohe.)

Für Hans Schmidt ist der Stadtbau (von nun an nicht mehr Städtebau) eine Aufgabe genauer Überlegungen, nüchterner Methodik, wirtschaftlicher Rechenexempel und wissenschaftlicher Forschungen. Dies nennt er die "Wirklichkeit im Stadtbau" [4] und stellt sich damit gegen Bernoulli und auch gegen Camillo Sitté mit seinem "Städtebau nach künstlerischen Gesichtspunkten".

"Diese Wirklichkeit wird uns von der Aufgabe entlasten, Poesie, Schönheit, Harmonie und Ordnung auf irgendwelchen gefühlsmässigen Wegen suchen zu müssen. Jede klare Lösung wird diese in sich selbst enthalten."

In der absoluten Ablehnung alles künstlerischen und gefühlsmässigen in Architektur und Städtebau zugunsten einer rationalen, technischen und wissenschaftlichen Genese des Entwurfes zeigt sich eine Diskrepanz im Wesen von Hans Schmidt, die in den späteren Phasen verschiedentlich wieder zum Ausdruck kommt: Schmidt ist ein ausserordentlich begabter Zeichner und Maler. Ursprünglich will er Maler werden, lässt sich aber vom Vater zu dem solideren Beruf des Architekten drängen. Schmidts Entwürfe, Skizzen und Darstellungen zeigen einen hohen künstlerischen und ästhetischen Wert. Durch seine zeichnerische Begabung gerät ihm jeder Plan, jede Perspektive zum schönen Bild. Er aber möchte, dass seine Pläne und Entwürfe auf ratio-

5 Bebauungsstudie für eine Gartenstadt und ein Stadtquartier in La Chaux-de-Fonds, 1919.
Quelle: Archiv GTA, ETH Zürich, Nachlass Hans Schmidt

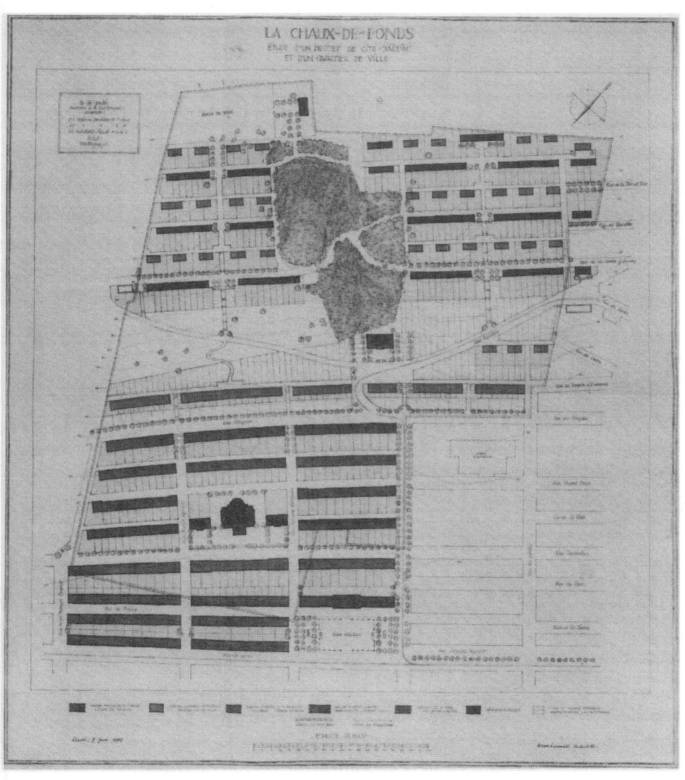

nalen Überlegungen, nicht auf gefühlsmässigen Empfindungen basieren. Erst 20 Jahre später, bei seiner Tätigkeit als Städtebauprofessor in Ost-Berlin, gesteht er wieder zu, dass auch ein rationaler Städtebau der künstlerischen Gestaltung bedarf.

Indem Hans Schmidt die bisherigen Begriffe in Architektur und Städtebau verwirft, trennt er sich auch von den herkömmlichen Ordnungen und Systemen des Städtebaus. Er stellt sich zudem auch in Opposition zum Bürgertum, das sich im klassischen Städtebau repräsentiert. Es geht Hans Schmidt in dem ersten wie in vielen weiteren Texten zum Stadtbau, die er gleichzeitig in der Schweizerischen Bauzeitung, im WERK und in seinem ABC veröffentlicht, um die rationale Ordnung der Stadt, dann aber um das Diktat der ökonomischen Situation und schlussendlich um eine politische Stellungnahme. Eine Gesamtschau der Probleme steht im Vordergrund, eine neue Begrifflichkeit, eine gesamtheitliche Lösung und eine neue Weltordnung.

Die Grundprinzipien, auf denen Hans Schmidt seinen wissenschaftlichen Stadtbau begründen will, lassen sich aus seinen verschiedenen Stellungnahmen der Jahre 1924 bis 1929, die er in den drei Fachzeitschriften und bei öffentlichen Vorträgen formuliert, ableiten. Es sind dies:

1) Die rationale anstelle der ästhetisch künstlerischen Ordnung der Stadt, aufgebaut auf einem Erschliessungssystem und ohne Begrenzung der räumlichen Ausdehnung;

2) Die funktionelle Gliederung nach Wohngebieten, Arbeitsgebieten und Zentren;

3) Die offene Bauweise für Wohngebiete, d. h. eine Zeilenbauweise ohne Strassenbezug;

4) Die Industralisierung des Bauens durch Typisierung, Montagebauweise und nutzungsneutrale Raumzellen;

5) Die Ausrichtung der Mietkosten nach den ökonomischen Möglichkeiten und den sozialen Bedingungen aber nicht auf Grund der Gestehungskosten.

Diese Festpunkte einer neuen Stadtbautheorie sind teilweise auch bei anderen Architekten und Stadtplanern dieser Zeit und bei verschiedenen Vertretern des Neuen Bauens feststellbar. Schmidt hat jedoch versucht, die Prinzipien zu formulieren und in einen systematischen Zusammenhang zu stellen. Dass er über den Drang und eine besondere Gabe der verbalen Formulierung verfügt, verleiht seiner Tätigkeit im Kreis des Neuen Bauens und in den Anfängen der CIAM ein bedeutendes Gewicht.

6 Bebauung äusseres Westplateau, Basel 1923. Gegenvorschlag Hans Schmidt.
Quelle: Archiv GTA, ETH Zürich, Nachlass Hans Schmidt

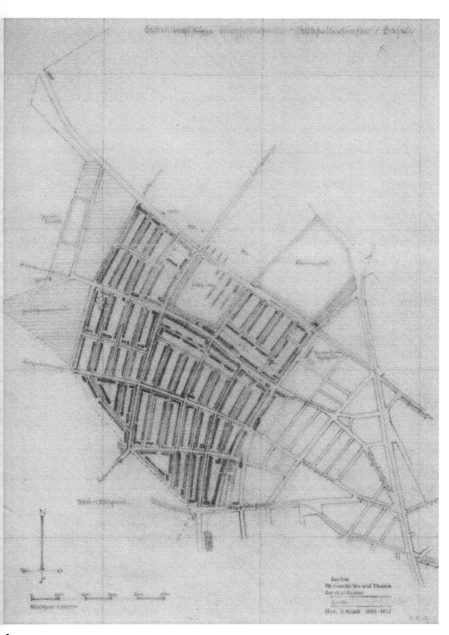

Thesen für die CIAM

Im Juni 1928 beteiligt sich Hans Schmidt an der Gründung der CIAM (Congrès International d'Architecture Moderne) auf dem Schloss La Sarraz im Kt. Waadt. Bereits im Vorfeld der Gründung zeigen sich einige Differenzen zwischen den eingeladenen Architekten; auch Hans Schmidt äussert im Namen der schweizerischen und holländischen Architekten Vorbehalte gegenüber dem vorgesehenen Programm. Le Corbusier möchte an diesem Kongress Propaganda für die moderne Architektur, insbesondere für sein Projekt des Völkerbundpalastes veranstalten und ausserdem seine "cinq points pour une architecture nouvelle" [5] zum Gegenstand einer Deklaration machen.

Am Kongress in La Sarraz stellt sich Hans Schmidt zusammen mit Mart Stam in Gegensatz zu Le Corbusier und verlangt, dass die Gesellschaft der modernen Architekten nicht in die ästhetischen Fragen der Baukunst abgleiten dürfe, sondern sich primär mit Fragen des Städtebaus, der Ökonomie und der Standardisierung zu beschäftigen habe. In der Erklärung von La Sarraz sind denn auch, im Gegensatz zum ursprünglichen Programm, die folgenden Hauptpunkte aufgeführt und erläutert:

Allgemeine Wirtschaftlichkeit
Stadt- und Landesplanung
Architektur und öffentliche Meinung
Architektur und Beziehung zum Staat.

Der 2. Kongress der CIAM wird im Februar 1929 in Basel vorbereitet und soll im Herbst des gleichen Jahres in Frankfurt stattfinden. An dem in Basel festgelegten Kongressthema "Soziale Forderung und technische Verwirklichung der Kleinwohnung" kann man den Einfluss von Hans Schmidt und von Ernst May erkennen. Schmidt bereitet denn auch ein Thesenpapier vor mit dem Titel "Aufgabe und Verwirklichung der Minimalwohnung" [6]

Sein Prinzip der Minimal- oder Standardwohnung begründet er mit der Tendenz zur Kleinfamilie und zum Wohnen Alleinstehender sowie mit der Vermeidung der Untermiete. Besonders bemängelt er, dass normalerweise 30% der Wohnungsnutzfläche für unnütze Möbel verbraucht werden. Bei der Verwirklichung der Minimalwohnung will er das Wohnungsprogramm nicht von den einfachsten Ansprüchen oder vom Einkommen der Bewohner her entwickeln. Seine Minimalwohnung ist nicht allein für Bewohner der untersten Einkommensklassen bestimmt. Vielmehr fordert er in seinen Thesen gleiches Wohnen für alle.

"Ein richtig aufgestellter Standard, also die Ration "Wohnung" muss die Minimalforderung für alle Erwerbenden werden können."

Es geht Schmidt folglich nicht nur um ein soziales Postulat, sondern um eine klassenlose Gesellschaft mindestens im Wohnbereich. Für die Gestaltung seiner Minimalwohnung stellt Schmidt Forderungen auf, die auf dem Funktionalismus basieren:

"Die teilweise Zurückführung auf die alte Lebensform (Gartenstadtbewegung) ist ein falscher Weg, da sie mit der Totalität einer neuen Lebensform unvereinbar ist." Daher verlangt Hans Schmidt in seinen Thesen:

"Die Wohnung hat genau wie der Platz im Eisenbahnabteil ein aus ihrem Zweck und Sinn heraus begründetes Minimum zu erfüllen: Minimalwohnung oder Standardwohnung."

Der Kongress in Frankfurt wird im Oktober 1929 unter dem Titel "Die Wohnung für das Existenzminimum" durchgeführt. Mittels eines Fragebogens über hygienische und wirtschaftliche Grundlagen der Minimalwohnung werden die Wohnbedürfnisse der "Mindestbemittelten" in den verschiedenen Ländern untersucht. Ernst May präsentiert seine Wohnüberbauung für das Existenzminimum in Frankfurt. Schmidts Thesenpapier für die Minimalwohnung ist von Gropius überarbeitet und verändert worden und Gropius trägt das Ergebnis unter dem Titel "Soziologische Grundlagen der Minimalwohnung" vor. Hans Schmidt selbst referiert über das Thema "Bauvorschriften und Minimalwohnung", wobei er unter diesem Titel seine gesellschaftspolitische Forderung einer gleichen Standardwohnung für alle Erwerbenden nicht vorbringen kann.

Der 3. CIAM-Kongress wird auf den November 1930 in Brüssel angesetzt und Hans Schmidt beteiligt sich im Februar 1930 an dessen Vorbereitung im Pariser Atelier von Le Corbusier. Zum Thema des 3. Kongresses werden in Paris "Rationelle Bebauungsweisen" bestimmt. Gleichzeitig will man "horizontale Schiebefensterkonstruktionen" behandeln und demonstrieren. Während der Vorbereitungen zum Kongress in Brüssel erhält Ernst May die Berufung nach Moskau und nimmt Hans Schmidt sowie Mart Stam in seine Gruppe auf, welche teilweise bereits im Oktober nach Russland fährt. Die im Wohnungs- und Städtebau aktiven CIAM-Mitglieder fallen deshalb für die Leitung am Brüsseler Kongress aus. An Stelle von Hans Schmidt wird neben Rudolf Steiger Werner M. Moser zum Schweizer Delegierten bestimmt. Da Schmidt wegen seiner Russlandtätigkeit auch an den weiteren Kongressen in Athen und Paris verhindert ist, endet seine aktive und massgebende Mitwirkung in den CIAM bereits nach zweieinhalb Jahren.

Anmerkungen

[1] Michiel Brinkmann und sein Sohn J.A. Brinkmann gehören später zusammen mit
 L. van der Vlugt und J.H. van den Broek zu den massgebenden Architekten der
 Niederlande und erbauen die van Nelle Fabrik

[2] WERK 1923/8

[3] Brief Hans Schmidt im Besitz des Autors

[4] Ideal und Wirklichkeit im Stadtbau, Werk 1930/6

[5] Les 5 points d'une architecture nouvelle, d'après œuvre complète
 1910–1929 1. Les pilotis
 2. Les Toits jardins
 3. Le plan libre
 4. La fenêtre en longueur
 5. La façade libre

[6] Hans Schmidt, Beiträge zur Architektur 1924–1964, Basel 1965

Texte und Projekte 1924–1930

Aus: **CHAOS IM STADTBAU,** ABC 1924/1

[...]

Das Chaos von Paris ist das Chaos jeder Stadt des 19. Jahrhunderts. Darum sollte eine jede von ihnen einen Eiffelturm besitzen, und die Architekten sollten Freibillete erhalten. 300 m über dem Erdboden würden sie erkennen, welches die Aufgaben und Grenzen ihrer Kunst sind:

Sie würden erkennen, dass Städte im Raum entstehen und nicht auf der Ebene des Reissbrettes – dass sie organisch plastische Gebilde sind und keine Grundrisse, die durch Baulinien und durchlaufende Hauptgesimshöhen in Wirklichkeit umgesetzt werden – dass die Wohnansprüche von Hunderttausenden mehr sind als eine tote Masse, aus der man die Räume der Strassen und Plätze herausschneidet. Sie würden die Körper der Häuser als wirkliches Material des Stadtbaues sehen lernen und begreifen, dass die Organisation, die Zusammenfügung dieses Materials auch dem Gesetze der Bewegung im Raum, dem Verkehr, erfolgen muss. Sie würden einsehen, das eine moderne Stadt niemals eine Sammlung malerischer Aspekte sein kann, seien sie nun klassizistisch komponiert wie in Paris oder mittelalterlich wie anderwärts. Der unbestechliche Ausblick vom Eiffelturm und vom Flugzeug würde sie belehren, dass es keine malerische und keine monumentale Stadt gibt, nur eine architektonische Stadt als den Ausdruck höchster Gesetzmässigkeit, Einheit und Ökonomie – dass sie weder mit der Regelmässigkeit, noch mit der Unregelmässigkeit zu spielen, sondern allein jede klare Lösung der Aufgabe zu suchen haben, die von selbst zur organisierten, also geregelten Form führt. Es wird eine unserer wichtigsten Aufgaben sein, die Gesetze einer organischen Bildung einer modernen Stadt aus den Elementen ihrer Gestaltung und aus den Forderungen der Zeit abzuleiten. Inzwischen fährt man fort auf den Bahnen des 19. Jahrhunderts und liefert die Erweiterungen unserer Städte dem Chaos aus. Soeben hat die Stadt Basel mit ausdrücklicher Zustimmung des Vereins der Architekten und Ingenieure und des "Heimatschutzes" den Strassenplan ihres nordwestlichen Erweiterungsgebietes festgelegt, wie hier nach dem Ausführungsplan wiedergegeben ist.

[...]

Wenn wir auf diese Weise dem Gerüst der Verkehrstrassen folgen und, dem bereits vorhandenen Anbau Rechnung tragend, das gleichförmige Element der Häuserreihen ausbreiten, so erkennen wir, dass die Freiflächen des Gottesackers, des Hilfsspitals und der Irrenanstalt tote Ausschnitte innerhalb unseres klar entstandenen Systems bilden. Diese ummauerten Bezirke waren vor die Tore einer Stadt hinaus verlegt worden, die man noch als geschlossenes festungsartiges Wesen empfand, als ein "Innen" gegenüber einem "Aussen". Ebenso entspringt die Anlage des Industriegürtels der Grenze entlang der Vorstellung einer ringförmig sich ausbreitenden Festungsstadt. Die Erkenntnis des organischen Werdens einer modernen Stadt führt uns dazu, auch diese Ele-

mente dem Gesetz des Ganzen einzuordnen, Wohnviertel und Industrie zu trennen, die Industrie mit dem Eisenbahnverkehr und das Wohnen mit den Grünflächen in Verbindung zu setzen. Diese Anordnung entspricht auch der Tatsache, dass das Gebiet rechts der Strasse nach Burgfelden um 5 m tiefer liegt, dass die Entwicklung der Industrie gegen Allschwil hin noch ganz in der Luft steht, und dass der herrschende Wind von Westen kommt.

Aus: **WANDLUNGEN DER STADT BASEL,** Werk 1924/4

[...] Dennoch sind diese neuen Aussenviertel mehr als ein Versuch, eine Ideologie geworden; sie zeigen uns, was wir nicht immer glauben wollen, dass auch wir die Folgen des Krieges verspüren und den Gang einer Entwicklung mitmachen, die weiter reicht als diese Folgen. Wir sind ärmer geworden, wir müssen das beste Villabauterrain für Reihenhäuser hergeben, im Westen, in Riehen und auf dem Bruderholz, wir müssen das solide Bauhandwerk der Vorkriegszeit einer Technik der bescheidenen Mittel opfern, die den neuen Bauten den Ruf der Hässlichkeit und Unsolidität eingebracht hat. Aber wir haben ein Stück Ehrlichkeit gewonnen, haben ungewollt einen Schritt in jene neue Wirklichkeit getan, die Rathenau in seinem Buche "Die neue Gesellschaft" so eindrücklich schildert. Dem ehemaligen Reichen ist der Luxus der grossen Villa zu teuer geworden. Selbst die begüterten Klassen begnügen sich heute mit dem simpeln praktischen Reihenhaus, ihnen folgt der Mittelstand bis hinab zum festbesoldeten kleinen Staatsangestellten, der vom Erstarken des Staatsorganismus am meisten profitiert hat und nun als Hauptabnehmer jener kleinsten Einzelhäuser auftritt. Nur die eigentliche Arbeiterbevölkerung ist nach wie vor auf das grosse Miethaus angewiesen und doch hatte ihr die ganze Kleinhausbewegung in erster Linie gegolten. Ein weiteres Herabsetzen der äusseren Ansprüche, ein stärkeres Heranziehen der Mittel der Technik im Bauwesen werden vielleicht rein ökonomisch auch dieses Ziel näher bringen – die letzten Möglichkeiten liegen wohl erst in der Selbständigmachung des Arbeiters durch das Mittel eines über die Individualität des Einzelnen hinaus entwickelten Kapitalismus. Damit würde auch das grosse Miethaus seinen heutigen Charakter der Wohnausbeutung verlieren, und das ihm zugrunde liegende Prinzip der Stockwerkswohnung könnte seinen gesunden technischen und wirtschaftlichen Möglichkeiten entsprechend ausgebildet werden.

Eine zusammengedrängte Innenstadt, wo die Kontraste sich häufen, das geschäftliche Leben sich gegeseitig steigert und überbietet – die Wohnquartiere, gleichförmig flach gebaut, immer weiter in die Landschaft hinausgezogen, durch den Blutstrom des Verkehrs an die Innenstadt gebunden: es ist die eindeutige Gestalt, zu der auch die Wandlungen Basels führen. Das Thema dieser Aufgabe ist so gross, wie je eines, seit wir Städte bauen und es liegt nur an der Konsequenz unserer Arbeit als Architekten, dafür jene Reinheit und Grösse des Ganzen zu finden, die wir an unsern alten Städten bewundern.

7 Basel, äusseres Westplateau, genehmigter Strassenplan (oben) und Gegenvorschlag Hans Schmidt (unten). Quelle: ABC – Beiträge zum Bauen 1/1924

8 Warum schön? Quelle: ABC – Beiträge zum Bauen 3-4/1925

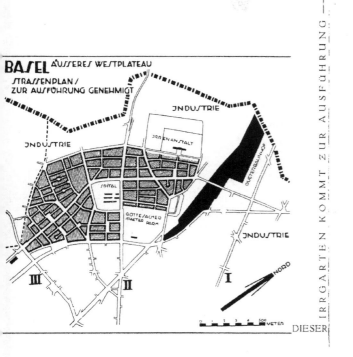

— IRRGARTEN KOMMT ZUR AUSFÜHRUNG —

DIESER

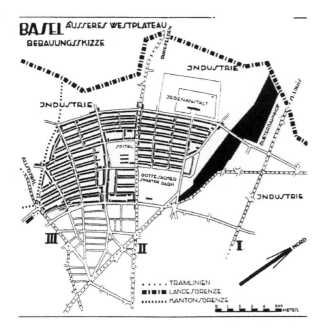

— EINE ÜBERSICHTLICHE LÖSUNG WAR MÖGLICH —

7

Warum
SIND UNSERE

MASCHINEN SCHÖN
WEIL SIE

Arbeiten
Sich bewegen
Funktionieren
FABRIK
SILO
LOKOMOTIVE
LASTWAGEN
FLUGZEUG
?

Warum
SIND UNSERE

HAUSER NICHT SCHÖN
WEIL SIE

Nichts tun
Herumstehen
Representieren
VILLA
SCHULPALAST
GEISTESTEMPEL
BANKPALAST
EISENBAHNTEMPEL
?

8

Aus: **DER VOLUMENKOMPLEX (Siedlungen – Industrieanlagen – Städte),** ABC 1925/5

[...]

Die Vergangenheit hat versucht, die Häusermassen der Stadt in eine geschlossene ästhetische Ordnung zu zwingen, um Strassenraum und Platzraum zu schaffen. Jedes Volumen hat seine Fassade, und diese Fassade ist Dekoration – ein Stück Platzwand. Die Dekoration muss einheitlich sein, die Gesimshöhe wird gleichmässig vorgeschrieben – die Ästhetik des Äusserlichen verlangt notwendigerweise gesetzliche Vorschriften, um den Schein der Einheit, den repräsentativen Anblick zu erreichen.

Die Notwendigkeit liess sich nicht hinter Fassademauern gefangen halten. Die Volumen der Häuser zerbrachen die Strassenwände, überschritten die gleichmässigen Gesimshöhen und suchten sich neuen Raum zu verschaffen.

Das moderne Bauen fordert, ausgehend von der Notwendigkeit, die neue Organisation der Volumen im Raum – die neue Stadt.

Das moderne Bauen nimmt der Fläche ihre Grenze –

Das moderne Bauen nimmt dem Volumen seine Geschlossenheit –

Das moderne Bauen nimmt dem Volumenkomplex, das man Stadt genannt hat, seine Starrheit – seine Geschlossenheit.

[...]

Aus: **BAUEN IST NICHT ARCHITEKTUR,** Werk 1927/5

[...] Das Bauen hat begonnen, möglichst neutrale allgemeingültige Typen für ein Maximum von Anforderungen zu schaffen, zu vereinfachen, zu normalisieren – wir Architekten stehen dieser Entwicklung immer noch im Weg. Wir denken vor allem an die Notwendigkeit neutraler Bautypen, an die Summen, die wir besonders in unseren Städten jährlich für Umbauten ausgeben müssen, weil das Leben sich rascher wandelt als unsere Bauwerke, weil es heute Bureaux verlangt, wo es gestern ein Hotel brauchte, Bureaux in Wohnungen verwandelt, Läden zu Restaurationsräumen umbaut, Stockwerke aufsetzt, Erweiterungen vornimmt und damit täglich die Illusion zerstört, ein Bauwerk habe irgendeinen anderen Charakter auszudrücken als den allgemeinsten, gleichgültigsten, den wir ihm überhaupt zu geben vermögen.

[...]

Aus: **WETTBEWERB FÜR DIE BEZIRKSSCHULE LENZBURG,** Schweizerische Bauzeitung 1927/15

[...]

Man spricht heute viel vom modernen Haus als "Maschine". Vielleicht wäre es zuerst einmal richtiger, sich vor Augen zu halten, dass das moderne Haus "von der Maschine gebaut wird". D. h. ein Entwurf hat, um im Sinne einer maschinellen Bauausführung rationell und damit billiger zu arbeiten, die maschinelle Produktionsweise zu Grunde zu legen, im Gegensatz zur überlieferten handwerklichen. Er hat also möglichst viel gleiche und ohne Unterbrechung zusam-

9 Wettbewerbsprojekt Petersschule in Basel, 1927; Skizze von Lageplan und Schnitt.
Quelle: Schweizerische Bauzeitung 9. April 1927

10 Bebauung mit Reihenhäusern, Spitzwaldstrasse, Allschwil, Projekt 1927
Quelle: Archiv GTA, ETH Zürich, Nachlas Hans Schmidt

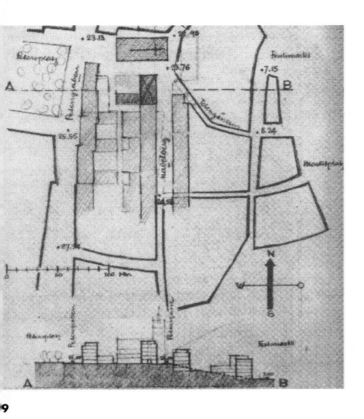

9

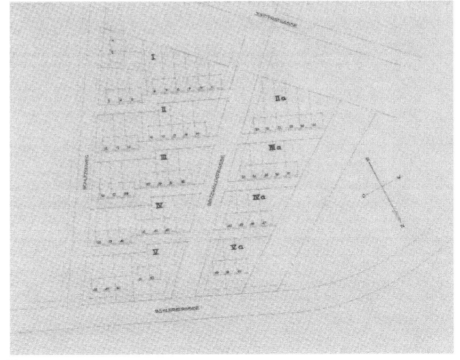

10

mengesetzte Einheiten zu schaffen, Einheiten von Konstruktionsteilen, Boden-
flächen, Lichtöffnungen, Mauerflächen. [...]

Aus: *Vom Neuen Bauen / **INDUSTRIALISIERUNG DES BAUENS**,*
Werk 1928/2

[...]
5. Grundsatz der örtlich zusammengefassten Produktion.
Die Entwicklung der industriellen Produktion beruht zum grossen Teil auf der
Möglichkeit der einheitlich und übersichtlich zusammengefassten Arbeit in der
Fabrik. Die Nachteile des heutigen Bauens sind zum grossen Teil die notwen-
dige Folge der zersplitterten Arbeit am Bauplatz. Wir haben also alles Interesse
daran, den wichtigsten Teil der Bauarbeit in der Fabrik vorzunehmen. Diese
Möglichkeit ist fast unbegrenzt beim nach Katalog und ab Lager gelieferten
Standardhaus (ein englisches Stahlhaus wird in einer Woche bezugsfertig auf-
gestellt). Aber die Voraussetzung für diese Möglichkeit ist das Einzelhaus. Wir
sehen jedoch, dass die ganze Tendenz des heutigen Lebens den Einzelbesitz am
Hause immer mehr ausscheidet, so gut wie dies für unsere wichtigsten Verkehrs-
mittel und öffentlichen Einrichtungen geschehen ist. Wir stehen also vorläufig an
einer Grenze, die wir nur durch Förderung der planmässig rationellen Organi-
sation des Zusammenlebens überhaupt, durch die Gemeinwirtschaft in Produk-
tion, Bodenausnutzung und Städtebau zu erweitern vermögen.

AUFGABE UND VERWIRKLICHUNG DER MINIMALWOHNUNG in: *Hans*
Schmidt, Beiträge zur Architektur 1924–1964, Basel 1965

Entwurf zu Thesen zum II. Kongress der CIAM Frankfurt a. M. 1929

I. Aufgabe

1. *Grundlegend für den Begriff der Minimalwohnung sind folgende soziologi-*
 schen Erscheinungen der Gegenwart:
 - *Die grosse Familie verliert ihre wirtschaftliche Berechtigung als Produk-*
 tions- und Konsumptionseinheit (bäuerliche und kleinstädtische Familie).
 - *Die heutigen Arbeitsverhältnisse (Freizügigkeit, wechselnde Arbeitsgele-*
 genheit in grossen und verschiedenen Betrieben) begünstigen die Abwan-
 derung und Sich-selbständig-Machen der Familienmitglieder.
 - *Diese Erscheinung führt zur Aufteilung der Familie in vermehrte und klei-*
 nere Einheiten, also zur Abnahme der durchschnittlichen Haushaltsgrösse
 bis zum selbständigen Wohnen Alleinstehender.
 - *Wohnungstechnisch bedeutet dies eine zunehmende Vermehrung und Ver-*
 kleinerung der selbständigen Wohnungseinheiten.

2. *Es ist deshalb falsch, die Minimalwohnung nur als eine Behelfsform anzu-*
 sehen. Die grosse Nachfrage nach Kleinstwohnungen bis hinab zur Ein-
 zimmerwohnung für Alleinstehende entspricht einem wirklichen Bedürfnis.
 Die heute beliebte Grosswohnung wird sich für die Zukunft als überlebt er-
 weisen.

11 Siedlung Schorenmatten, Wohn-
kolonie für kinderreiche Familien der Stadt
Basel. Projekt 1927; erstes, nicht aus-
geführtes Projekt.
Quelle: ABC – Beiträge zum Bauen
1/1924

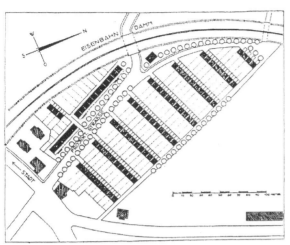

TYPENGRUNDRISSE

entwickeln sich aus der notwendigen Vorarbeit einer immer erneuten Vereinfachung und Normalisierung der Grundrisselemente. Wir veröffentlichen eine Folge von Grundmassen, die auf diese Normalisierung der Elemente hinarbeiten. Es hat sich gezeigt, dass die Einheit von 1,00 m (vgl. auch die Stuttgarter Häuser von J. J. P. Oud & M. Stam) das geeignete Grundmass für diese Normalisierung abgibt:

Breite Bettstelle	brutto	1,00 m
Treppe	"	1,00 m
W. C.	"	1,00 m
Breite Schlafkabine	i. L.	2,00 m
Kleinküche	i. L.	2,00 m
Bad	i. L.	2,00 m
Breite Schlafzimmer	i. L.	3,00 m
Arbeitszimmer	i. L.	3,00 m
Wohnzimmer	i. L.	4,00 m usw.

Mit diesen Grundmassen lassen sich in Einklang bringen die Einheiten für Fassadenplatten, die wirtschaftlichen Spannweiten für Deckenelemente (3,00 m) und die Normalweiten für Fenstereinheiten und äussere Türen.

Auf diesem Wege wird es möglich, die Bodenfläche des Hauses, ausgehend von normalisierten Konstruktionssystemen, mit der Zeit ebenso rational einzuteilen, wie dies heute im Waggon- und Automobilbau geschieht.

(Entwürfe: Artaria & Schmidt · Basel · 1927)

ZUGANGSSEITEN

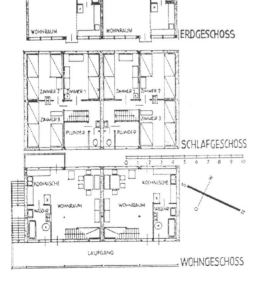

OBERGESCHOSS

ERDGESCHOSS

SCHLAFGESCHOSS

WOHNGESCHOSS

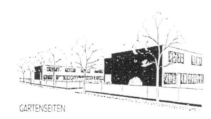

GARTENSEITEN

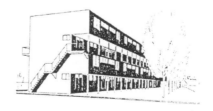

WOHNKOLONIE (Projekt 1927)
für kinderreiche Familien der Stadt Basel.
pro Wohnung max. 9 Betten (Eltern und 7 Kinder).

83 Flachbauwohnungen ·
die 4,00 m breiten Wohnwege zur Gewinnung eines dritten Schlafzimmers als Durchgang überbaut.

34 Stockwerkswohnungen ·
offene Laufgänge und Treppenanlagen.

7

3. Die offizielle Wohnungspolitik einiger Länder (Deutschland, Schweiz), bei der die Mittel- und Grosswohnungen bevorzugt werden, ist deshalb kulturell und wirtschaftlich falsch.

Beispiel:
Gruppierung nach Grössenklassen der im Jahre 1927 in Deutschland erbauten Wohnungen

1- bis 3räumig	4räumig	5räumig	darüber
31.8%	43.3%	13.3%	9.6%

(nach Dr. Heymann in "Baumarkt" 39/1929)

4. Die Folgen dieser verkehrten Wohnungspolitik sind:
- Züchtung eines übersetzten Standards, der die allgemeinsten Ansprüche nicht befriedigt und in die Altwohnungen und Notwohnungen verweist.
- Begünstigung des Zusammenwohnens, da die Grosswohnung anders nicht wirtschaftlich ausgenützt werden kann.
- Begünstigung der Untermiete, da zu viel teure Grosswohnungen und zu wenig billige Kleinstwohnungen gebaut werden.
- Belastung der Wirtschaft mit einer unzeitgemässen und zu teuren Wohnform, die infolgedessen sehr rasch entwertet und herabgewirtschaftet sein wird.

II. Verwirklichung
1. Die Wohnung hat genau wie der Platz im Eisenbahnabteil ein aus ihrem Zweck und Sinn heraus begründetes sachliches Minimum zu erfüllen: Minimalwohnung oder Standardwohnung.
2. Dieses Minimum ist nicht nur wirtschaftlich begründet (Reduktion der Herstellungskosten), sondern ebensosehr kulturell erwünscht (Einschränkung des Wohnaufwandes).

Beispiel:
30% der heute geforderten Wohnungsnutzfläche dienen zur Aufstellung unnützer Möbel. Aber die notwendigsten Betriebserleichterungen fehlen.

3. Es wäre falsch, die Minimalwohnung als eine nach Zimmerzahl und Nutzfläche reduzierte Form der üblichen Grosswohnung anzusehen. Sie ist vielmehr auf Grund eines von Einblick und Erfahrung aufgestellten Programmes von sich aus zu formulieren.
4. Dieses Programm wird von den biologischen und soziologischen Minimumansprüchen der Bewohner auszugehen haben.
5. Es bedarf besonderer Aufmerksamkeit, um ein solches Minimum unter den heutigen wirtschaftlichen und national zersplitterten Verhältnissen klar herauszuarbeiten. Man wird zu unterscheiden haben zwischen:
- sachlich erfassbaren Ansprüchen;
- traditionell eingebildeten Ansprüchen.

12 Siedlung Schorenmatten, Wohnkolonie für kinderreiche Familien der Stadt Basel, 1929. Situation des ausgeführten Projektes von Artaria und Schmidt mit August Künzel.
Quelle: Wohnungsbau Basel 1915–35, Lehrstuhl Prof. Schnebli, Seminarwoche WS 76/77

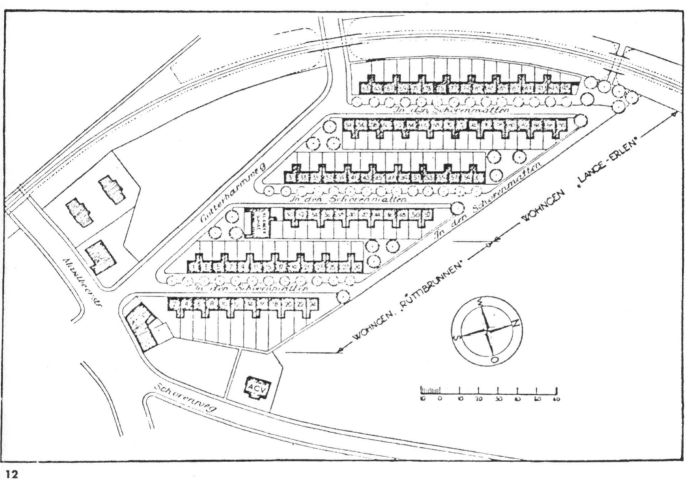

12

6. Das festzusetzende Minimum wird in vielen Fällen über dem traditionellen Minimum einzelner Länder oder Bevölkerungsgruppen liegen, soweit dieses durch Verelendung und falsche Gewohnheiten herabgesetzt worden ist.

Beispiel:
Die moderne grossstädtische Industriebevölkerung geht unmittelbar aus der Landbevölkerung hervor. Sie behält ihre primitiven Lebensansprüche bei, oft in sehr herabgesetzter Form, statt ihrer neuen Lebensform entsprechende Ansprüche zu stellen. Die teilweise Zurückführung auf die alte Lebensform (Gartenstadtbewegung) ist ein falscher Weg, da sie mit der Totalität einer neuen Lebensform unvereinbar ist.

7. Es wäre also verkehrt, bei der Aufstellung eines solchen Minimalprogrammes einseitig von den heutigen untersten Ansprüchen, die eine Folge der Verelendung sind, auszugehen.

8. Ebenso falsch wäre es, dieses Minimalprogramm vom heutigen Einkommen abhängig zu machen. Die Frage der Verwirklichung, also der Ausbalancierung mit entsprechenden Einkommen, ist Sache der Wirtschaft. Ein richtig aufgestellter Standard, also die Ration «Wohnung», muss die Minimumforderung für alle Erwerbenden werden können.

9. Dabei ist es notwendig, diesen Standard soweit irgend möglich für alle am Kongress beteiligten Länder im Rahmen der rein geographischen Unterschiede (Klima) gemeinsam aufzustellen, da dies dem kommenden Ausgleich der Lebensbedürfnisse durch die moderne Wirtschaft und Produktion entspricht.

10. Die Erfahrungen aller europäischen Länder zeigen, dass bei der heutigen Spanne zwischen Einkommen und Erstellungskosten und den bestehenden Zinssätzen an eine Befriedigung der Wohnansprüche der Masse auf dem Wege der freien Wirtschaft nicht gedacht werden kann.

11. Industrie und Banken arbeiten zwangsläufig für diejenigen Abnehmer, die die grössten Gewinne bei geringstem Arbeitsaufwand versprechen und sind deshalb für den Bau billiger Wohnungen nur schwer zu haben.

12. Die Erwartung, dass die moderne Technik unter Anwendung ihrer neuesten Methoden und Hilfsmittel bedeutend billigere und komfortablere Wohnungen liefern werde, ist illusorisch, da diese Technik nur im Rahmen von Industrie und Technik arbeiten kann, und infolgedessen jede Verbilligung in erster Linie an diese abführen muss.

13. Die Verwirklichung der Minimalwohnung in tragbarer Form fordert infolgedessen:
 - Unterstützung durch den Staat in Form von erleichterter Geldbeschaffung, wobei eine oberste Wohnungsgrösse festzulegen wäre, um die Vergeudung der öffentlichen Gelder für zu grosse Wohnungen zu verhindern.

13 Wettbewerbsprojekt Umgestaltung Barfüsserplatz Basel, 1929. Situation. Quelle: Archiv GTA, ETH Zürich, Nachlass Hans Schmidt

14 Wettbewerbsprojekt Umgestaltung Barfüsserplatz Basel, 1929. Fotomontagen, Blick Richtung Barfüsserkirche (oben), Blick Richtung Falknerstrasse (unten). Quelle: Archiv GTA, ETH Zürich, Nachlass Hans Schmidt

13

14

- Möglichste Erleichterung von Seiten der Behörden in bezug auf Bauvorschriften und Aufschliessungskosten.
- Bereitstellung von Bauland durch den Staat unter Umgehung der Terrainspekulation.

Aus: **BAUTEN DER TECHNIK,** Katalog der Ausstellung "Bauten der Technik" des Folkwangmuseums (Essen) in Basel

Die Grundlage der Technik ist die wissenschaftliche Ratio, das heisst, die rationelle verstandesmässige Erkenntnis. Sie steht damit bewusst jenseits des "Wunders". Technische Wunder gibt es nur für den Laien. Die Technik selbst kann sich auf keine Wunder verlassen, sowenig wie dies die heutige Wissenschaft tun kann. Auch wo wir nichts wissen, wo unsere Erkenntnis und unser Verstand nicht mehr ausreichen, bemühen sich der Techniker und der Wissenschaftler dies zu erklären, gesetzmässig zu begründen. Sie berufen sich nicht auf das Wunderbare als Erklärung des Unerklärlichen.
[...]
Die Technik baut heute wissenschaftlich rationell – das Bauen ist für sie überall, wo sie keine wesensfremden Rücksichten zu nehmen hat, ein Konstruieren, ein Rechnen mit bestimmten Gesetzen, den Gesetzen der Kräfte, die in der Natur wirksm sind, und des Widerstandes, den das Material diesen Kräften entgegesetzt, ein Rechnen mit den Einflüssen, die die Natur als Zerstörerin auf das Werk zu gewinnen sucht, und mit Bedingungen, die die Wirtschaftlichkeit an die Verwirklichung des Werkes stellt. Die Formen des Ingenieurbaus werden heute durch die Rechnung, den Arbeitsvorgang der Maschine und der Montage und in neuester Zeit durch den Laboratoriums- und den Modellversuch bestimmt. Damit ist das Problem der Form an sich überwunden, die Form ist zum einfachen Resultat eines technisch-logischen Gedankenganges gemacht.

Aus: **IDEAL UND WIRKLICHKEIT IM STADTBAU,** Werk 1930/6

[...] Die heutige technische Produktion ist dadurch gross geworden, dass sie es gelernt hat zu rechnen, und zwar selbst mit den Faktoren, die der Vernunft kaum zugänglich erschienen. Unsere baulichen Aufgaben sind heute Rechenexempel – wo das Rechnen aufhört, beginnt der Dilettantismus. Warum sollte es im Stadtbau anders sein? Schon heute mehren sich die Zeichen dafür, dass das grosse Gebiet des Stadtbaues, das sich bisher hinter den romantischen oder klassizistischen Kulissen der Stadtbaukunst verbarg, den Weg zur Wirklichkeit findet. Diese Wirklichkeit wird uns von der Aufgabe entlasten, Poesie, Schönheit, Harmonie und Ordnung auf irgenwelchen gefühlsmässigen Wegen suchen zu müssen. Jede klare Lösung wird diese von selbst enthalten.
[...]
Ein modernes Stadtviertel ist keine Angelegenheit von Prachtstrassen, die mit geschlossenen Höfen erkauft werden müssen, die Strasse ist kein Abrollen von einheitlich geregelten Strassenfassaden, die wir nicht anders als nach der fatalen

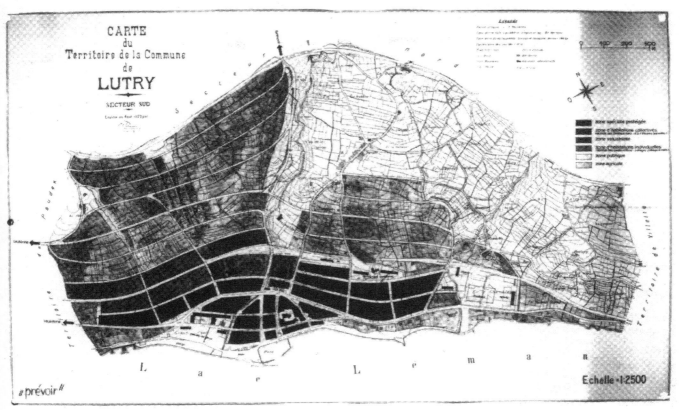

15

16

Comment lotir la zone villégiature ?

Les propriétaires des petites villas préfèrent les lots restreints (500-800 m² de surface). Il faut donc prévoir aux désavantages d'un lotissement trop serré.

Les maisons bordent la rue, livrées à la poussière et barrant la vue aux promeneurs.

On vous propose un système de lotissement plus favorable qui permet des lots restreints sans construire trop de rues coûteuses et qui évitent les désavantages habituels.

La route cantonale qui suit les bords du lac ne suffira plus !

Il faut donc prévoir une deuxième route qui se tient au milieu de la zone villégiature entre les lignes de chemin de fer de St. Maurice et de Fribourg.

La nouvelle route franchira le vallon de la Lutrive par un pont et joindra la route cantonale sur Grandvaux à Chatelard.

Les traits caractéristiques du pays-

Ne livrez pas les points typiques de votre paysage (collines , au petit Bouchat" , en Chatel" , Crêt Bernard" , Tour de Bertholoz") au lotissement. Gardez les comme espaces publiques.

Gardez les vallons ombrageux qui coupent les pentes en les réservant comme promenades publiques.

Mode von 1930 oder 1931 auf Kilometerlänge festlegen könnten. Eine Kleinhaussiedlung mit Grundstücken von 200–300 m² Grösse Raum kann durch keine Zonenvorschrift der Welt in ein zwischen Bäumen verstecktes Dorf oder in eine vornehme Villenkolonie verwandelt werden. Und wir können von unsern Architekten nicht erwarten, das einfache und billige Haus könne etwas anderes sein, als ein technisches und wirtschaftliches Rechenexempel.

Dieselben Notwendigkeiten, die uns dazu führen, ein Haus in allen Teilen einfach und logisch auszudenken und das Resultat auf die wirtschaftlichste Form zu bringen, führen uns heute dazu, die Gesamtheit der Häuser, die Siedlung, den Stadtplan zum Gegenstand genauer Überlegung zu machen. Der wichtigste Schritt, die Abkehr vom geschlossenen Block, von der nach der Strasse orientierten Randbebauung (auf die alle unsere Vorschriften zugeschnitten sind), ist grundsätzlich bereits vollzogen. Die Wissenschaft beginnt den Fragen der günstigsten Besonnung, also der Stellung der Häuser und Hauszeilen ihre Aufmerksamkeit zuzuwenden (Justin Bidoux, La science des plans de ville). Die wirtschaftlichste Form des Zeilenbaues wird aus allen Faktoren (Hausgrundriss, Strassenform, Kanalisationsanlage) errechnet (Arbeiten von Prof. Heiligenthal, Karlsruhe, von Stadtbaurat May und Baurat Kaufmann im "Zentralblatt der Bauverwaltung", Nr. 24 und 36, Jahrgang 1929; sowie von Prof. W. Gropius im "Neuen Berlin", Nr. 4, Jahrgang 1929). Man kann hoffen, dass die Zeit vorbei ist, wo unsere Kenntnisse über den Stadtbau überall da, wo der Ingenieur zum Worte kommt, beim Verkehrswesen, beim Strassenbau und bei der Versorgung der Städte, auf soliden rechnerischen Grundlagen beruhen, während die eigentlichen Bebauungsfragen dem Gefühl des Architekten und den blinden Paragraphen der Bauordnungen ausgeliefert werden.

[...]

Ordnung und Schönheit könne überhaupt nicht von aussen entstehen, sondern können nur das Resultat einer Lebensforderung sein, die nur durch Ordnung, also nur durch klare Überlegung und nüchterne Methodik überhaupt zu erfüllen ist. Das ist die Ordnung, die heute den Verkehr und die Versorgung grosser Menschenmassen ermöglicht, und es wird dieselbe Ordnung sein, die den Stadtbau auf den richtigen Weg bringen muss.

[Anmerkung des Autors] Darauf folgt eine Entgegnung von Peter Meyer, die dieser mit den beiden vielsagenden Sätzen: "So ist es. Ist es so?" einleitet. Er stellt darin die andere Stimme dar, die einen gewissen Ausgleich zu Hans Schmidts sehr freien Wortinterpretationen schafft.

17 Wettbewerbsprojekt für die rech[t]ufrigen Quartiere in Genf. Übersichtsp[lan]. Quelle: Schweizerische Bauzeitung 17. Mai 1930

18 Siedlung Neubühl, Wollishofen-Zürich, 1928–1932. Lageplan. Artaria und Schmidt in Zusammenarbe[it] mit Max Ernst Haefeli, Werner Max Moser, Rudolf Steiger, Emil Roth, Carl Hubacher. Quelle: Schweizerische Bauzeitung 19. Sept. 1931

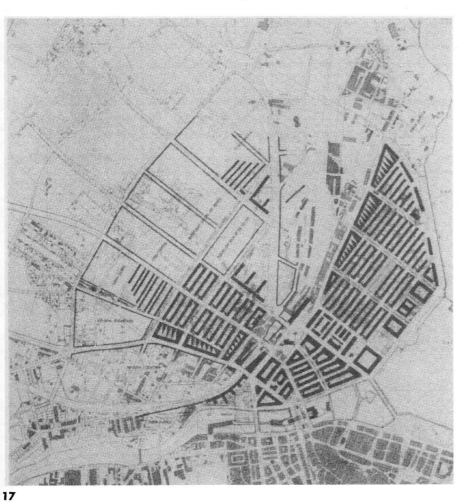

17

18

Moskau 1930 bis 1937
Aufbruch zum sozialistischen
Städtebau

Anlass zur Ausreise in die UdSSR

Es sind verschiedene Gründe, die Hans Schmidt im Spätherbst 1930 zur Ausreise nach Moskau veranlassen: Die Wirtschaftskrise und damit die Rezession im Bauwesen sind in der Schweiz in diesem Jahr auf dem Höhepunkt angelangt, während die sowjetische Wirtschaft von dieser Entwicklung im Westen nicht betroffen ist. Das Büro Artaria und Schmidt steht wegen Überschuldung in Liquidation, und die erhoffte Berufung als Professor an die ETH Zürich in der Nachfolge von Karl Moser ist mit der Wahl von Rudolf Salvisberg im Sommer 1929 entfallen. Unter diesen wirtschaftlich ungünstigen Umständen eröffnet die Berufung durch Ernst May in die Moskauer Planungsgruppe für Hans Schmidt neue berufliche Perspektiven.

Ernst May, noch Stadtbaudirektor von Frankfurt, ist vom Chef der Zekom-Bank Moskau mit der Überprüfung von Stadterweiterungen und neuen Stadtgründungen beauftragt und stellt im Oktober 1930 seine Gruppe von Planungsfachleuten zusammen. Hans Schmidt wird als Spezialist für Massenwohnungsbau und Typisierung gewählt. Nach Angaben von Kurt Jungmanns sollen sich damals gegen 1400 Baufachleute um die Aufnahme in May's Gruppe beworben haben [1]. Die Ausreise in die Sowjetunion bildet somit für Hans Schmidt einen Ausweg aus der Krise und gleichzeitig die realistische Hoffnung, seine Ideen eines sozialistischen Städtebaus verwirklichen zu können.

Die Zusammensetzung der Architektengruppe in Moskau

Im Vertrag mit der Zekom-Bank, der 1932 an den Trust Standardgorprojekt und später an das Gorstroyprojekt übergeht, werden die Mitglieder der Gruppe May für eine fünfjährige Arbeitsperiode verpflichtet. Die Gruppe umfasst ca. 20 Mitglieder, darunter Architekten, Eisenbahnspezialisten, Stadttechniker, Gartenarchitekten und Baustellenspezialisten [2]. Die meisten Mitarbeiter kommen aus dem von Ernst May geleiteten Baudezernat der Stadt Frankfurt. Die einzigen Ausländer sind Fred Forbat aus Ungarn,

Hans Schmidt aus der Schweiz und Mart Stam aus Holland. Ernst May führt in seinem Mitarbeiterverzeichnis für die russische Periode 1930–33 im ganzen 26 westliche und 11 russische Mitarbeiter auf. Die Gruppe, die im Oktober 1930 nach Moskau abreist, setzt sich nach den bei Ernst May und bei Grete Schütte-Lihotzky zu findenden Angaben aus den folgenden Fachleuten zusammen:

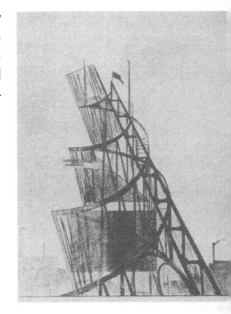

1

Hans Burkhardt	für Städtebau
Fred Forbat	für Architektur
Max Frühauf	Bauingenieur, für Bauleitung
Gustav Hassenpflug	für Architektur
Wilhelm Hauss	Tiefbauingenieur, für Installationen
Werner Hebebrand	Architekt, für Krankenhausbau
Walter Kratz	Architekt, für Wohnungsbau
Kurt Liebknecht	Architekt
Karl Lehmann	Bauingenieur, für Tiefbau und Verkehr
Hans Leistiko	Grafiker, für grafische Gestaltung
Albert Löcher	Architekt, für Städtebau
Erich Manthner	Architekt, für Städtebau
Ernst May	Architekt, Leiter der Gruppe
Hans Schmidt	Architekt, für Wohnungsbau
Walter Schütte	Architekt, für Schulhausbau
Grete Schütte-Lihotzky	Architektin, für Kinderanstalten
Walter Schulz	Architekt, für Bauleitung
Walter Schwagenscheidt	Architekt, für Städtebau
Mart Stam	Architekt, Wohnungsbau
Ulrich Wolf	Gartenarchitekt, für Gartenbau

Als für die Gruppe zuständigen Verwaltungsdirektor in Moskau nennt May den russischen Politkommissar Gasparian.

In der Folge von Hitlers Machtergreifung kehren die ersten Mitglieder bereits 1933 nach Deutschland zurück, und nach der Abreise des resignierten Ernst May im Dezember 1934, ist seine Gruppe auf mehr als die Hälfte reduziert.

Hannes Meyer bewirbt sich 1930 nach der fristlosen Kündigung als Bauhausdirektor ebenfalls um eine Aufgabe in der Sowjetunion und gründet 1931 in Moskau mit sieben seiner Schüler vom Bauhaus die Brigade "Rote Front". Einzelne seiner Mitarbeiter werden 1932 dem Gorstroyprojekt zugewiesen und arbeiten dort für Hans Schmidt, so Philipp Tolziner, Konrad Püschel und der Basler René Mensch. Hannes Meyer ist vor allem als Professor am Moskauer Architekturinstitut WASI tätig, später zudem am Städtebauinstitut Giprogor als Chefarchitekt für Ostsibirien. 1934 beendet Meyer

1 W. E. Tatlin, Denkmal der dritten Internationale, 1920.
Aus: L. A. Shadova, Tatlin, 1987

2 Generalplan der Stadt Magnitogorsk Erster Entwurf der Gruppe May 1930, Büro für Projektierung und Planung Zekom bank
Aus: J. Buekschmitt, Ernst May, 1963

3 Magnitogorsk. Realisierungsprojekt des 1. Bauabschnittes der rechtsufrigen Stadt 1948–54
Aus: Hans Schmidt, Die Tätigkeit deutscher Architekten und Spezialisten des Bauwesens in der Sowjetunion in den Jahren 1930–1937

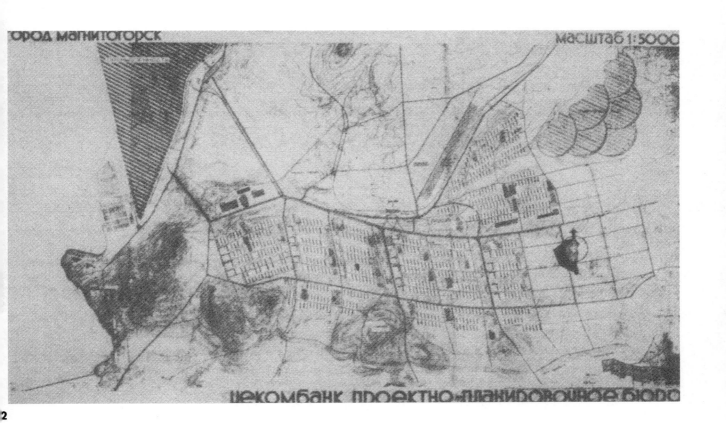

2

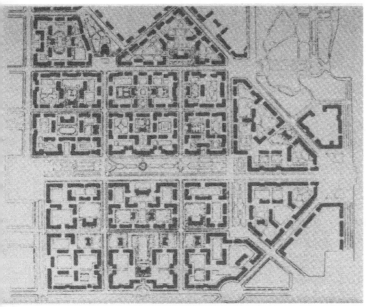

3

seine Tätigkeit und verlässt die Sowjetunion 1935, weil er die Anerkennung an der Akademie verloren hat.

Nach Ernst Mays Abreise und Hannes Meyers Trennung von seiner Brigade werden 1933 die ausländischen Architekten unter der Leitung von Hans Schmidt im Gorstroyprojekt zusammengefasst. [3]

Als letzte Mitglieder der Gruppe May verlassen Hans Schmidt mit Frau und Tochter zusammen mit dem Ehepaar Walter und Grete Schütte-Lihotzky im Juli 1937 die UdSSR über Odessa.

Die städtebaulichen Aufgaben von Hans Schmidt

Der Gruppe May ist im Rahmen der wechselnden Organisationen die Aufgabe gestellt, neue Industriestädte in und hinter dem Ural zu planen. Für welche Standorte Planungen und Gutachten erstellt wurden und wer von den Architekten jeweils dafür zuständig zeichnet, ist heute nur schwer feststellbar. Buekschmitt nennt in seinem Buch über Ernst May als Stadtprojekte Magnitogorsk, Nishny Tagil, Avtostroy, Kusnjezk (=Stalinsk), Leninakan (früher Alexandropol), Prokopiewsk. Schmidt erwähnt in seinem Bericht von 1967 zusätzlich Makeevka, Balchas, Orsk und Karaganda.

Eigentliche Planungen und deren Bearbeiter sind nachweisbar für folgende Städte (Übersichtsplan Seite 63):

Magnitogorsk: Bearbeitet 1930–32 von Ernst May, Mart Stam (mit seinem umstrittenen "modernen Plan"), Hans Schmidt (auf Grund seines Reiseberichtes) und Fred Forbat. Die Pläne der verschiedenen Entwicklungsphasen sind mehrfach publiziert.

Avtostroy: Bearbeitet ca. 1932 von Ernst May und weiteren Mitgliedern der Gruppe (Plankopf bei Buekschmitt). Dieses Automobilfabrikationszentrum liegt südwestlich von Nishni Nowgorod (heute Gorki). Zwei Pläne sind bei Buekschmitt abgebildet.

Neuplanung Moskau: Am Wettbewerb 1932 für die Neugestaltung von Moskau beteiligen sich neben den russischen Architekten auch die Gruppe May, der Kölner Stadtplaner Kurt Meyer und die Brigade Hannes Meyer. Das Projekt der Gruppe May wird bearbeitet von Ernst May, Werner Hebebrand, Verkehrsingenieur

4 Magnitogorsk. Projekt einer Bandstadt der Architektengruppe "OSA" 1930 Gesamtplan.
Aus: Hans Schmidt, Die Tätigkeit deutscher Architekten und Spezialisten des Bauwesens in der Sowjetunion in den Jahren 1930 bis 1937

5 Magnitogorsk. Projekt "OSA" 1930. Detail der Bebauung.
Aus: Hans Schmidt, Die Tätigkeit deutscher Architekten und Spezialisten des Bauwesens in der Sowjetunion in den Jahren 1930 bis 1937

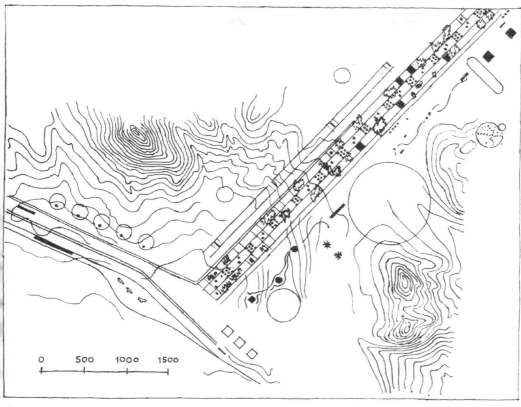

4

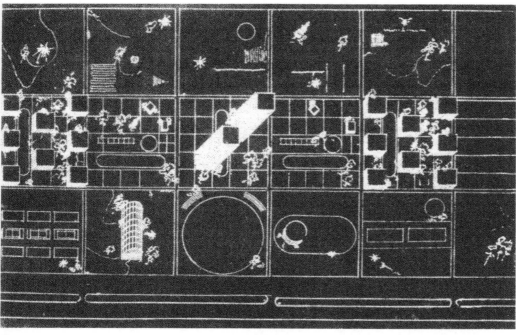

5

	Karl Lehmann und Hans Schmidt. Pläne verschiedener Wettbewerbsbeiträge bei Hans Schmidt (Publikation 1967), im Katalog Hannes Meyer und im Buch von Buekschmitt.
Nesvetay:	Station an der neuen Bahnlinie Moskva–Donbass 1933/34. Bearbeitet von Hans Schmidt, als Mitglied der Arbeitsgruppe unter M. J. Ginzburg. Projekte für Wohnhäuser bei Christian Borngräber publiziert.
Orsk:	Bearbeitet 1934–1936 von Hans Schmidt und den Mitarbeitern der ehemaligen Bauhausgruppe Konrad Püschel, Tibor Weiner und Philipp Tolziner. Pläne und Zeichnungen von Hans Schmidt in verschiedenen Publikationen und im Archiv GTA.

Bei der Planung Magnitogorsk bis zu derjenigen von Orsk ergeben sich für die westlichen Stadtplaner zunehmend die gleichen Schwierigkeiten. Der Gruppe May und insbesondere Hans Schmidt und Mart Stam geht es um die schnelle Verwirklichung der sozialistischen Stadt. Die zuständigen sowjetischen Instanzen sind jedoch schwerfällig in ihren Entscheidungen und sie verfügen nicht über die notwendige Baukapazität. Vor allem widerspricht das funktionalistische Stadtkonzept, das die Architekten des Neuen Bauens vertreten, den traditionell geprägten Vorstellungen einer sowjetischen Stadt aus der Sicht der russischen Funktionäre und Architekten. Gegenüber der Umsetzung der hochfliegenden modernen Stadtpläne in die Realität entstehen immer neue Hindernisse realer und ideologischer Art. Auch das kontinuierliche Abändern und Anpassen der Stadtpläne an die Vorstellungen und Bedingungen der sowjetischen Funktionäre bewirkt kaum einen Fortschritt im realen Bau der Städte. Vor allem wächst die Ablehnung der russischen Architekten gegenüber der ausländischen Planergruppe.

Die Fronten zwischen Funktionalismus und sozialistischem Realismus

Die Kritik an der konstruktivistischen, rationalistischen, funktionalistischen Architektur setzt in Moskau bereits vor der Ankunft der Gruppe May ein. Offenbar sind aber die westlichen Architekten über diese Opposition im Unklaren, da sie sich bei ihrer Abreise nach Moskau vor allem am Verband moderner Architekten OSA und dessen Zeitschrift Sowremennaja Architektura orientiert hatten. Der ideologische und architektonische Umschwung

6 Planung der Stadt Avtostroy durch die Gruppe May. Das Automobilfabrikationszentrum mit Wohnstadt liegt westlich der Stadt Nishny Nowgorod (heute Gorki). Aus: J. Buekschmitt, Ernst May, 1963

7 Planungsentwurf für die Stadt Leninsk 1933 von der Gruppe May im Rahmen Standardgorprojekt. Aus: Hans Schmidt, Die Tätigkeit deutscher Architekten und Spezialisten des Bauwesens in der Sowjetunion in den Jahren 1930 bis 1937

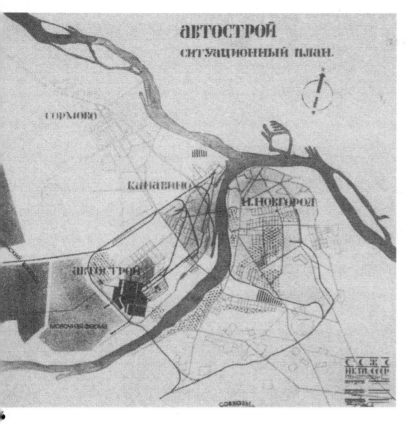

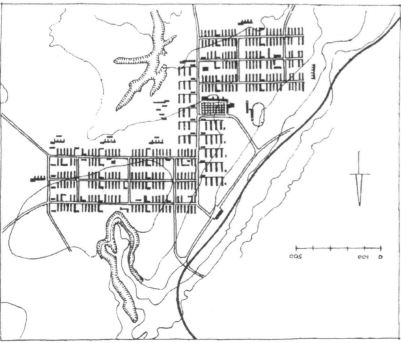

7

wird den ausländischen Architekten offensichtlich erst mit der Prämierung des Wettbewerbes für den Sowjetpalast 1932 richtig bewusst. Vorher beurteilen wahrscheinlich die meisten unter ihnen die Differenzen als den normalen Streit zwischen Traditionalisten und Modernen.

Die Etablierung des sozialistischen Realismus der Stalin-Ära zu Beginn der dreissiger Jahre und das Verhalten der westlichen und östlichen Architekten gegenüber der neuen Partei-Doktrin wurde bereits mehrfach untersucht und beschrieben. In der vorliegenden Untersuchung über die Städtebautheorien von Hans Schmidt geht es vor allem um seine persönliche Haltung in diesem Streit zwischen den architektonischen Ideologien und um die Auswirkungen auf seine architektonische Tätigkeit. Zum andern ist hier zu untersuchen, wie weit und in welcher Form die neue Architekturdoktrin der KPdSU Einfluss auf den Städtebau und auf die konkreten Planungen von Hans Schmidt gehabt haben.

Die persönliche Haltung von Hans Schmidt lässt sich aus verschiedenen Texten entnehmen, die er in seinen sieben Moskauer Jahren als Manuskripte geschrieben und später veröffentlicht hat. Einige Stellungnahmen sind auch als Antwort auf Umfragen in sowjetischen Zeitschriften erschienen.

Im Gegensatz zu Hannes Meyer, der sich schon drei Monate nach seiner Ankunft um die Aufnahme in die WOPRA (die Allrussische Vereinigung proletarischer Architekten, welche die funktionalistische, konstruktivistische Architektur bekämpft) bewirbt, setzt sich Hans Schmidt vorerst zögernd und ablehnend mit der neuen Doktrin auseinander. In einem Manuskript von 1933 "Was ist richtig?" bezeichnet Hans Schmidt "die Restauration des alten, überwundenen Begriffs der äusserlichen angeklebten Architektur" als eine Fehlinterpretation der Partei- und Regierungsdoktrin, welche lediglich verlangt habe, dass der Architektur mehr Aufmerksamkeit geschenkt werde. [4] In einem weiteren Manuskript des Jahres 1933 schreibt er [5]:

"Unter diesen Bedingungen ist der Rückschlag, den das Neue Bauen in der Sowjetunion heute erleidet, verständlich und bedauerlich, aber er beweist noch gar nichts gegen die Richtigkeit unserer Forderungen."

In weiteren Diskussionsbeiträgen und Manuskripten der Moskauer Jahre zeigt Hans Schmidt wohl Verständnis für die Entwicklung der sowjetischen Architekturtendenzen und Doktrinen, als eine notwendige Übergangsphase zwischen Kapitalismus und Sozialismus. Er verteidigt aber stets noch seine eigene Auffassung und lehnt jeden Eklektizismus ab, wenn er auch zugesteht, dass das neue Bauen und seine eigenen Arbeiten nicht frei von einem "Purismus" seien. Schmidt's Haltung ist in seinen Texten geprägt vom Bemühen, Verständnis für die neue Doktrin und für den russischen Arbeiter aufzubringen, "dem für das Verstehen der neuen Architektur Zeit gelassen werden muss".

8 Erstprämiertes Projekt für den Sowjetpalast in Moskau 1933 von den Architekten B. Jofan, V. Gelfreich, L. Rudnev.
Aus: Alberto Asor Rosa u. a., Socialismo, città, architettura, 1971

9 Schema des Moskauer Zentrums.
1 Sowjetpalast
2 Leninmausoleum
3 Verwaltungsgebäude.
Aus: Alberto Asor Rosa u. a., Socialismo, città, architettura, 1971

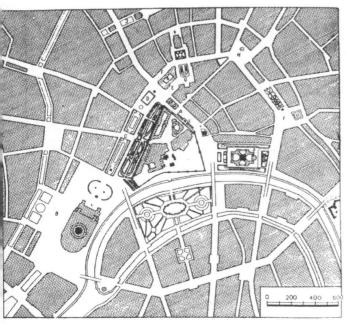

9

In Schmidts Architekturentwürfen findet der sozialistische Realismus jedoch in dieser Zeit noch keinen Niederschlag, dies geschieht bemerkenswerter Weise erst einige Jahre nach seiner Rückkehr in die Schweiz. Im Bereich des Städtebaus hat sich die neue Doktrin des sozialistischen Realismus für Hans Schmidt in besonderer Weise ausgewirkt. Die grossen Differenzen zwischen den westlichen Planern und den sowjetischen Architekten zeigen sich vor allem beim Wettbewerb von 1932 für Gross-Moskau, wobei sie vorerst in unterschiedlichen Theorien und Stadtsystemen zum Ausdruck kommen. Am Wettbewerb beteiligen sich sowohl die sowjetischen Architekten als auch die Gruppe May, die Brigade Hannes Meyer und der Kölner Stadtplaner Kurt Meyer. Hans Schmidt schreibt 1967 im Rückblick auf das Resultat des Wettbewerbes:

"Mit dem Moskauer Wettbewerb wurde den Städtebauern eine Aufgabe gestellt, wie sie der Städtebau der Neuzeit seit langem nicht mehr gesehen hatte: eine 4-Millionen-Stadt sollte nach den modernsten Erkenntnissen umgestaltet, vielleicht sogar völlig neu gestaltet werden. Es lohnt sich deshalb, nicht nur wegen der Teilnahme verschiedener deutscher Architekten, auf diesen Wettbewerb einzugehen.

Moskau ist das typische Beispiel einer konzentrisch angelegten Ringstadt. Ein aus dem Jahre 1925 stammender Entwurf von Gestakovic sah vor, das Ringsystem in das System einer Sternstadt überzuführen. Inzwischen war von den sowjetischen Städtebauern und Theoretikern die Frage nach dem typischen System der sozialistischen Stadt aufgeworfen worden. Sie wurde meist dahin beantwortet, dass das Ringsystem kapitalistisch, das rechteckige sozialistisch sei.

Le Corbusier, der damals unter den Architekten der Sowjetunion grosses Ansehen genoss, schlug 1931 vor, die Stadt radikal auf ein Rechteckschema umzubauen."

Die zum Moskauer Wettbewerb eingereichten Projekte zeigen ein ausserordentlich breites Feld von unterschiedlichen Stadtorganisationssystemen. Unter den russischen Architekten besteht ein Gegensatz zwischen den Desurbanisten aus dem Kreis der OSA, welche eine Auflösung der Stadt zu dezentralisierten Wohngruppen in der Landschaft postulieren, und denjenigen, die eine kompakte geometrische Stadtform suchen. Das Projekt der Gruppe May will von Moskau nur den Kern mit den historischen Bauten und den durchgrünten Regierungsgebäuden erhalten. Die Erweiterung der Stadt soll in Form eines Kranzes von Trabantenstädten, in einem "Städtekollektiv" erfolgen.

Den Entwürfen der Gruppe May und der Brigade Meyer wird vorgeworfen, dass sie desurbanistische Tendenzen verfolgen, was aus Sicht der offiziellen Stadtplanungsdoktrin einem Fehler gleichkommt.

10-18 Moskau. Ausgangslage Anfang des 20. Jahrhunderts und 7 Projekte für die Stadt zwischen 1925 und 1932. Aus: Hans Schmidt, Die Tätigkeit deutscher Architekten und Spezialisten des Bauwesens in der Sowjetunion in den Jahren 1930 bis 1937

10 Moskau. Anfang 20. Jahrhundert

11 Plan Sestakovic 1925

12 Plan Le Corbusier 1931

13 Wettbewerbsprojekt Kurt Meyer 1932

╲ Eisenbahnen

▥ Industrie

▨ Wohngebiet

■ Zentren

░ Grün

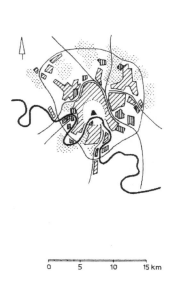

10

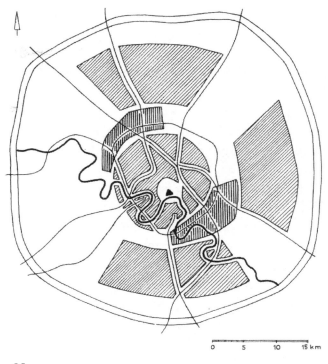

11

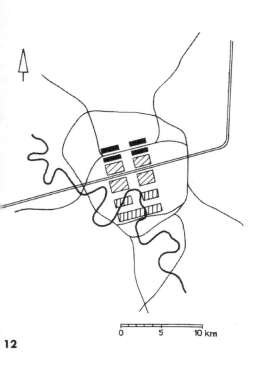

12

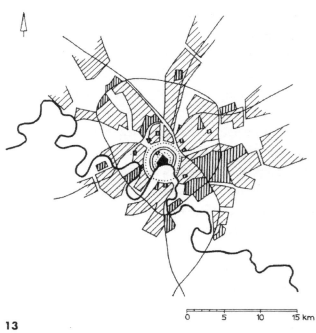

13

Die Einschränkungen in der Realisierung der Theorien

Nicht nur beim Moskauer Wettbewerb sondern auch bei den in Gang befindlichen Stadtbauprojekten der Gruppe May setzt schon bald die Kritik der russischen Architekten und der Parteigremien ein. Eines der Grundprinzipien von Hans Schmidts Stadtbautheorien, der konsequente Zeilenbau in Nord-Südrichtung, weckt besonderen Widerstand. Er wird von den russischen Kritikern als "Stempel" bezeichnet, was heissen soll, dass das gleiche Siedlungsmuster auf dem Plan wie mit einem Stempel wiederholt wird. An Stelle des Zeilenbaus werden für die neuen Städte Boulevards mit Alleen und strassenbegleitenden Fassaden verlangt, "auf dem der Kumpel abends mit seinem Mädchen spazierengeht und die Schaufenster betrachtet."

Hans Schmidt kann sich dieser Argumentation nicht ganz verschliessen. Bei der Planung der Stadt Orsk versucht er verschiedene Kombinationen seiner Zeilenbauweise mit strassenbegleitenden Wohnblöcken, um so der Forderung nach Boulevards entgegenzukommen. *"Die Endfassung gelangte zu einem kompakten Stadtkörper, dessen Rückgrad eine Hauptstrasse bildet, die das Stadtzentrum und zwei Bezirkszentren miteinander verbindet und am Südende den Kulturpark erschliesst"* beschreibt Hans Schmidt das Resultat seiner Stadtplanung. Dieses Resultat steht somit im Gegensatz zu den Entwurfsparametern einer sozialistischen Stadt, die Hans Schmidt 1933 für die Projektierung von Orsk aufgestellt hat. [6]

Auch ein weiteres Grundprinzip der sozialistischen Stadt, das von Hans Schmidt und den deutschen Architekten vertreten wird, kann bei den neuen Städten nicht realisiert werden. Es geht dabei um das Postulat, dass die Stadt aus Kommunehäusern mit vergesellschafteter Hauswirtschaft bestehen und das Wohnen im Familienverband aufgelöst werden soll.

Dieses Modell einer Gesellschaft ohne Familie ist mit dem Postulat der "freien Liebe" verbunden und kann zurückgeführt werden auf die Gesellschaftsvorstellungen der Utopisten des 19. Jahrhunderts und auf die Anarchisten. Inwiefern es von den sowjetischen Kommunisten in den 20er Jahren mit Überzeugung übernommen und vertreten wird, ist zumindest fraglich. In jedem Fall wird die Umsetzung der kollektiven, familienlosen Gesellschaft in neue Modelle der Stadtplanung von den zuständigen Instanzen abgelehnt. Die Entwürfe von M. J. Ginzburg zusammen mit Architekten der OSA für entsprechende Wohnhauskommunen in der Stadtplanung Avtostroy scheitern am Widerstand von Partei und Regierung, vor allem aber an der starken Familienbindung der russischen Bevölkerung.

Auch die Vorschläge für prinzipielle neue Systeme der sozialistischen Stadt, wie sie von der Gruppe May und von den modernen Architekten der

14

14 Sowjetischer Entwurf für ein Kommunehaus mit zwei Wohnflügeln für Einzimmerwohnungen und einem flachen Mittelteil für gesellschaftliche Räume.
Aus: Kurt Junghanns, Die Beziehungen zwischen deutschen und sowjetischen Architekten.
Quelle: El Lissitzky, Russland

15 Wettbewerbsprojekt Hannes Meyer 1932

16 Wettbewerbsprojekt Ernst May 1932

17 Wettbewerbsprojekt Brigade Kratjuk 1932

18 Wettbewerbsprojekt N. A. Ladovskij 1932

⟍ Eisenbahnen

▨ Industrie

▨ Wohngebiet

■ Zentren

⣿ Grün

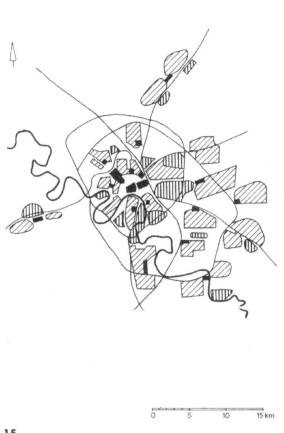

15

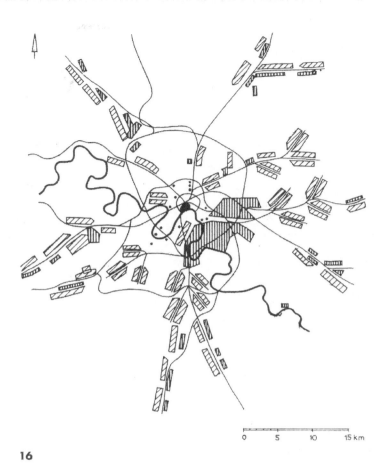

16

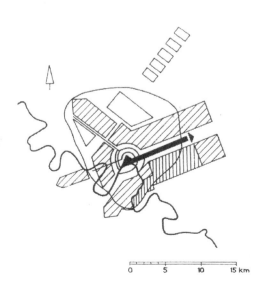

17

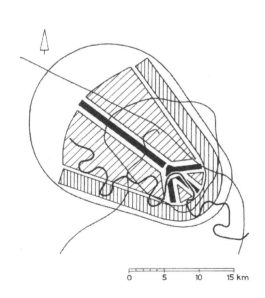

18

OSA vorgeschlagen werden, stossen auf Ablehnung. In seinem Vortrag vor dem CIAM 1931 in Berlin spricht Ernst May von drei möglichen sozialistischen Stadtsystemen:

1. die Streusiedlung, eine in die Landwirtschaft integrierte Stadtform, nach den Ideen von Bruno Taut;

2. die Bandstadt, eine parallele Anlage von Wohnstadt und Industriezone, getrennt durch einen breiten Grüngürtel;

3. die Trabantenstadt, eine Auflösung der Gross-Stadt in einzelne Industrie- und Wohngruppen, satellitenartig an Erschliessungslinien aufgereiht (siehe Projekt Moskau der Gruppe May).

Alle drei Stadtsysteme werden in den verschiedenen Stadtprojekten der Gruppe May und in den Plänen von Hans Schmidt vorgeschlagen. Die offiziellen Stellen lehnen diese Konzepte wegen des "desurbanistischen Prinzipes" konsequent ab. Akzeptiert und verwirklicht wird nur das geschlossene Stadtsystem, der geschlossene Stadtkörper in geometrisch definierter Form.

So bleibt auch für Hans Schmidt von seinen Grundprinzipien und Idealen einer sozialistischen Stadt bei der Realisierung von Orsk nur wenig erhalten. Im letzten Jahr seiner Moskauerzeit ist sein Einfluss und sein Kontakt zur Baustelle in Orsk eingeschränkt und seine Tätigkeit reduziert sich auf den Entwurf von Vorschlägen für die Normierung von Wohnungsküchen. Trotzdem ist seine Begeisterung für die Ziele und Aufgaben des sowjetischen Städtebaus ungebrochen. Im Juli 1937 wird er zur Ausreise gezwungen, wobei ihm die Mitnahme irgendwelcher Pläne und Unterlagen seiner Planungen untersagt wird. Zusammen mit Frau und Tochter sowie mit dem Ehepaar Walter und Grete Schütte-Lihotzky verlässt er die Sowjetunion über Odessa. Aber schon kurz nach seiner Heimkehr in die Schweiz, im Herbst 1937, berichtet er mit Überzeugung und Begeisterung im "Schweizerischen Ingenieur- und Architektenverein" SIA über "Entwicklungstendenzen der Architektur der Sowjetunion". Er wirbt um Verständnis für die besonderen Umstände, mit denen die sowjetischen Architekten auf dem Weg zur modernen Architektur und zur sozialistischen Stadt konfrontiert sind. Bei der Erläuterung der verschiedenen Wettbewerbsvorschläge für den Sowjetpalast geht er sogar soweit, im Projekt des Architekten B. Jofan – ein Turmbau mit geradezu faschistischem Pathos – "den Schritt zu einer monumentalen Form der Zukunft erkennen zu wollen und zu können."

19 Moskau. Wettbewerbsprojekt der Gruppe Ernst May 1932, Verwirklichung des Generalbebauungsplanes in 3 Etappen.
Aus: J. Buekschmitt, Ernst May, 1963

7 СХЕМА ОЧЕРЕДНОСТИ ВЫПОЛНЕНИЯ ПЛАНА

1.ЭТАП

2.ЭТАП

3.ЭТАП

Anmerkungen

[1] Kurt Junghanns. Die Beziehungen zwischen deutschen und sowjetischen Architek-
 ten in den Jahren 1917 bis 1933. In: Wissenschaftliche Zeitschrift der Humboldt-
 Universität zu Berlin, gesellschafts- und sprachwissenschaftliche Reihe. 1967/3.

[2] Die Angaben über die Mitglieder der Gruppe May stammen aus J. Buekschmitt:
 Ernst May, Bauten und Planungen 1963, sowie aus Christian Borngräber: Hans
 Schmidt und Hannes Meyer in Moskau, Archithese 23/24 1978.

[3] Die Angaben über die Anwesenheit der verschiedenen Architekten in Moskau sind
 entnommen aus: Hans Schmidt: Die Tätigkeit deutscher Architekten in der Sowjet-
 union, Hannes Meyer, Katalog 1990, Christian Borngräber: Hans Schmidt und
 Hannes Meyer in Moskau, Werk Archithese Heft 23/24 1978.

[4] In Hans Schmidt, "Beiträge zur Architektur 1924–1964", Basel 1965.

[5] Die Sowjetunion und das Neue Bauen, in: ebd.

[6] Projektierung der sozialistischen Stadt Orsk, in: ebd.

Texte und Projekte 1930–1937

Aus: **DER NEUE WEG** in: Hans Schmidt/Hannes Meyer, Schweizer Städte-
bauer bei den Sowjets. Briefe an die Zeitung "Vorwärts", Basel 1935; Reprint,
Baden 1990.

[...]
Seht Genossen; das ist die Zukunft, die wir uns heute erarbeiten, das ist es, was
wir darunter verstehen, wenn wir von einer Verbindung des Sozialismus mit den
höchsten Produktivkräften der Technik sprechen, von der Befreiung durch die
Maschine aus Elend, Trägheit und Unwissenheit, von der Auflösung der Groß-
städte, von der Verbindung zwischen Stadt und Land.
[...]
Seht Genossen, das ist die Aufgabe des Fünfjahresplans, die Aufgabe unserer
Stossßbrigaden, Komsomolzen und Parteiarbeiter, dafür werben unsere Zeitun-
gen, Plakate und Schriftsteller. Sie zwingt heute das Leben in Sowjetrussland
durch alle Schwierigkeiten und Widerstände hindurch auf einen grossen Weg.

Aus: **2500 KILOMETER NACH OSTEN** in: Hans Schmidt/Hannes Meyer,
Schweizer Städtebauer bei den Sowjets. Briefe an die Zeitung "Vorwärts", Ba-
sel 1935; Reprint, Baden 1990.

[...]
Magnitogorsk zeigt im Ausschnitt das heftige Tempo des russischen Aufbaues so
gut wie seine Schwierigkeiten. Zu den Schwierigkeiten gehört der Mangel an
Material, das die vorläufig eingleisige Zufahrtslinie nur mit vieler Mühe heran-
führt. Mangel an geeigneten Lebensmitteln inmitten eines noch kaum entwickel-
ten Steppenlandes, Rückstand des Wohnungsbaus, dem der allmächtige Fabrik-
bau Material und Arbeitskräfte wegnimmt, Mangel an ausgebildeten Arbeitern
unter dem wiederum die entstehende Wohnstadt zuerst zu leiden hat. Es ist
keine Phrase, wenn die Sowjetpresse von Schlachten spricht, die zu schlagen
sind, von Siegen, die errungen werden müssen. Wer die Arbeitsfront kennen ge-
lernt hat, weiss, was sie an Kraft und Nerven fordert, aber auch was sie in täg-
lich neuem Kampfe für das Werden der ersten sozialistischen Wirtschaft leistet.

Aus: **DIE KULTURAUFGABEN DES SOZIALISMUS** in: Hans Schmidt/ Han-
nes Meyer, Schweizer Städtebauer bei den Sowjets. Briefe an die Zeitung "Vor-
wärts", Basel 1935; Reprint, Baden 1990.

[...]
So steht Sowjetrussland heute vor einer Kulturaufgabe allergrössten Umfanges.
Die Grösse dieser Aufgabe und das Tempo, in dem sie gelöst werden muss und

wird, gibt dem Leben des sozialistischen Staates den grossen Auftrieb, der in so starkem Gegensatz zum Abbau des Westens steht.

Mit den Worten Sowjetrusslands heisst diese Aufgabe: der Fünfjahrplan. Der Aussenstehende vergisst leicht über den Zahlen und Distanzen des Planes, welche Bedeutung dieses Unternehmen für die kulturelle Entwicklung des Landes besitzt, aber auch welche Schwierigkeiten dabei zu überwinden sind. Man lernt in Sowjetrussland erkennen, was die satten bürgerlichen Ideologen des Westens nicht mehr wissen wollen, nämlich wie sehr alle Kultur, alles Leben überhaupt von den materiellen Grundlagen abhängt. Erst die genügende Versorgung mit Verkehrsmitteln, mit hygienisch einwandfreien Siedelungen, guten Wohnungen, Schulen, Krankenhäusern, Kleinkinderanstalten kann das Lebensniveau des russischen Volkes heben. Das ist eine Frage der Produktion von Kohle, Metall und Elektrizität, des Baues von Maschinen, Fabriken und Wohnungen, der Ausbildung von Arbeitern und technischen Kadern. Dies alles muss sozusagen gleichzeitig geschehen. Die Bahnlinie muss schon das Material für den Bau der Fabrik herschaffen, während sie selbst noch im Bau ist. Die Arbeiter müssen aus dem Lande herausgezogen und bereits für ihre Arbeit in der Fabrik angelernt werden, wenn der Bau der Fabrik beginnt. Im selben Tempo müssen die Wohnungen – meist ganze Städte mit Zehntausenden von Einwohnern bereitgestellt werden.

Gleichzeitig müssen die Jahrhunderte alten Mauern von Trägheit, Unwissenheit und Resignation – unter dem schönen Namen Religiosität und Mystizismus von reaktonären Schriftstellern als spezifisch "russische Eigenschaften" verherrlicht – in Jahrzehnten eingerissen werden. […]

Aus: **DIE AUFGABEN DER SOWJETISCHEN ARCHITEKTUR UND DIE MITARBEIT DER AUSLÄNDISCHEN SPEZIALISTEN** *(Manuskript 1932) in: Hans Schmidt, Beiträge zur Architektur 1924–1964, Basel 1965.*

[…]

Die Diskussionen, die um das Wesen und die Aufgaben der sowjetischen Architektur eingesetzt haben, zeigen, daß wir mit dem Resultat nicht zufrieden sind und daß wir auf dem bisherigen Wege nicht stillstehen dürfen. Die wichtigsten Aufgaben der sowjetischen Architektur, die Schaffung eines modernen Bauwesens auf industrieller Basis, die notwendige Entfaltung der verschiedenen Möglichkeiten des vielgestaltigen Landes, die Schaffung eines kulturvollen Wohnungsbaus, die Entwicklung eines architektonischen Ausdrucks für eine ganz neue Form der Gesellschaft, die Herausbildung des sozialistischen Städtebaus – alle diese großen Aufgaben warten auf ihre Lösungen.

Das Bauwesen der Sowjetunion, seine handwerkliche und industrielle Basis sind noch nicht ausreichend entwickelt, wir sind mit der Qualität vieler Bauten – technisch und architektonisch – nicht zufrieden. Auf dem Gebiet des industrialisierten Bauens, der modernen Baumaterialien und Baumethoden besitzen wir wohl eine Reihe interessanter Versuche, aber nur wenige in breiterem Maßstab anwendbare Resultate und Methoden. Die Frage der architektonischen Form be-

20 Übersichtskarte Europa und UdSSR mit Eintragung der Städte im Ural-Gebiet, an deren Planung Hans Schmidt beteiligt war (siehe Aufstellung Seite 48)

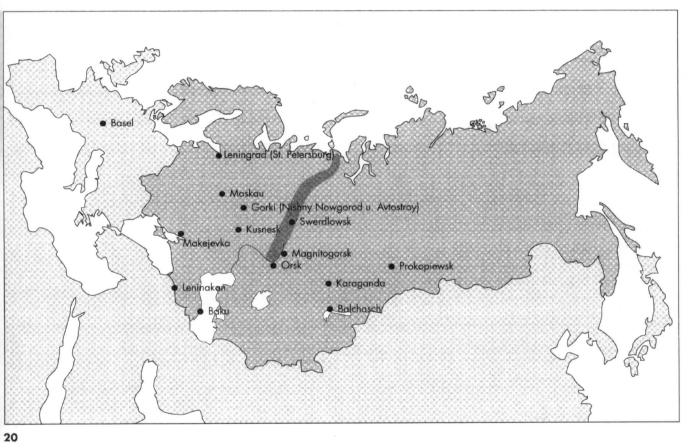

findet sich im Zustand großer Unklarheit. Der sozialistische Städtebau, die technische und architektonische Verwirklichung eines Städtebaus von bisher nicht gekannten Ausmaßen, bewegt sich zum größten Teil noch auf dem unsicheren Boden praktischer Erfahrung.

[...]

Wie stehen die ausländischen Spezialisten zu diesen Aufgaben?

Die Stellung der ausländischen Spezialisten als Mitarbeiter bei der Entwicklung der sowjetischen Architektur ist keine einfache. Sie können keine fertigen Rezepte in das so ganz neue Wesen der Sowjetunion hineintragen. Sie können in ihrer Arbeit nicht von den kulturellen und politischen Problemen des Landes abstrahieren. Sie müssen sich selber – gemeinsam mit den besten Kräften der Sowjetunion – den Boden erkämpfen, die Grundlage schaffen, auf denen ihre Arbeit und die Arbeit der Sowjetunion gedeihen soll.

Was müssen die ausländischen Spezialisten der sowjetischen Architektur geben? Sie müssen ihr die Methodik und den realen, mit der Praxis verbundenen Sinn geben, der ihre Arbeit im Westen geleitet hat. Sie müssen ihr die technische Sorgfalt und das Bewußtsein für die Arbeit des Bauplatzes geben, aus dem allein die fruchtbare Verbindung zwischen Plan und Ausführung, zwischen der Arbeit des Architekten und des Bauarbeiters entstehen kann.

Sie müssen den Beweis erbringen, daß die ökonomische Verantwortung, die in den Forderungen der Standardisierung und Typisierung zum Ausdruck kommt, kein Hindernis für eine sozialistische Architektur bedeutet.

Sie müssen ihre sowjetischen Kollegen und Auftraggeber durch ihre Arbeit davon überzeugen, daß die Aufgabe der Sowjetarchitektur als einer wirklich sozialen und umfassenden Architektur nicht im Spiel mit Formen besteht, sondern darin, den Hebel zu bilden zur Förderung der Technik, der Kultur, des Lebensniveaus der sozialistischen Gesellschaft.

Aus: **WAS IST RICHTIG?** (Manuskript 1933) in: Hans Schmidt, Beiträge zur Architektur 1924–1964, Basel 1965.

Man braucht nicht viele Worte über die heutige Situation zu verlieren:
Die letzten Arbeiten unseres Projektierungsbüros zeigen deutlich genug, daß wir uns auf dem geraden Wege zur Restauration befinden, zu Restauration des alten, überwundenen Begriffs der äußerlichen angeklebten Architektur, der abgestandenen Form der alten Zinskaserne, der Straße mit Parade- und Hoffassaden. Wir erhöhen die Stockwerke und verkleinern die Fenster, wir kleben Konsolen unter die Balkone und Steinquader an die Sockel – alles der Architektur zuliebe. Partei und Regierung haben verlangt, daß der Architektur mehr Aufmerksamkeit geschenkt werde. Aber wo haben die Partei und die Regierung davon gesprochen, daß der Weg zur Architektur über überflüssige Gesimse und Ornamente zu gehen habe? Können wir als Architekten, als Spezialisten die Verantwortung dafür übernehmen, daß die berechtigten und begründeten Direktiven von Partei

21 Schema für eine raumbildende Kombination von Wohn- und gesellschaftlichen Bauten. Architektengruppe Ernst May. Aus: Kurt Junghanns, Die Beziehungen zwischen deutschen und sowjetischen Architekten in den Jahren 1917 bis 19.. Quelle: Die Form 7, 1932

22 Hans Schmidt: Wohnhaus in Nesvetay an der Eisenbahnlinie "Moskva–Donbas", 1933. Umzeichnung durch ein Kollektiv unter Leitung der Gebrüder Stenberg. Aus: Christian Borngräber, Hans Schmidt und Hannes Meyer in Moskau; in: Werk/Archithese 1978/23, 24.

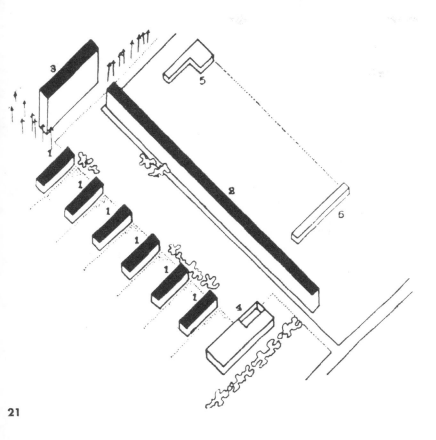

21

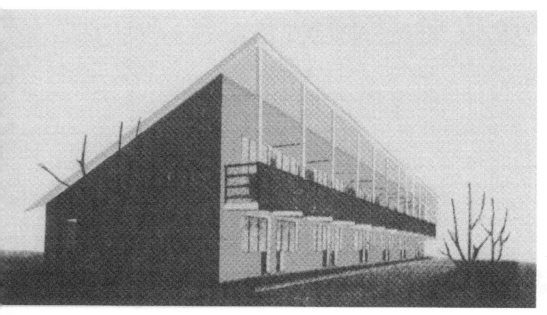

2

und Regierung in einen Schritt nach rückwärts verdreht werden? Wozu sind wir Spezialisten? Dazu, um in erster Linie zu begreifen, daß Architektur nicht eine Sache für sich sein kann, sondern nur als feste und unlösbare Verbindung architektonisch-formaler, politisch-kultureller und technisch-ökonomischer Forderungen ein Recht auf Bestehen hat. Wenn wir heute der Architektur zuliebe Fassaden machen, die wir technisch-ökonomisch nicht verantworten können, wenn wir in unseren sozialistischen Städten fünfstöckige Paradekasernen aufstellen, so verletzen wir unsere Pflicht als Architekten, als Spezialisten, auf denen die große Verantwortung für die Gestaltung der emporwachsenden sozialistischen Architektur liegt.

[...]

Es muß alles darangesetzt werden, daß die heutigen Forderungen nicht zu einem Schritt rückwärts in die Fehler der Reißbrettarchitektur, sondern zu einem Schritt vorwärts in der Verwirklichung einer realen und wahrhaft kulturellen Architektur führen. Wenn es Gorstroiprojekt versteht, dieses Ziel zum Grundsatz seiner Arbeit zu machen, so wird sich auch die Arbeit seiner ausländischen Mitarbeiter fruchtbarer und befriedigender gestalten, als sie es heute ist.

Aus: **DIE SOWJETUNION UND DAS NEUE BAUEN** (Manuskript 1933) in: Hans Schmidt, Beiträge zur Architektur 1924–1964, Basel 1965.

[...] Man kann sogar von einer Verfallserscheinung desselben Kapitalismus sprechen, aber nur in dem Sinne, dass diese Ideen bereits über die dem Kapitalismus gesteckten Grenzen hinausgehen, so daß das Neue Bauen im Westen sich damit begnügen mußte, eine neue Mode auf dem großen Kunstmarkt zu werden, deren man heute schon wieder ein wenig überdrüssig ist. Der Westen besitzt heute im großen Maßstab die technischen Möglichkeiten und die kulturellen Bedingungen, die das Neue Bauen als Ausgangspunkt für die Umstellung unseres ganzen Verhältnisses zu Architektur vorausgesetzt hatte. In der Sowjetunion können selbst die außerordentlichen Anstrengungen auf dem Gebiet der Industrialisierung und der Kulturrevolution vorläufig erst das Fundament legen.

Unter diesen Bedingungen ist der Rückschlag, den das Neue Bauen in der Sowjetunion heute erleidet, verständlich und bedauerlich, aber er beweist noch gar nichts gegen die Richtigkeit unserer Forderungen. Es ist nicht einmal verwunderlich, wenn dieselben jungen Architekten, die jahrelang auf Watmanpapier das Vorbild Le Corbusiers mit Glasfassaden und Dachgarten zu Tode ritten, heute auf demselben Watmanpapier unter Leitung der alten Meister der Architektur Fassaden mit klassischer Schönheit entwerfen. Hatte das Neue Bauen vergebens den so heftig angefochtenen Satz aufgestellt, daß es sich bei seinen Zielen nicht um einen Wechsel des Stils handeln könne, sondern um eine grundsätzlich neue Auffassung von den Aufgaben des Bauens überhaupt? Auch die Architekten der Sowjetunion, vor denen eine besonders große und schwere technische und kulturelle Aufgabe liegt, werden eines Tages zur Besinnung kommen.

23 Generalplan der Stadt Orsk 1935 von Hans Schmidt und Mart Stam. Vogelperspektive des nördlichen Stadtteil Aus: Jose Luis Sert, Can Our Cities survive, 1947

24 "Transport von Baumaterialien und sonstiger Frachten der Orsker Eisenbahn siedlung". Quelle: Archiv GTA, ETH Zürich, Nachla Hans Schmidt

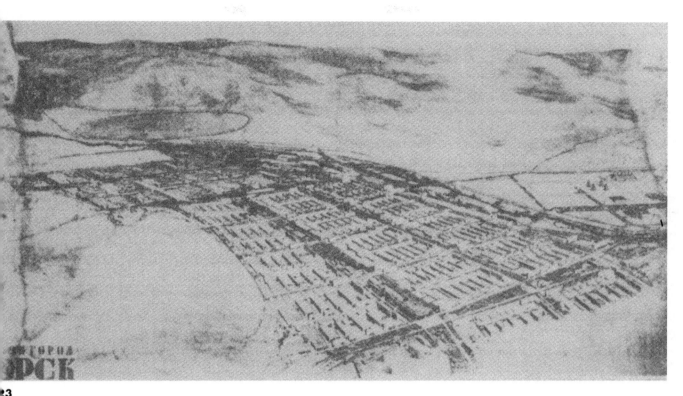

23

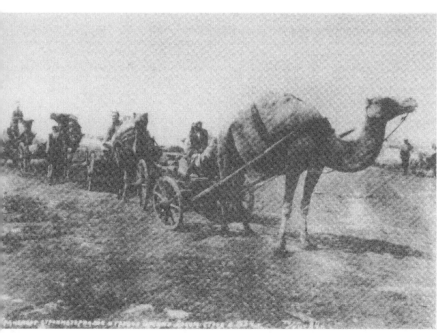
24

Aus: **PROJEKTIERUNG DER SOZIALISTISCHEN STADT ORSK** (Manuskript 1933) in: Hans Schmidt, Beiträge zur Architektur 1924–1964, Basel 1965.

Die Stadt Orsk, an deren Projektierung ich zusammen mit einer Reihe sowjetischer und ausländischer Architekten, Ingenieure und Oekonomen des Trustes Gorstroiprojekt seit etwa drei Jahren arbeite, ist, verglichen mit ihren stürmisch wachsenden Nachbarn Magnitogorsk, Kusnezk, Prokopjewsk und anderen, noch nicht viel mehr als ein erster Anfang. Einige Siedlungen von provisorischen Häusern aus Holz und Lehm, zwei provisorische Kraftstationen, Steinbrüche, Ziegelfabriken, Holzbearbeitungswerke, die Fundamente für die ersten Zechen einer großen Lokomotivfabrik und einer Naphthaverarbeitungsfabrik, die begonnenen ersten steinernen Häuser der Stadt, das ist heute der Grundstein eines neuen Industriekombinats der Sowjetunion, einer neuen sozialistischen Stadt.

Halten wir uns nicht lange auf mit der Beschreibung der ökonomischen und technischen Besonderheit dieser zukünftigen Stadt – stellen wir gleich die Frage: Worum geht es für uns bei der Projektierung einer sozialistischen Stadt, und wie ist diese Aufgabe bei der neuen Stadt Orsk gelöst?

Was ist überhaupt eine sozialistische Stadt?

Denken wir einen Augenblick an solche Fabrikstädte wie die Städte der Ruhr oder Nordfrankreichs oder an die Arbeiterviertel solcher Städte wie Berlin, Chemnitz, Zürich, London und so weiter. Denken wir an das unübersehbare Meer von planlos, richtungslos aneinandergewachsenen Straßen und Häuserblocks, wo das Grün, die Sonne, der Himmel nur in kärglichen Rationen verteilt werden, wo die Fassaden der grauen Straßen nur dazu da zu sein scheinen, um die noch graueren Höfe zu verdecken. Denken wir an die prunkvollen Geschäftsstraßen und Hauptplätze derselben Städte, wo ihre heutigen Besitzer und Herren ihre Verkaufs- und Verwaltungspaläste erbaut haben, oder an die vornehmen Villenviertel, wo dieselben Herren sich an die Sonnenseite des Daseins gesetzt haben.

Denken wir daran und stellen diesem Bilde die Hauptmerkmale der sozialistischen Stadt gegenüber:

– Die sozialistische Stadt wird nicht planlos von einer Gesellschaft von Grundstücksspekulanten und Unternehmern, sondern planmäßig von einer sozialistischen Gesellschaft gebaut.

– Die sozialistische Stadt wird nicht als ein Instrument der Ausbeutung der Natur, sondern als ein Werk der Natur gebaut, sie wird, wie Engels fordert, eine "grüne Stadt" sein.

– In der sozialistischen Stadt wird die Arbeiterklasse selbst ihre Plätze und Häuser bauen und besitzen, sie wird die bestmöglichen Bedingungen des Lebens für sich selbst verwirklichen.

Die sozialistische Stadt als planmäßige Stadt

Die Möglichkeit, eine Stadt planmäßig zu bauen, ist dem Architekten durch die Entwicklung des Kapitalismus im 19. Jahrhundert vollkommen genommen wor-

25 Lageplan der Stadt Orsk von Hans Schmidt und Mart Stam.
Quelle: Archiv GTA, ETH Zürich, Nachlass Hans Schmidt

26 "Orsk – Blick auf die Baustellen des 10., 9., 5. und 4. Hauses in der Sozgorod von Südosten".
Quelle: Archiv GTA, ETH Zürich, Nachlass Hans Schmidt

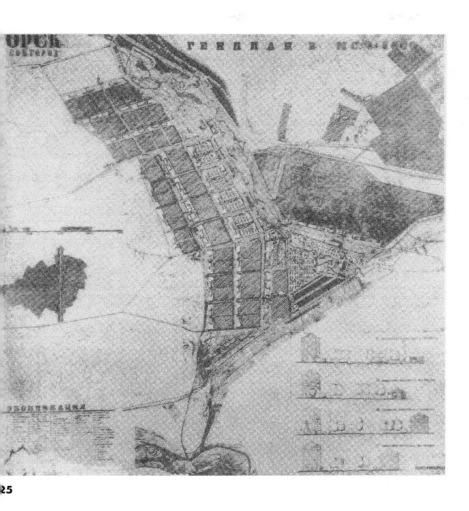

25

6

den. Selbst die planmäßig angelegten Städte der vorkapitalistischen Vergangenheit wurden durch das 19. Jahrhundert zerstört, in ein Chaos verwandelt, so daß wir uns heute die Schönheit einer planmäßig gebauten Stadt kaum mehr vorstellen können.

Natürlich beginnt die Planmäßigkeit oder im umgekehrten Falle die Planlosigkeit einer Stadt nicht erst bei den Häusern. Sie beginnt bei solchen grundlegenden Fragen wie der Entscheidung über die Größe und Lage der Stadt, über die Planung der Transportwege, über die Verbindung mit der Industrie und dem umliegenden Rayon, über die rationellste Ausnutzung aller natürlichen und künstlichen Hilfsquellen dieses Rayons.

Im Fall der Projektierung von Orsk erforderte dies die Mitarbeit einer Reihe von Spezialisten der verschiedenen ökonomischen und technischen Spezialgebiete. Nur so besitzt der Architekt als eigentlicher Leiter des Projektes die Möglichkeit, für seine Stadt die besten Lebensbedingungen, den einfachsten Transport, die richtigste Lage der Industrie, die einheitlichste Planung der Schutzzonen, Grünanlagen und Parks und die wirksamste Ausnutzung der Lage in der Landschaft zu erreichen.

Eine ganz besondere Bedeutung bekommt die Planmäßigkeit des Projektierens und Bauens einer Stadt natürlich da, wo die eigentliche Arbeit des Architekten beginnt: bei der Führung der Straßen, der Anordnung der Plätze, der Aufteilung der Stadt in einzelne Viertel oder Quartale. Typisch für alle kapitalistischen Städte ist das erdrückende, unübersehbare Chaos, das ausweglose Labyrinth — ganz gleich, ob sie nur als ein großer Wirrwarr wie die meisten europäischen Städte oder als ein endloses Schachbrett wie die amerikanischen Städte angelegt sind. Beide Fehler – der Wirrwarr und das trockene Schema sind Gefahren, die in den ersten Versuchen des sozialistischen Städtebaus der Sowjetunion nicht immer vermieden worden sind. Hier handelt es sich schon nicht mehr um technische Fragen des Transportes und der Kanalisation, in denen uns die kapitalistische Technik die wertvollsten Erfahrungen liefert. Hier handelt es sich um architektonisches Neuland.

Im Projekt der Stadt Orsk ist diese Frage so gelöst, daß die Stadt als einfaches Straßennetz mit regelmäßig wiederholten, übersehbaren Elementen angelegt ist, wobei diese Regelmäßigkeit und Einfachheit den Wechsel, die Veränderung, den Gegensatz zur Wirkung bringt. Das heißt, wir versuchen in der Architektur den Satz zu verwirklichen, wonach es keine Gleichheit gibt ohne Verschiedenheit und keine Verschiedenheit ohne Gleichheit.

Die sozialistische Stadt als grüne Stadt

Um diese Forderung zu verwirklichen, genügt es nicht, eine sozialistische Stadt, mit einer gewissen Norm von Boulevards, Grünplätzen und Parks auszustatten. Die sozialistische Stadt soll dem Menschen überhaupt die Verbindung mit der Natur der offenen Landschaft wiedergeben, welche den engen Arbeitervierteln der kapitalistischen Städte fehlt. Die Stadt Orsk befindet sich hier in einer besonders günstigen Lage dadurch, daß sie sich als ein breites Band an einem leicht geneigten Hang hinzieht, im Rücken eine Hügelkette, vor sich eine weite

27 Generalplan der Stadt Orsk von Hans Schmidt.

1 Stadtzentrum
2 Wohnbezirkszentrum
3 Wohnquartier (8. Quartal, erste gebaute Etappe)
4 Spezialschulen und Institute
5 Spital
6 Kulturpark
7 Zone für Einfamilienpavillons
8 Industrie
9 Bahnhof (Bahnstrecke Ovenbourg–Orsk).

Quelle: Archiv GTA, ETH Zürich, Nachlass Hans Schmidt

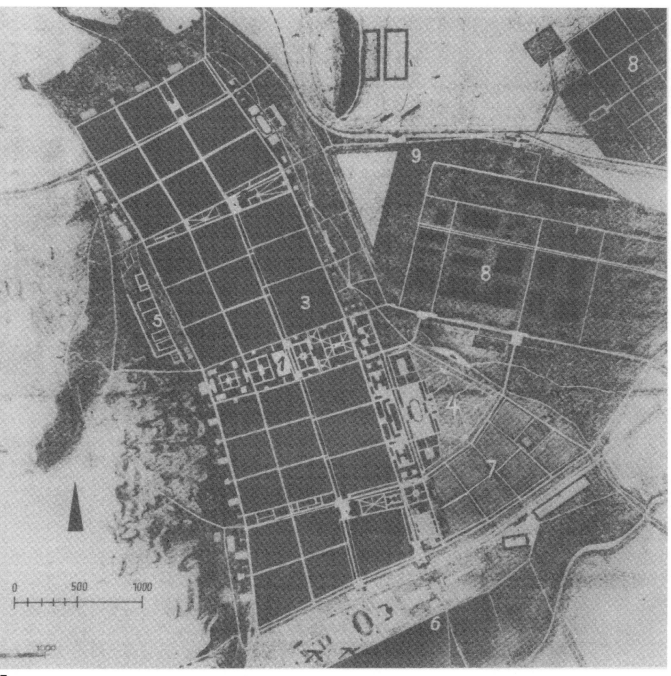

Ebene mit dem Uralfluß. Die Schönheit der natürlichen Lage mit ihrer weiten Aussicht ist im Projekt ausgenutzt durch terrassenartig übereinanderliegende Straßen, durch quer durch die Stadt gelegte breite Grünzonen und schließlich durch eine solche Art der Stellung der Häuser innerhalb der einzelnen Viertel oder Quartale, die möglichst viele Durchblicke auf die Landschaft ergibt.

Die sozialistische Stadt als Werk der Arbeiterklasse

Es ist heute kein leeres Wort, wenn man in der Sowjetunion von den außerordentlichen Möglichkeiten spricht, welche der Sozialismus dem Architekten in die Hand gibt. Die Tatsache, daß eine Stadt von einer Klasse für sich selbst gebaut werden kann, welche die Herrschaft über die Produktionsmittel, die Entscheidung über ihre Kultur für sich erobert hat, diese Tatsache bedeutet das Verschwinden all der Widersprüche, welche den Städtebau des 19. Jahrhunderts in eine Sackgasse gebracht haben. Sie bedeutet gleichzeitig die Freimachung der architektonischen Möglichkeiten, welche wir in den städtebaulichen Kunstwerken der Vergangenheit verwirklicht finden. Für den Architekten bedeutet dies eine große, aber schwere Aufgabe. Schwer deshalb, weil er ihre Lösung weder in der Phantasie ausdenken noch aus fertigen Beispielen der Vergangenheit übernehmen kann, sondern ständig fortschreitend mit der technischen und kulturellen Entwicklung der sozialistischen Gesellschaft in zäher Arbeit finden muß. Denken wir nur an die neuen technischen Mittel, welche die wachsende sozialistische Industrie erschaffen wird und ohne die der Bau von Städten für Zehntausende von Einwohnern nicht denkbar ist. Denken wir an die Umwälzung der Lebensformen, an die steigenden kulturellen Bedürfnisse und Ausdrucksmöglichkeiten der sozialistischen Gesellschaft, welche die Architektur der neuen Städte entscheidend bestimmen müssen. Es ist einleuchtend, daß das Projekt einer sozialistischen Stadt all diese Möglichkeiten im heutigen Moment erst andeuten kann, daß es sich selber, ausgehend vom heutigen realen Moment, beständig weiterentwickeln und entfalten muß. Wichtig für den Architekten dabei ist, daß er sein Projekt nicht nur auf dem Papier, sondern auch auf dem Bauplatz verwirklicht, daß er es nicht in einem Hieb vollendet, sondern, dauernd daran weiterarbeitend, das Wachsen der Stadt selbst erlebt und leitet.

Aus: **DIE PLANUNG DER NEUEN STADT ORSK** in: "Der Orsker Werktätige", 1933. Übersetzung Luzius Eggenschwiler.

1. Der Platz für die Stadt

Die Wahl des Platzes für eine neue Stadt ist eine sehr verantwortungsvolle und machmal sehr schwierige Aufgabe. Von einem richtig oder falsch gewählten Platz (Standort) hängen nicht nur die materiellen Verhältnisse des Lebens der neuen Stadt ab – die eigentliche Architektur der Stadt, die Anordnung ihrer Hauptverkehrsadern und Plätze, ihr äusseres Aussehen und schliesslich ihre Verbindung mit der Natur, dem Wasser und den Orten der Erholung wird in entscheidender Form durch die natürlichen Eingenschaften des Geländes bestimmt. Dabei darf man nicht vergessen, dass unsere sozialistischen Städte nicht nur die

28 Orsk. Erster Wohnkomplex (Nr. 3 im Generalplan) Entwurf Hans Schmidt 1935.
Quelle: Archiv GTA, ETH Zürich, Nachlass Hans Schmidt

29 Erster Planabschnitt der Stadt Orsk 1935.
Quelle: Archiv GTA, ETH Zürich, Nachlass Hans Schmidt

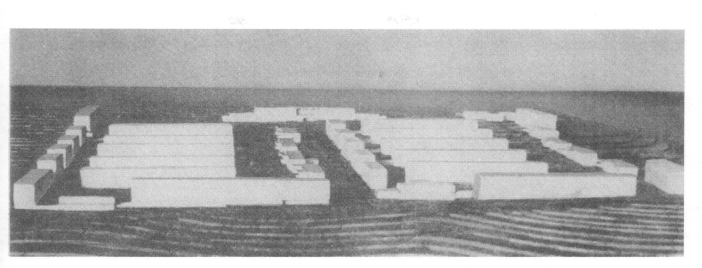

28

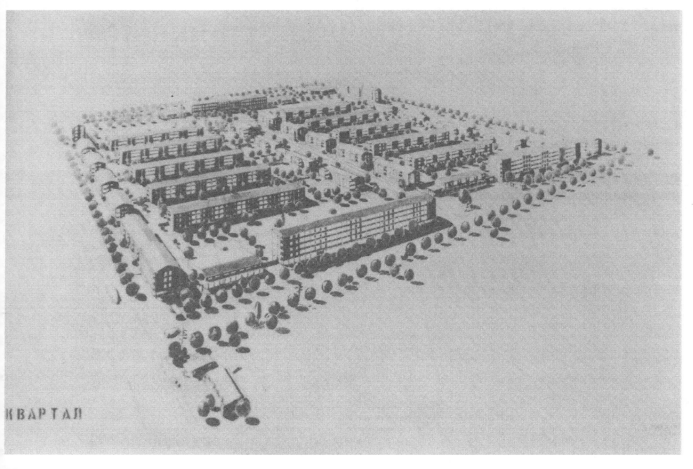

29

Aufgabe der Anordnung der Stadt an und für sich stellen, sondern (zusätzlich) deren Verbindung mit den mächtigen Giganten unserer sozialistischen Industrie, welche in ihrer Fläche fast immer die Fläche der Stadt selbst übertreffen.

Im Falle von Orsk stiess diese doppelte Aufgabe mit den Besonderheiten der Topographie des gesamten (Ansiedlungs-)gebietes zusammen, d. h. mit dem Vorhandensein einer grossen Flussaue des Flusses Ural, welche die Mitte des Geländes einnimmt und welche eine Anordnung von Industrie- und Stadtfläche nur am Rande dieser Aue erlaubt. Die Plazierung der neuen Stadt im Zentrum des Gebiets kam nicht in Frage. Eine Anordnung der Stadt auf den die Flussniederungen umsäumenden Anhöhen kam im Hinblick auf die Abgelegenheit von den Wasserquellen, auf die den starken Winden ausgesetzte Lage (wörtlich und poetischer: "die Durchwehtheit durch starke Winde", Anm. des Übersetzers) und auf das komplizierte Relief ebenfalls nicht in Frage. Eine Anordnung der neuen Stadt Orsk auf der sich zwischen der Flussniederung und den Anhöhen erstreckenden Terrasse erscheint in technischer, sanitärer und architektonischer Hinsicht am glücklichsten. Die Stadt nimmt einerseits eine erhöhte Lage im Verhältnis zu ihrer Umgebung ein, andererseits wird sie von den starken Fallwinden geschützt durch eine Kette von Hügeln, welche vom Tal des Flusses Elsanka (Jelschanka) bis zum "Orsker Tor" verläuft. Von Osten, von der Seite des alten Orsk und der Industriegebiete her, erscheint die neue Stadt in Gestalt eines grossen Panoramas, welches an der Schlucht des Flusses Ural beginnt und bis zum Ausfluss der Elsanka reicht.

[...]

Aus: **PRINZIPIEN MEINER ARBEIT** (Antwort auf eine Umfrage, 1934) in: Hans Schmidt, Beiträge zur Architektur 1924–1964, Basel 1965.

[...]

Die Einheit des Raumes

Die wichtigste Feststellung ist zunächst die, daß der Raum immer eine Einheit bleiben muß, das heißt, daß jede Unterteilung des Raumes mit dem ganzen Raum, der für uns praktisch unendlich ist, in Verbindung bleibt. Also kein Zimmer, kein Hof, kein Platz, keine Straße, kein Quartal, keine Stadt kann ein abgeschlossener Raumteil bleiben, sondern geht in den allgemeinen Raum über. Auch die Landschaft ist ein Stück der Organisation des Raumes, das heißt, Zimmer, Hof, Platz und so weiter müssen mit der Lanschaft und dadurch mit dem allgemeinen Raum in Verbindung treten.

Die Mittel zur Erfassung des Raumes

Die Aufgabe des Architekten besteht darin, den Raum für den Menschen verständlich zu organisieren. Der Raum kann vom Menschen entweder dadurch erfaßt werden, daß er ihn übersieht (vom Flugzeug oder von einer Anhöhe aus) oder daß er sich in ihm bewegt. Da aber der Mensch seine Raumeindrücke hauptsächlich in der Bewegung empfängt, muß auch der Architekt den Raum aus der Bewegung organisieren, das heißt, die Rolle des Transportes – also die

30 Stadt Orsk. Entwurfsperspektive von Hans Schmidt für den Platz des Stadtsowjets 1934.
Quelle: Archiv GTA, ETH Zürich, Nachlass Hans Schmidt.

31 Stadt Orsk. Perspektive eines Strassenzuges.
Quelle: Archiv GTA, ETH Zürich, Nachlass Hans Schmidt

ОРСК / ПЛОЩАДЬ ГОРСОВЕТА

30

31

Frage: Wo, wohin und wie bewegt sich der Mensch ? – wird aus einer rein technischen Frage zu einer der elementarsten architektonischen Aufgaben.
[...]

Universalität

Die notwendige räumliche Harmonie ist nur möglich, wenn die einzelnen Elemente der Architektur als allgemeingebrauchte, typische gestaltet sind, also eine gewisse Universalität in ihren gegeseitigen Beziehungen haben. Diese Universalität der architektonischen Elemente und die daraus entspringende räumliche Harmonie zeigen die Städte und Dörfer der Vergangenheit. Dieselbe Universalität, wenn auch auf höherer Stufe, ermöglicht die Bautechnik mit ihrer reichen Skala von typischen Gegensätzen, Standards, Materialien und Farben.

Aus: **WAS HABE ICH ALS ARCHITEKT IN DER UDSSR GELERNT?** in: *Sowjetskoje Iskusstwo 1934; zitiert nach: Hans Schmidt, Beiträge zur Architektur 1924–1964, Basel 1965.*

[...] Für die Architektur der Sowjetunion sind alle Probleme der Architektur in erster Linie Probleme des Städtebaus. Der sozialistische Aufbau kann sich nicht damit begnügen, einzelne hochqualifizierte Kunstwerke, einzelne Monumente oder Fassaden zu schaffen, er stellt dem Architekten die Aufgabe, vollkommene, allseitige soziale, technische und architektonische Organismen zu schaffen.[...]
[...]
Wenn ich also konkret bezeichnen soll, was ich als Architekt in der UdSSR gelernt habe, so ist es in erster Linie jenes Arbeitsgebiet der sowjetischen Architektur, das vom sozialistischen Aufbau die stärksten Impulse erhalten und auch im Westen das größte Interesse erweckt hat – die Planung der neuen Städte auf der Grundlage eines einheitlichen sozialen, technischen und architektonischen Programms. Ganz neu waren für mich die direkte Zusammenarbeit mit den verschiedenen am Städtebau beteiligten Spezialisten, den Oekonomen, den Ingenieuren für Transport, Wasserversorgung, Kanalisation und so weiter, die klare Orientierung der Stadt auf ihre produktive Existenzgrundlage, die Industrie, sowie die Verbindung mit der ökonomischen und technischen Planung eines ganzen Rayons. Die lehrreichste Aufgabe für mich als Architekten ist natürlich die Bebauung selbst, das Zusammenwirken der Bauten, Straßen, Plätze, des Grüns und der Natur zum neuen Gesicht der sozialistischen Stadt.

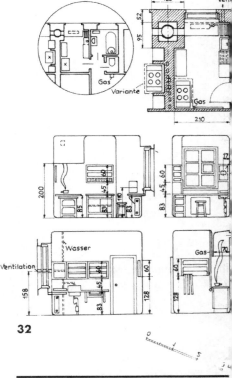

32

32 Standardisierte Kücheneinrichtung, Entwurf Hans Schmidt 1937.
Quelle: Hans Schmidt, Die Tätigkeit deutscher Architekten und Spezialisten des Bauwesens in der Sowjetunion in den Jahren 1930 bis 1937. In: Wissenschaftliche Zeitschrift der Humboldt-Universität zu Berlin, gesellschafts- und sprachwissenschaftliche Reihe. 1967/3

1938 bis 1955
Politisches Engagement und
Rückwendung zur Klassik

Aus Moskau zurück in Basel

Die misslichen Begleitumstände seiner Rückreise aus der Sowjetunion in seine Heimatstadt Basel bilden für Hans Schmidt offensichtlich keinen Grund zur Resignation oder zum Stillhalten. Sein Sendungsbewusstsein und sein Kampfgeist für eine Verbesserung der Gesellschaft durch eine Neuordnung ihrer Umwelt sind ungebrochen. Das Projektieren und Realisieren von Bauten tritt, bedingt durch die Umstände der Kriegszeit, in den Hintergrund. Umso mehr beschäftigen ihn die theoretischen Fragen des Städtebaus und die damals neu ins Blickfeld tretenden Aufgaben der Regional- und Landesplanung. Vor allem aber versucht Hans Schmidt in logischer Konsequenz seine Vorstellungen einer besseren Stadt- und Gesellschaftsordnung durch den aktiven Eintritt in die Politik zu fördern und einer Realisierung entgegen zu bringen. Er folgt damit dem Beispiel seines Lehrers Hans Bernoulli, der schon einige Jahre früher durch eine aktive politische Tätigkeit bei den Freiwirtschaftern und später im Landesring der Unabhängigen seinen städtebaulichen Überzeugungen zum Durchbruch zu verhelfen suchte. Die 17 Jahre von Schmidts zweiter Basler Periode sind denn auch geprägt vom politischen Kampf in der Opposition zum bürgerlichen Basel und zur entsprechenden Auffassung von Stadtplanung. Städtebau wird für ihn zu einer politischen Frage und seine politische Tätigkeit ist nicht zuletzt auf eine Verbesserung der Stadt durch die ökonomischen Theorien von Marx und Engels ausgerichtet.

Landesverteidigung und Landesplanung

Nachdem Hans Schmidt schon im Weltkrieg 1914–18 Aktivdienst geleistet hatte, wird er bei Kriegsbeginn 1939 wieder zur Grenzbesetzung aufgeboten und verbringt bis zum Kriegsende 1945 einen wesentlichen Teil seiner Zeit im Militärdienst. Die Landesverteidigung gegenüber Nazideutschland und den Axenmächten erachtet er offenbar als eine selbstverständliche Pflicht.

Als Arbeitsbeschaffungsmassnahme und auch im Sinne der geistigen Landesverteidigung werden in den Kriegsjahren von Bundes- und Kantons-

behörden planerische Aufgaben an Architekten vergeben. Hans Schmidt konzentriert seine Studien und theoretischen Ansätze, nicht zuletzt unter dem Eindruck seiner Russlanderfahrung, auf Planungsfragen. Schon 1938 legt er in der Schweizerischen Bauzeitung unter dem Titel "Öffentlichkeit und Basler Stadtplan" [1] eine Methode der Stadtplanung vor, welche Bestandesanalysen, Planungskonzepte und auch die Partizipation der Öffentlichkeit umfasst. Für die Landesausstellung 1939 in Zürich erhält Hans Schmidt von den Fachverbänden BSA und SIA den Auftrag, in der Abteilung "Plan und Bau" den Abschnitt "Städtebau und Landesplanung" zu konzipieren und zu gestalten. An verschiedenen Siedlungsbeispielen aus der Schweiz zeigt er in grossformatigen Tafeln die Probleme der Zersiedelung, der ungeordneten Bebauung und des Verkehrs und schlägt Lösungen in Form moderner Bebauungspläne und einer kommunalen Bodenpolitik vor. Leider sind die offenbar didaktisch überzeugend konzipierten Tafeln nicht mehr erhalten.

Zur Vorbereitung einer landesweiten Planung war 1937 die Schweizerische Landesplanungskommission gegründet worden, der neben Fachleuten aus verschiedenen Gebieten auch Hans Schmidt angehört. Mit einem Kredit des eidgenössischen Militärdepartementes wird im Juli 1941 ein Zentralbüro dieser Kommission in Zürich eingerichtet, das die Grundlagen für eine schweizerische Regional- und Landesplanung erarbeiten soll. Die Leitung des Zentralbüros wird dem Ingenieur H. Blattner und Hans Schmidt als Architekten übertragen. In einem umfangreichen Bericht [2], der vom Delegierten für Arbeitsbeschaffung herausgegeben wird, sind alle Elemente einer zukünftigen Landesplanung aufgearbeitet: die Sachgebiete von Landwirtschaft bis Abraumbeseitigung, die Organisationsform und die notwendigen gesetzlichen Grundlagen, sowie die siedlungspolitischen Konzepte. Der methodische Aufbau des Berichtes sowie einzelne Kapitel zeigen eindeutig die Handschrift von Hans Schmidt und beweisen, dass er mit einer durchgehenden Planung des Landes auch die Realisierung seiner städtebaulichen Theorien zu erreichen hofft.

Als weitere Arbeitsbeschaffungsmassnahme wird im Jahre 1942 die Sanierungsplanung von 35 schweizerischen Kurorten an verschiedene Architektengruppen in Auftrag gegeben [3]. Zusammen mit Werner M. Moser und den Architekten Leopold M. Boedecker, Bruno Giacometti, Nicolaus Hartmann und Jakob Padrutt bearbeitet Hans Schmidt die Planung von St. Moritz Dorf und St. Moritz Bad. Anhand von Plänen und Schaubildern vor und nach einer Sanierung beweist Hans Schmidt, wie dieser Hotel- und Bäderstadt eine verbesserte städtebauliche und kubische Gestalt gegeben werden könnte. Sehr rigoros rückt er in seinen Vorschlägen den grossen Hotelbauten der Gründerjahre zu Leibe, entfernt Kuppeln und architektoni-

1 Albert Speer, Deutscher Ausstellungspavillion an der Weltausstellung in Paris 1937.
Aus: Werk 1937/11

2 B. Jofan, Russischer Ausstellungspavillion an der Weltausstellung in Paris 1937
Aus Aus: Werk 1937/11

3 Schweizer Soldaten beim Schwören des Eides im Aktivdienst.
Quelle: Augenzeuge Lothar Jeck, Basel 1983

1

2

3

schen Zierrat, legt einen grossen Kurpark an und erreicht damit – wenigstens auf seinen Schaubildern – ein kubisch modernes und einheitliches Stadtbild. Das eklatante Gegenteil seiner Vorstellungen, die sorgfältige Restaurierung der alten Hotelpaläste und die masslose Überbauung von St. Moritz, wird er 30 Jahre später bei seiner letzten Reise zur BSA-Tagung im Bergell feststellen können.

Städtebauliche Entwürfe in der Wende zum Klassizismus

In der Januarnummer des WERK 1938 [4] kommentiert Peter Meyer als Redaktor das neue Musée de l'art moderne und lobt das in einem schwächlichen Klassizismus gehaltene Gebäude als bemerkenswerten "Beitrag zum Problem des Monumentalen" das "heute wieder in den Mittelpunkt der Modernität rückt". Hans Schmidt repliziert im Aprilheft des gleichen Jahres, bezeichnet die Architektur des neuen Museums als fragwürdigen Formalismus und belegt dies mit einer Analyse der klassischen Baukunst und den Erkenntnissen der Moderne. Der streitlustige Peter Meyer setzt der 6 Spalten umfassenden Kritik von Hans Schmidt im gleichen Heft eine 11-spaltige Duplik entgegen, wobei er Hans Schmidt, und mit ihm die moderne Avantgarde und deren "höchstanfechtbare Ideologien" scharf angreift. Noch im Jahre 1938 tritt Schmidt somit als Kämpfer für eine technische und funktionelle Architektur auf. Bereits in seinen Entwürfen und Wettbewerbsprojekten der Jahre 1942 bis 45 zeigen sich bei ihm jedoch klassizistische Tendenzen an (Wettbewerb Dorfzentrum Riehen und Rittergasse Basel). Die meisten Wettbewerbe und Gutachten, an denen sich Hans Schmidt in den Jahren 1942 bis 54 beteiligt, betreffen städtebauliche Aufgaben, so die Planung Clarastrasse Basel 1943, das Bahnhofgebiet Basel 1947, die Planung des Bäumlihofareals, die Überbauung mit Schule und Kirche Wasgenring und die Planung des Gellertareals. In diesen städtebaulichen Projekten hält Schmidt noch weitgehend an seinen Prinzipien der Zeilenbauweise und der gereihten Stadt fest, ergänzt diese jedoch durch Akzente in Form von Hochhäusern. Teilweise wie z. B. beim Wettbewerbsprojekt für den Bahnhofplatz Basel [5] werden diese Hochhäuser in klassisch monumentaler Form auf eine Symmetrieaxe ausgerichtet. Im Ideenwettbewerb für das Areal des Stadttheaters mit Kunsthalle [6] (das sogenannte Basler Kulturzentrum) schlägt Hans Schmidt an Stelle der neugotischen Elisabethenkirche einen ca. 30geschossigen Turmbau vor, der mit seiner symmetrischen Abtreppung Analogien zum stalinistischen Kulturpalast in Warschau aufweist. Auch der davorliegende Längsbau des Theaters mit Säulenportikus zeigt eine monu-

4

4 Peter Meyer in seinem Arbeitszimmer.
Photo: Anita Volland-Niesz, in: Peter Meyer, Aufsätze, Zürich 1984

5 J. C. Dondel, A. Aubert, P. Viard, M. Dastugue, Musée de l'art moderne, Paris 1937.
Aus: Werk 1938/1

6 Le Corbusier, Entwurf für das Musée de l'art moderne, Paris.
Aus: Werk 1938/1

5

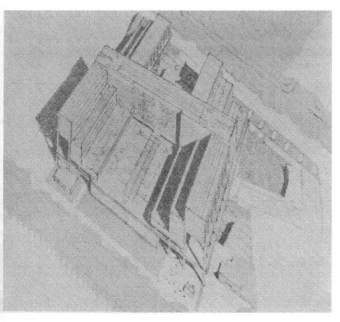

6

mentale Klassik. Diese Projekte sind stets mit umfangreichen Studien über Proportionen und Masse der klassischen Baukunst belegt. Die Gebäudeentwürfe Schmidts aus dieser Periode, (vor allem die verschiedenen Schulhausprojekte) sind ganz in klassizistischen Formen angelegt. In den städtebaulichen Entwürfen, die für unsere Untersuchung relevant sind, verlässt Schmidt jedoch seine funktionalen Prinzipien des Städtebaus nicht. Klassizistische Formen wendet er bei Einzelbauten, insbesondere bei öffentlichen Gebäuden an.

In seinen Schriften begründet Schmidt seine Wende zu klassischen Formen nirgends, auch gegenüber seinen Kollegen und seinem Mitarbeiter C. A. Löhnert gibt er keine Begründung für seine veränderte Auffassung. Damit bleibt es offen, ob Schmidts architektonische Wende auf der Solidarität zur stalinistischen Parteidoktrin, auf einem Zweifel an der Tauglichkeit der Architekturformen der Moderne oder auf einer eigenen Entwicklung und Überzeugung beruht.

7

Der Einstieg in die Basler Partei- und Planungspolitik

Das Engagement von Hans Schmidt in der Basler Parteipolitik [7] dürfte vorerst zu einem wesentlichen Teil darin begründet sein, dass er auf diesem Wege seine sozialpolitischen und stadtplanerischen Anliegen direkt zu verwirklichen hofft. Schon kurz nach seiner Rückkehr im Juni 1938 bewirbt er sich um die Stelle des Stadtplanchefs von Basel. Gewählt wird jedoch der aus der traditionelleren Stuttgarterschule stammende Paul Trüdinger.

Schmidt sucht aber auch weiterhin den Zugang zu offiziellen Funktionen und wird 1939 zum Mitglied der staatlichen Heimatschutzkommission bestimmt (welche die Aufgabe der heutigen Stadtbildkommission innehatte). Im April 1940 wird er als Vertreter des BSA in den Basler Denkmalrat berufen und 1944 in die Baukommission des Baudepartementes und in das Fachkollegium des Stadtplanbüros gewählt. Dass Hans Schmidt auch von seinen Fachkollegen als unbestrittene Autorität anerkannt wird, zeigt seine Wahl zum Obmann der BSA-Ortsgruppe Basel im Jahre 1939.

Über die früheren parteipolitischen Bindungen Hans Schmidts sind keine Angaben auffindbar, trotzdem er allgemein, vor und nach seinem Russlandaufenthalt als "Linker" oder "Roter" gilt, heute würde man seine damalige Haltung als "links-intellektuell" bezeichnen. 1943 tritt er der kommunistischen Partei der Schweiz bei, die 1921 gegründet, zwischen 1940 bis 1945 vom Bundesrat verboten worden war. Ein Jahr später beteiligt er sich an der Gründung der PdA (Partei der Arbeit), lässt sich als deren Regierungsrat aufstellen und kandidiert in den gleichen Wahlen 1944 erfolgreich

7 Wahlurkunde des Grossen Rates Basel (Kantonsparlament) 1947

8-9 Wettbewerb zur generellen Abklärung späterer Baumöglichkeiten an der Rittergasse in Basel (1. Preis) 1942. Blick durch die Rittergasse gegen das Münster.
Aus: Schweizerische Bauzeitung, 5. September 1942

8 Blick durch die Rittergasse gegen das Münster

9 Lageplan von der Freien Strasse bis zum Rhein

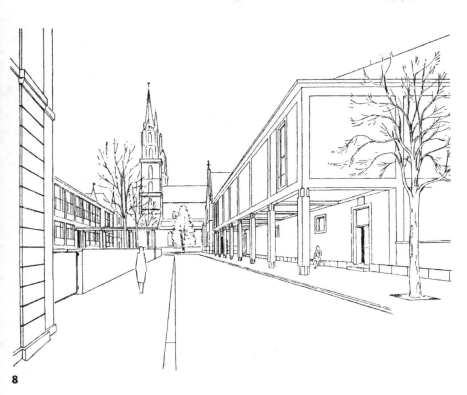

8

9

für den Grossen Rat der Stadt Basel (kantonales Parlament). Gleichzeitig mit ihm wird auch sein Lehrer und Kollege Hans Bernoulli auf der freiwirtschaftlichen Liste als Grossrat gewählt.

Die jahrelangen Auseinandersetzungen innerhalb der sozialistischen Bewegung der Schweiz schlagen sich auch in der Verteilung der Basler Parlamentsmandate nieder [8]. Im Zeitpunkt des Parteiverbotes 1941 halten die Kommunisten 15 Mandate, die Sozialdemokraten deren 55. Bei den Wahlen 1944, – die sowjetische Armee ist daran, die deutsche Wehrmacht aus Russland zurückzudrängen –, erhält die neue Partei der Arbeit 18 Mandate, die sozialdemokratische Partei deren 45. Hans Schmidt bleibt gewählter Grossrat bis 1955. In der Partei der Arbeit ist er vorerst Präsident der Föderation der PdA, später Vizepräsident der PdA Schweiz. In der politischen Diskussion, in den Wahlkämpfen und in den Redeschlachten des Parlamentes werden Hans Schmidt und seine Genossen stets mit dem Begriff "moskauhörig" bedacht, und die Niederschlagung des Ungarnaufstandes 1956 führt zu zahlreichen Parteiaustritten und zur Dezimierung der Fraktion. Hans Schmidt ist in diesem Zeitpunkt bereits in Ostberlin.

Hans Schmidts Mandat als Grossrat bringt ihm vorerst einzelne der oben aufgeführten Aufgaben und Funktionen in der Basler Stadtplanung. Bald nach Kriegsende führt jedoch die Abstempelung als "Moskauhöriger" zu einem zunehmenden Boykott gegenüber dem praktizierenden Architekten Schmidt. Die Infektionsabteilung des Basler Bürgerspitals bleibt der letzte grössere Bauauftrag und die Genossenschaftssiedlungen gelangen nur teilweise zur Ausführung. Auch das stadtplanerische Gutachten über den Wiederaufbau von Warschau 1946 bringt keine Folgeaufträge, auch nicht in den Oststaaten.

Im Kreis seiner Architektenkollegen, die unterschiedliche parteipolitische Couleur aufweisen, bleibt er als Fachmann und Instanz für Städtebau weiterhin akzeptiert. Dies zeigt sich in der kollegialen Zusammenarbeit für verschiedene Basler Planungskonzepte und in den vergleichenden Analysen, die er für die Zeitschrift WERK verfasst. Seine architektonischen Entwürfe im Stil der Stalin-Aera werden eher als Marotte eines bekannten Querkopfes belächelt.

Die vorgängig aufgestellte Hypothese, dass Hans Schmidt in seinem parteipolitischen Engagement vor allem ein Mittel zur Durchsetzung seiner sozialpolitischen und stadtplanerischen Ideen sieht, mag für seine parteipolitische Tätigkeit in den ersten Nachkriegsjahren fraglich sein. Die These bestätigt sich allerdings wieder mit seiner Übersiedelung nach Ostberlin 1955, da sich damit für ihn die Möglichkeit eröffnet, den sozialistischen Städtebau im grossen Massstab zu realisieren. Mit seiner Abreise in den Osten brechen allerdings die bisher gepflegten Kontakte zu den Architek-

10

10 Botschaftsgebäude der Schweiz in Warschau nach Kriegsende 1947. Quelle: Archiv GTA, ETH Zürich, Nachlass Hans Schmidt

11 Siedlung Haslerain, Riehen (Bau- und Wohngenossenschaft ARBA), 1945. Perspektive der Strasse am Friedhof Quelle: Archiv GTA, ETH Zürich, Nachlass Hans Schmidt

12–13 Dorfkerngestaltung Riehen, 1943; Wettbewerbsprojekt. Quelle: Archiv GTA, ETH Zürich, Nachlass Hans Schmidt

12 Lageplan (Saalbau, Gasthof, Polizeigebäude und Kantonalbank).

13 Perspektive vom Kilchgässli, Saalbau und Gasthof

11

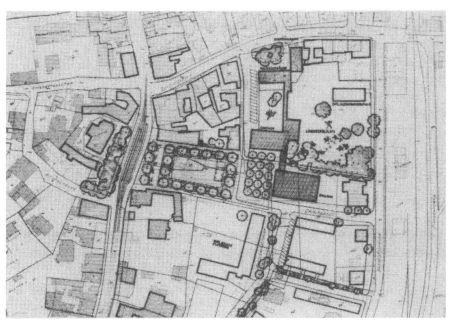

12

13

tenkollegen weitgehend ab, denn in Europa beginnt der "Kalte Krieg" und für die Basler ist mit der Übersiedlung in die DDR der Nachweis für Schmidts "Moskauhörigkeit" erbracht.

Anmerkungen

[1] Hans Schmidt, "Öffentlichkeit und Basler Stadtplan", Schweizerische Bauzeitung, 20. August 1938

[2] "Schweizerische Regional- und Landesplanung", Bericht der Schweizerischen Landesplanungskommission an das Eidgenössische Militärdepartement, erschienen in der Schriftenreihe zur Frage der Arbeitsbeschaffung, 1942.

[3] "Bauliche Sanierung von Hotels und Kuroerten", Bericht herausgegeben im Auftrag des Eidgenössischen Amtes für Verkehr.

[4] Peter Meyer, "Musée de l'Art moderne Paris, Werk 1938/1

[5] Wettbewerb für die Gestaltung des Gebietes beim Bundesbahnhof in Basel, Schweizerische Bauzeitung 15. Mai 1948.

[6] "Das neue Kulturzentrum der Stadt Basel", Werk 1954/4.

[7] Die Angaben über die politische Tätigkeit basieren auf einem Gespräch mit seinem ehemaligen Mitarbeiter C. A. Löhnert 1991 und auf der unveröffentlichten Lizentiatsarbeit an der Universität Zürich von Ursula Suter, 1990: "Hans Schmidt, Übersicht über sein architektonisches Werk zwischen 1937 und 1955".

[8] Angaben aus René Teuteberg "Basler Geschichte", Christoph Merian Verlag Basel 1986.

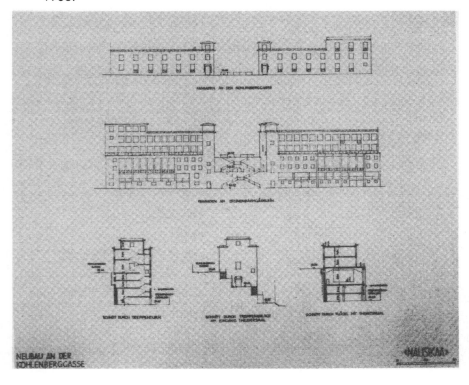

14 Wettbewerbsprojekt Mädchengymnasium Basel, 1953. Fassaden an der Kohlenberggasse und am Steinenbachgässlein, Schnitte durch Treppenturm, Treppenanlage und Theatersaal.
Quelle: Archiv GTA, ETH Zürich, Nachlass Hans Schmidt

15 Städtebauliche Studie für das Quartier Eierbrecht in Zürich 1943.
Oben: bestehende Bebauung
Unten: Erweiterung und Korrekturen mit dem Ziel eines geordneten Siedlungsbildes.
Aus: Werk 1943/7

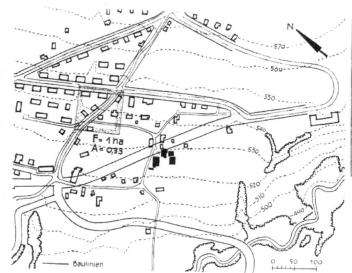

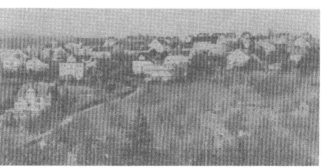

F = 1 ha
A = 0,33

N

—— Baulinien

0 50 100

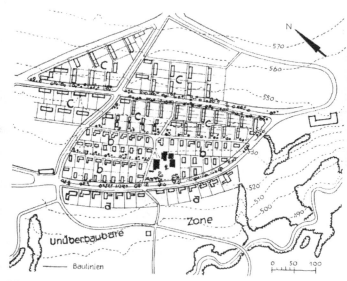

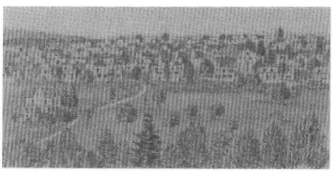

N

—— Baulinien

Unüberbaubare Zone

0 50 100

15

Texte und Projekte 1938–1955

Hans Schmidt um 1955

Aus: **ÖFFENTLICHKEIT UND BASLER STADTPLAN** in: *Schweizerische Bauzeitung, 20. August 1938*

[...]

Eine allgemeine Frage, die sich in der heutigen Situation aufdrängt, betrifft die Zusammenarbeit zwischen der Stadtplanungsarbeit und der Öffentlichkeit. Jeder Stadtplan bedeutet eine Auseinandersetzung zwischen den materiellen und ideellen Interessen aller Bewohner. Er kann also nicht nur als eine Angelegenheit der amtlich bestellten Spezialisten angesehen werden, sondern ist auf eine sachliche Mitarbeit aller Kreise angewiesen. Die erste Voraussetzung für eine solche Mitarbeit, die eine Forderung der Demokratie ist und durch kein autoritäres Diktat ersetzt werden kann, ist Aufklärung, Schaffung des Verständnisses und Interesses, Beseitigung der heutigen Extreme – der Gleichgültigkeit und der einseitigen Nurkritik. Die zweite Voraussetzung wäre die Schaffung einer wirksamen organisatorischen Form, die verantwortlicher und aktiver als die heutigen, meist ehrenamtlichen Kommissionen alle am Stadtplan interessierten und beteiligten Kreise ans Werk setzen würde. Die Durchführung dieser Aufgabe mag nicht leicht sein – dass sie notwendig ist, hat die Erfahrung nur allzu deutlich gezeigt.

Aus: **BEGRIFF DER REGIONAL- UND LANDESPLANUNG** in: *Schweizerische Regional- und Landesplanung, Schriftenreihe zur Frage der Arbeitsbeschaffung, Zürich 1942*

[...]

Die Durchführung einer systematischen Regional und Landesplanung wird damit auch für die Schweiz zur Notwendigkeit. Voraussetzung einer solchen Planung ist, dass die verschiedenen die Nutzung von Grund und Boden bestimmenden natürlichen Faktoren ebenso objektiv und übersichtlich erfasst werden wie die an der Nutzung beteiligten wirtschaftlichen und kulturellen Interessen der Landwirtschaft, der Industrie, des Verkehrs, der Energiewirtschaft, der Siedlung, der Erholung und des Natur- und Heimatschutzes. Ziel der Planung müsste es sein, alle diese Interessen in der Weise zu koordinieren, dass für das Ganze ein Maximum an Wirtschaftlichkeit und Wohlfahrt erreicht wird.

Aus: **DIE SIEDLUNG** in: *Schweizerische Regional- und Landesplanung, Schriftenreihe zur Frage der Arbeitsbeschaffung, Zürich 1942*

[...]

Die weitere Folge der planlosen Überbauung trägt der Bewohner selbst. Anfänglich noch für sich im Grünen wohnend, gerät er mit fortschreitender Über-

16 Hotel- und Kurortsanierung St. Moritz 1943. St. Moritz Bad, Vorschlag für die städtebauliche und architektonische Verbesserung. Quelle: Archiv GTA, ETH Zürich, Nachlass Hans Schmidt

17 Hotel- und Kurortsanierung St. Moritz 1943. St. Moritz Dorf, Vorschlag für die Verbesserung des Siedlungsbildes. Quelle: Archiv GTA, ETH Zürich, Nachlass Hans Schmidt

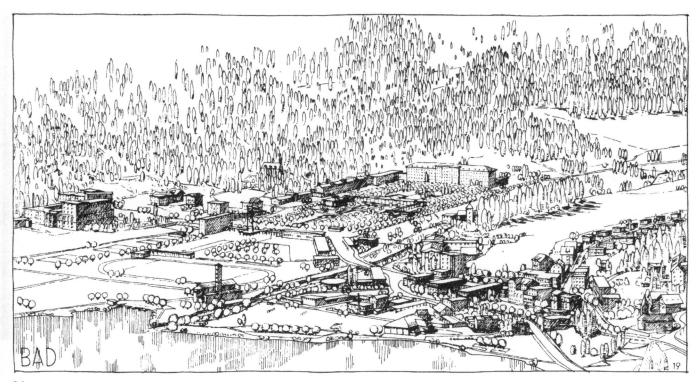

16

17

bauung immer mehr in das Dickicht von Häusern, dem er eigentlich entfliehen wollte. Die "Gartenstadt" wird zum übliche Häuserhaufen. Alle diejenigen Vorsorgen eines guten Bebauungsplanes, die durch überlegte Zusammenfassung der Häuser, durch Alleen, Grünanlagen, Aussichtsstrassen, Freihaltung wichtiger Punkte, Anlage von öffentlichen Gebäuden, wie Schulen usw., an ausgewählten Stellen eine bewusste Formung und Charakterisierung der Siedlung ihre Auflockerung und Verbindung mit der Landschaft zustandebringen können, sind verspielt und können nicht mehr nachgeholt werden.

[...]

Die Planlosigkeit der Siedlungsentwicklung kann nur durch eine vorausschauende Lenkung der Bebauung durch die Gemeinden selbst bekämpft werden. Dafür ist es notwendig, dass einerseits alle diejenigen Gemeinden, die eine bauliche Entwicklung in irgend einer Form zu erwarten haben, im Besitze gültiger Bebauungspläne sind, und dass andererseits die zur Durchführung der Bebauungspläne erforderlichen gesetzlichen Bestimmungen vorhanden sind.

[...]

Aus: **DIE SIEDLUNG,** Werk 7/1943

[...]

Wir singen überall das Lob unserer alten Dörfer und Städtchen, aber wir haben noch immer nicht recht begriffen, dass der eigentliche Reiz ihrer Strassenbilder darin liegt, dass sie mehr sind als nur ein Zusammenfügen von privaten Häusern und Gärten. Was sie zusammenbindet, was sie im städtebaulichen, architektonischen Sinne formt, ist letzten Endes immer ein Stück kollektiven Bewusstseins, gemeinsamen Willens. Vielleicht ist es nicht viel mehr als eine gemeinsam erkannte und gemeisterte Notwendigkeit, das Regeln der Traufkanten, die Führung des Dorfbaches, die Aufstellung der Brunnen. Vielleicht ist es nicht viel mehr als das notwendige Sichzusammendrängen in der Enge der Stadtmauern oder das fast widerwillige Sichzusammenfinden der Häuser eines Dorfes. Demgegenüber sieht man es den meisten unserer Siedlungen und Gartenstadtquartieren schon von weitem an, dass jeder einzelne Besitzer eines Einfamilienhauses sich auf seinem Grundstücklein niedergelassen hat, als sei er der einzige auf der Welt, auch wenn das Grundstücklein nicht mehr als 500 m² misst und ihm gerade erlaubt rund um seine Villa herumzugehen. Der unglückliche Planer weiss nicht, ob er die Strassen besser gerade ziehen oder im Bogen legen soll. Weder im einen noch im andern Fall wird die Strasse etwas anderes als eine ermüdende Schaustellung von immer wieder andern oder gleichen Häuschen, Einfriedungen Blautännchen und exotischen Büschen.

[...]

Alle Zeiten, die wirklich Städte zu bauen wussten, haben sich Haustypen geschaffen oder die bestehenden so gewandelt, dass sie Elemente eines Ganzen werden konnten. Vor allem ist die Architektur des 17. und 18. Jahrunderts als letzte grosse allgemeineuropäische, ja Weltarchitektur in einer bis dahin kaum gekannten Folgerichtigkeit dazu übergegangen, das einzelne Haus als typisch

18 Ortsplanung Zollikon 1943. Ausschnitt aus dem Bericht: Bebauung – Kleinhausquartiere.
Quelle: Archiv GTA, ETH Zürich, Nachlass Hans Schmidt

19 Ortsplanung Zollikon 1943. Ausschnitt aus dem Bericht: Bebauung – Kleinhausbau und Strassennetz.
Quelle: Archiv GTA, ETH Zürich, Nachlass Hans Schmidt

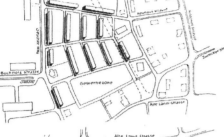

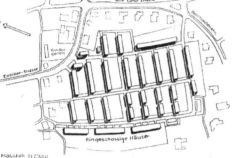

Masstab 1:7'500

18

Bebauung
Kleinhausquartiere

1. Buchholzquartier

Die störende und auch verkehrstechnisch nicht gut liegende Gustav-Maurer-Strasse ist fallen zu lassen (vgl. unter Strassennetz). Die Ueberland-Strasse bleibt auf 250 m kreuzungsfrei.

2. Hägniquartier

Aufteilung generell, da die Unterlage mit 5,00 m Kurvendistanz zu wenig genau ist.

Die Hügelkante ist durch besondere Vorschrift für eingeschossige Bebauung zu reservieren, um die Aussicht vom Plateau freizuhalten.

Bebauung
Kleinhausbau
und Strassennetz

Das Kleinhaus verlangt ein seinen besonderen Bedingungen angepasstes Strassennetz.

Bei der üblichen Bebauung werden die Häuser den Strassen entlang errichtet. Der Abstand zwischen zwei Strassen diktiert die Tiefe der Parzelle. Zu grosse Strassenabstände erzwingen schmale Parzellen oder schlechte Ausnützung im Block-innern. Die Einhaltung des Baulinienabstandes nötigt zur Anlage unbrauchbarer Vorgärten.

Beim Kleinhausbau sollten die Häuser grundsätzlich senkrecht zu den Strassen stehen. Die Parzellentiefe kann unabhängig von den Strassenabständen gewählt werden. Innerhalb des Baulinienabstandes können gesonderte schmale Fahrwege angelegt werden, wodurch sich die Verkehrssicherheit der Strasse erhöht.

Für die Kleinhausbebauung an den ebenern Lagen beidseitig des Zürichsees empfiehlt sich im allgemeinen die Ost-Westrichtung der Hauszeilen mit Südlage der Hauptwohnräume, also der einreihige Zeilenbau. Damit stimmt überein, dass die durchgehenden Strassenzüge in der Nord-Südrichtung verlaufen – parallel zu den Hängen und den Seeufern.

Nach diesen Grundsätzen sind die Kleinhaus-Viertel im Bebauungsplan anzulegen.

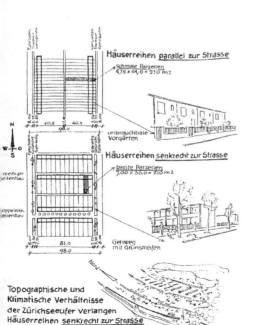

Häuserreihen parallel zur Strasse
schmale Parzellen
4,75 x 44,0 = 210 m2

unbrauchbare Vorgärten

Häuserreihen senkrecht zur Strasse
breite Parzellen
7,00 x 30,0 = 210 m2

Gehweg mit Grünstreifen

Topographische und klimatische Verhältnisse der Zürichseeufer verlangen Häuserreihen senkrecht zur Strasse

städtebauliches Element aufzufassen, und hat sich dabei nicht gescheut, den eigenwilligen lokalen Charakter der Materials, das betont Regionale – den "Heimatstil" – bewusst zurückzudrängen.

[...]

Ein wirkliches Sichzusammenschliessen der Siedlungen zu einem Ganzen und das harmonische Aufgehen dieser Siedlungen in der Landschaft kann nur von einer Architektur erreicht werden, die dem Hause das Einmalige, nicht Wiederholbare nimmt, seine Masse nach Möglichkeit reduziert, den Kubus auflöst und den Baumwuchs die Möglichkeit gibt, das Haus zu überschneiden. Wenn man die Sache von dieser Seite aus ansieht, so wird man zugeben müssen, dass gerade die moderne Architektur – wenigstens soweit sie sich nicht mit den bekannten weissen Kubussen begnügte – auf einem richten Wege war.

[...]

Aus: *RAPPORT SUR LE PLAN GENERAL DE LA VILLE DE VARSOVIE*, Typoskript 14. 10. 1946, Archiv GTA. Zusammenfassung des französischen Textes durch Raoul Rosenmund.

In den "Bedingungen und Zielen des Rapports" schreibt Hans Schmidt, dass er vom Stadtpräsidenten M. S. Polwinski und dem Präsidenten des Exekutivkommitees des hohen Rates eingeladen worden sei, seine Meinung zum Generalplan der Rekonstruktion der Stadt Warschau abzugeben.

Er hatte dort während 2 Wochen Gelegenheit, sich über den baulichen Zustand, sowie die geographischen, ökonomischen, sozialen und geschichtlichen Grundlagen der Stadt zu informieren.

Er lobt die Kenntnisse in moderner Stadtplanung und das Grundlagenmaterial, worauf sich diese abstützen. Dank dieser Ausgangslage sei es es ihm nicht schwer gefallen, die Verantwortung für die Beratertätigkeit zu übernehmen.

In der Beschreibung der "geographischen Situation" bemerkt Hans Schmidt, die geographische Lage einer Hauptstadt sei für ihn eine Angelegenheit ersten Ranges. Es scheint ihm offensichtlich, dass die Wahl Warschaus zur Hauptstadt Polens im Jahre 1595 durch die Verkehrsgunst (Vereinigung der drei Flüsse Weichsel, Bug und Narew) diktiert wurde.

Die Zerstörung der Stadt zu 80% durch "les barbares Nazis" könnte seiner Meinung nach die Frage aufwerfen, ob die Stadt woanders aufgebaut werden sollte. Dass diese Frage nicht gestellt worden sei, findet Hans Schmidt richtig, denn die Geschichte habe die Richtigkeit dieser Entscheidung gezeigt.

Unter "Oekonomische, soziale und demographische Grundlagen der Stadt" stellt Hans Schmidt fest, der Generalplan gehe von der Tatsache aus, dass Warschau nicht nur administratives, sondern auch wirtschaftliches, industrielles und intellektuelles Zentrum sei. Er unterstützt diese Ansicht, da die politischen und kulturellen Aufgaben der Unterstützung aller Volksgruppen bedürfen. Das Programm will die Wohnbevölkerung auf 1 200 000 Einwohner beschränken, im Vergleich zur Situation vor dem Krieg (1939) mit 1 300 000 Einwohnern. Dieses Maximum werde vor 10–15 Jahren nicht erreicht werden (1946 waren es 520'000 Einwohner). Die Erfahrungen in Moskau nach der Revolution hätten

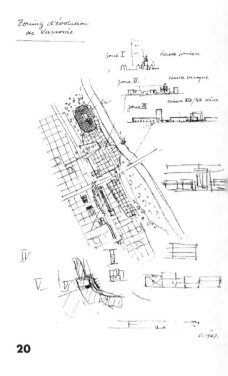

20

20 Skizze zum Bericht über den Generalplan der Stadt Warschau, 1947. "Zoning d'évolution de Varsovie": Zone I: Gotischer Massstab, Zone II: Barocker Massstab, Zone III: Massstab des 19. und 20. Jahrhunderts.
Quelle: Archiv GTA, ETH Zürich, Nachlass Hans Schmidt

21 Neugestaltung Clarastrasse, 1943. "Clarastrasse nach heutigem Ausbau (oben), Clarastrasse nach heutigem Zonenplan ausgebaut (Mitte), Clarastrasse ausgebaut nach Vorschlag Hans Schmidt".
Aus: Schweizerische Bauzeitung, 4. März 1944

22 Neugestaltung Clarastrasse, 1943. Ansicht eines Hofes mit Wohnungen (oben), Ansicht der Strasse
Quelle: Archiv GTA, ETH Zürich, Nachlass Hans Schmidt

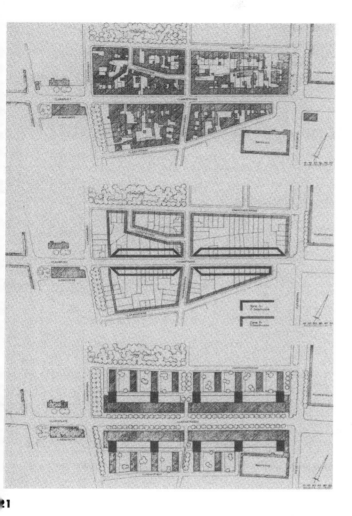

21

22

gezeigt, dass es schwierig sein werde den Zustrom der Menschenmassen in die Hauptstadt zu begrenzen, ohne auf rigorose Massnahmen zurückzugreifen.

Die allgemeine Struktur der Stadt wird durch topographische Elemente stark geprägt. So etwa durch das Tal der Weichsel, dessen Ufer auf der einen Seite eine klare, etwa 20 Meter hohe Hangkante bildet, während die andere Uferkante fast flach verläuft. Die Altstadt, "stare miasto", die im 17ten und 18ten Jahrhundert errichteten Teile einschliesslich einer Reihe von Villen und kleinen Parks, die im südlichen Teil der Hangkante entlang der Weichsel errichtet wurde, zeigen ein sehr klares Verständnis für diese topographische Struktur.

Am Anfang habe sich die Bebauung des 19ten Jahrhunderts parallel zur Hangkante Richtung Süden weiterentwickelt. Bald sei aber die Ausweitung nach dem Prinzip des Öltropfens in alle Richtungen weitergegangen, wobei die Bebauung gleichzeitig monoton und chaotisch gewirkt habe. Der neue Plan von Warschau begründe sich nicht nur aus der Zerstörung der Stadt, sondern auch in den neuen Möglichkeiten, die sich durch die Verstaatlichung des Bodens, die Einführung einer neuen städtebaulichen Struktur und die Beendigung der Zersiedelung ergeben.

Die im Plan vorgesehene Struktur sehe drei verschieden bebaute Streifen vor, die alle Nord-Süd ausgerichtet sind, also dem Lauf der Weichsel folgen. Diese Konfiguration entspreche nicht dem bekannten Bild der ringförmigen Stadt, wie Paris, London oder Moskau, ziehe aber sehr kühn die Konsequenzen aus der topographischen Situation.

Zum "Stadtzentrum" bemerkt Hans Schmidt, dank den vielen Möglichkeiten, die die Altstadt anbiete, sei es möglich die neuen Gebäude, die für administrative, politische und kulturelle Zwecke gebaut würden, in passender Weise einzugliedern. Das ökonomische Zentrum werde sich logischerweise um den Kernpunkt der Stadt herum bilden: die Kreuzung der Hauptarterien Marszalkowska und Jerozelimska und die Achse der Marszalkowska selbst.

Die vorgesehene Dichte der Arbeitsplätze von 600 Personen pro Hektare, von der ausgegangen werde, sei auf 1000 P/Ha erhöhbar, so grosszügig sei dieses Zentrum konzipiert.

Der südliche Teil des Zentrums ist den Hochschulen vorbehalten. Er hält auch dies für richtig, da es sich gezeigt habe, dass auch in Städten, wo dies nicht von Anfang an vorgesehen gewesen sei, aufgrund der notwendigen engen Zusammenarbeit ein Zusammenrücken der Hochschulinstitutionen stattgefunden habe.

Das Gutachten schliesst Hans Schmidt mit folgenden Worten (Originaltext):

Mais ce n'est pas tout. Une ville, si modeste qu'elle soit, d'autant plus une ville comme Varsovie, capitale d'une Pologne née nouvelle et démocratique, est davantage qu'une somme de facteurs dits fonctionnaux, comme l'habitation, les lieux de travails, le transport et les espaces de loisirs. L'habitant de la ville, qui habite quelquepart, qui travaille autrepart, veut sentir la ville comme un être collectif, le citoyen de la Pologne qui visitera sa capitale, doit trouver à un endroit bien choisi le centre, le coeur même de la ville.

L'étude des villes historiques nous apprend le rôle important que jouaient dans l'ensemble l'agora, le forum, la place du marché ou l'Hotel de ville. Il est vrai

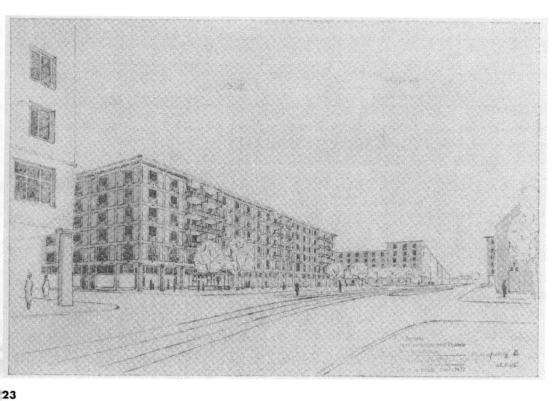

23

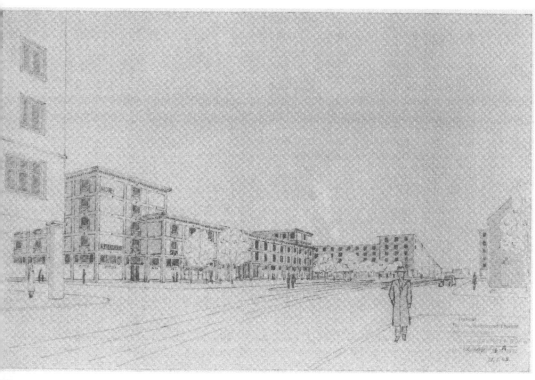

4

que la fonction très élargie du transport dans une ville moderne ne nous permets
pas de copier à l'esclave des places anciennes. Mais il serait encore plus faux
de nier leur rôle dans la vie actuelle et de ne pas chercher une solition corre-
spondente.

Pour Varsovie nouvelle la question s'impose de toute rigueur et comme une ta-
che architecturale de premier ordre. Ni la place du marché moyenageuse, ni les
belles places de la ville baroque, soit par leurs dimensions, soit par leur situation
dans la ville, ne peuvent accomplir cette tâche. L'emplacement noveau doit être
trouvé dans la partie la plus active de la ville moderne, très près de la Marzal-
kowska, étroitement lié avec elle et, si possible, avec le centre politique du pays
– le parlement – qui se trouve aux bords de l'escarpe.

Aus: **BEBAUUNG DES GELLERT-AREALS IN BASEL,** Werk 1951/10

Erster Teil

Die gemeinsame, einer bestimmten Aufgabe gewidmete Arbeit einer grösseren
Gruppe von Architekten ist nichts Alltägliches – vielleicht sogar etwas, was dem
einzelnen Architekten umso weniger liegt, je stärker er seine eigenen Auffassun-
gen entwickelt hat. Und doch ist es so, dass die Architektur die Zusammenarbeit
geradezu verlangt, sobald sie über die einzelne Bauaufgabe hinausgeht und
sich in grössere Zusammenhänge begibt. Sicherlich trifft dies zu beim Woh-
nugsbau, wo Überlegungen über den Standard, die Lebensgewohnheiten, die
Nachfrage eine wichtige Grundlage bilden. Es trifft erst recht zu beim Städte-
bau, wo überhaupt erst das Allgemeine, die Siedlung, das Quartier, die Stadt
über den Wert einer Lösung entscheidet.

Die Ortsgruppe Basel des BSA hat, von diesen Gedanken ausgehend, schon
seit einigen Jahren nach der Möglichkeit gesucht, eine solche gemeinsame Ar-
beit zu unternehmen. Den Anstoss zu einer ersten Verwirklichung gab vor zwei
Jahren eine Aussprache über die Ergebnisse des subventionierten Wohnungs-
baus, der in Basel mit dem Jahre 1949 einen gewissen Abschluss gefunden
hatte. Die Basler stehen wohl nicht allein, wenn sie das Ergebnis einer fünfjähri-
gen Wohnungsbauperiode mit kritischen – auch selbstkritischen – Augen be-
trachten.

[...]

Zweiter Teil

[...]

Haben die Architekten, welche die ganze Arbeit unternommen und sich schliess-
lich auf das beschriebene gemeinsame Projekt geeinigt haben, mehr verspro-
chen, als sie zum Schluss gehalten haben?

Man darf vielleicht – über die bewusste Berücksichtung derjenigen realen Fak-
toren hinaus, von denen bereits die Rede war – Überlegungen zu gute halten,
die vor allem aus der Tradition des Basler Wohnungsbaus heraus verstanden
werden müssen. Basel besitzt noch Viertel aus der zweiten Hälfte des 19. Jahr-

25 Vorschlag für eine Verschiebung
des Bundesbahnhofes Basel über das
Birsigtal mit Ausnützung der Topographie
zur Verkehrsführung, 1945. Schnitt und
Situation.
Quelle: Archiv GTA, ETH Zürich, Nach-
lass Hans Schmidt

26 Wettbewerbsprojekt für die Gestal-
tung des Gebietes beim Bundesbahnhof in
Basel mit zwei symmetrisch flankierenden
Hochhäusern.
Aus: Schweizerische Bauzeitung, 15. Mai
1948

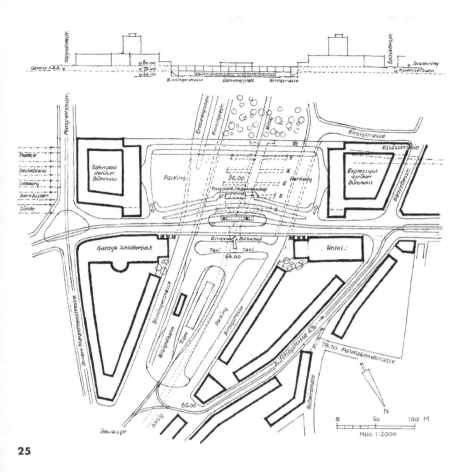

25

26

hunderts, bei welchen die einfachen Elemente: Strasse, Haus, Garten sich wie selbstverständlich zum Ganzen, zum Quartier, zum Stadtteil zusammenfügen. Erbteil aus dem nahen Frankreich, letzter Ausläufer seiner klassischen Kunst des Städtebaus? – die Wissenschaft mag dies untersuchen. Nach den Perioden des Historizismus und der Romantik, die zu Beginn des 20. Jahrhunderts mit einigem Lärm in diese Sille hereinbrachen, hat – in den Zwanzigerjahren – Hans Bernoullis Hirzbrunnenquartier jene Tradition, mit einem Seitenblick auf verwandtes Norddeutsches, Niederrheinisches, zurückgerufen. Die folgende Zeit der flachen Dächer und scharf begrenzten Kuben hat das Wesen der Sache nicht entscheidend verändert, vielleicht darum, weil man sich noch nicht vor den grossen einfachen Linien, vor der "Monotonie" fürchtete.

Es sieht so aus, als habe man heute diese Sicherheit verloren. Das Wohnen, das Viertel, der Stadtteil, jene simple Harmonie von Hauszeilen, Strassenperspektiven und geborgenen Gärten, hat einem Arrangieren von "Wohnblöcken" Platz gemacht, bei dem alles Private sich nach vorne drängt – der Sitzplatz, die Loggia, das Naturholzerkerfenster, die vom Gartengestalter geistreich komponierte Grünfläche -, zum photogrerechten Ausstellungsobjekt wird und schliesslich jeden Charakter verliert. Wenn der geneigte Leser – oder Kollege- mit dieser Kritik nicht einverstanden sein sollte, so versteht er jetzt wenigsten, was sich die Architekten der Basler Ortsgruppe bei ihrem gemeinschaftlichen Projekt für das Gellertareal gedacht haben.

Aus einem **BRIEF AN WERNER MOSER,** zum Wettbewerbsentscheid über das Basler Kulturzentrum 2. Juli 1953, Archiv GTA

[...]

Zur Diskussion nur kurz:

Ich gebe zu, dass ich schon seit längerer Zeit zu einer anderen Auffassung des Raumes und Bauwerkes gekommen bin. Ich will darüber jetzt nicht diskutieren, da mir sehr viel praktische, theoretische und historische Begründung notwendig erscheint, für die ich in Projekten, Notizen und Lektüre grosses Material habe, das ich irgendeinmal ausarbeiten müsste.

Das gibt vielleicht ein wenig Streit. Denn wie der deutsche Kunsthistoriker Pinder sagt :"Stile sind unerbittlich". Aber sie sind keine ewigen "Prinzipien", sondern zeitbedingte Unerbittlichkeiten.

Auch der Platz in Bergamo ist unerbittlich. So schön er ist – er macht mich noch in der Erinnerung nach Luft schnappen und an den Bibliotheksbau vis-à-vis des Plalladioschülers denken, den ich besonders geliebt habe.

Aber wie gesagt, das Alles kann man nicht bloss andeuten, sonst führt es zu Missverständnissen.

Natürlich urteilen – unterdessen und überhaupt immer – die Preisrichter auf Grund ihrer Präferenz, und vor allem wird das gebaut, was unerbittlich "in der Zeit liegt". Das ist in Ordnung und ich füge mich, wenn es mich auch gerade im Falle Kulturzentrum hart getroffen hat. Dafür anerkenne ich dankbar, in Gelter-

27-28 Überbauungsstudien Gellertareal Basel. 1950
Aus: Werk 1951/10

27 Bebauungsplan und Modell des Vorschlages von Hans Schmidt

28 Modell des gemeinsamen Vorschlages der BSA Ortsgruppe

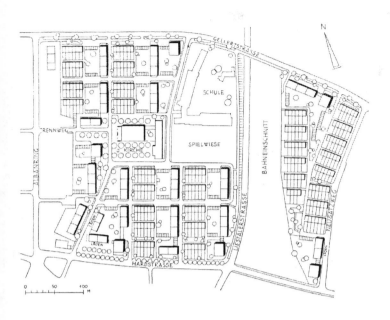

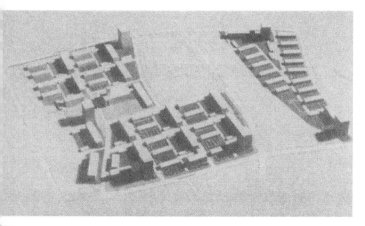

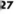

27

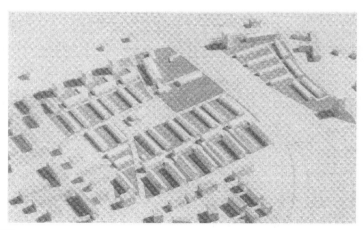

28

kinden und vor einem Jahr in Muttenz – verständnisvolle Preisrichter gefunden zu haben. Ich masse mir sogar selber an, das Starke auch gegen meine Präferenz würdigen zu können.
Mit den besten Grüssen auch
von Lili für Dich und Silva
Dein H.

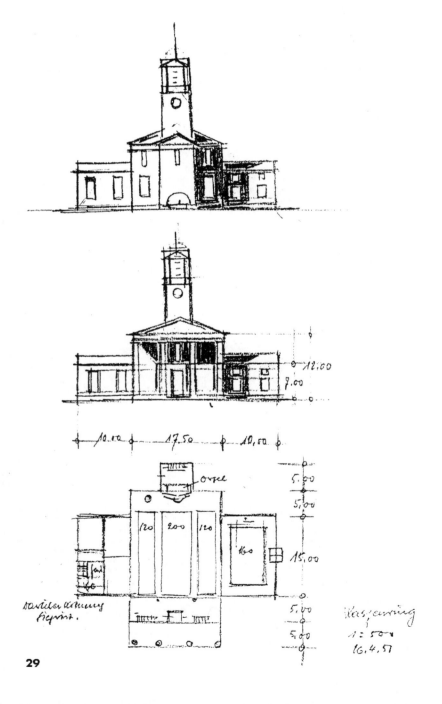

29 Wettbewerb Wasgenringareal, Basel, 1951. Skizze für die Thomaskirche am Eingang der Bebauung.
Quelle: Archiv GTA, ETH Zürich, Nachlass Hans Schmidt

30 Wettbewerbsprojekt Stadttheater/ Kulturelles Zentrum Basel, 1953.
Perspektive mit Theaterplatz und Hochhaus an Stelle der Kirche.
Perspektive mit Theaterplatz unter Erhaltung der Elisabethenkirche.
Vorplatz Schauspielhaus mit Blick gegen den Kirschgarten
Aus: Werk 1954/4

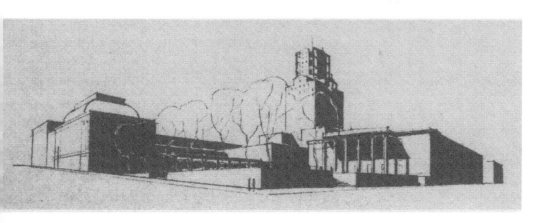

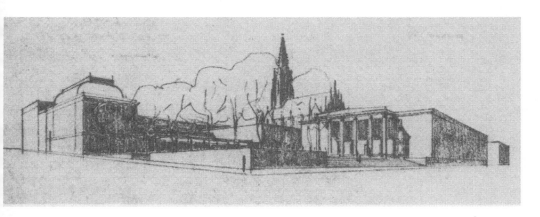

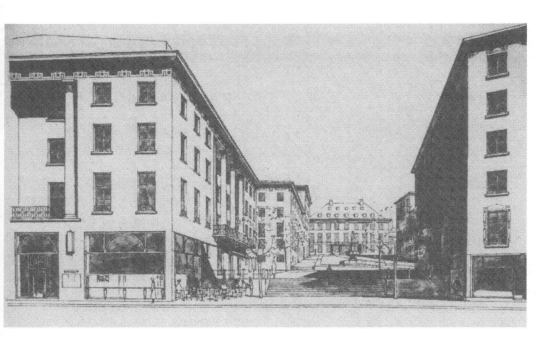

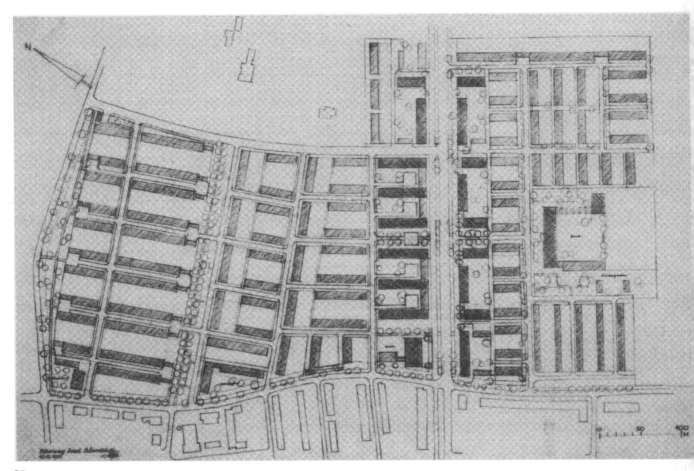

31

31 Bebauungsplan Bäumlihof, 1950. Städtebauliches Projekt für ein neues Wohnquartier in der heutigen Grünzone. Quelle: Archiv GTA, ETH Zürich, Nachlass Hans Schmidt

32 Wettbewerbsprojetk für "Basels neuen Marktplatz" (3. Preis), 1949. Analoges Projekt zu seiner Semesterarbeit über die "Anlage eines neuen Marktes in Basel" von 1918. Isometrie. Aus: Schweizerische Bauzeitung 10. September 1949

32

1955 bis 1969
Die Realisierung des sozialistischen Städtebaus in der DDR

Die Berufung nach Ostberlin

In Analogie zur Ausreise nach Moskau im Jahre 1930 sind es sowohl die wirtschaftlichen Gründe, wie auch die Herausforderung des Städtebaus, die Hans Schmidt Ende 1955 zur Ausreise nach Ost-Berlin bewegen. Immerhin steht er in seinem 63. Lebensjahr, in einem Lebensabschnitt also, in dem die wenigsten eine neue Karriere beginnen.

Im Mai 1954 besucht Hans Schmidt auf Einladung von Kurt Liebknecht, dem Präsidenten der Deutschen Bauakademie, erstmals die DDR. Er ist Gast an der Plenarsitzung der Deutschen Bauakademie, und später (1955) am Zweiten Bundeskongress des BDA der DDR. Anlässlich seiner ersten Reise besucht er neben Berlin auch Dresden und Potsdam und lässt anschliessend in der DDR-Fachzeitschrift "Deutsche Architektur" einen Reisebericht erscheinen: "Architektonische Eindrücke einer Reise in die Deutsche Demokratische Republik". In grosser Begeisterung schildert Hans Schmidt darin die ostdeutsche Landschaft, die historischen Bauten und besonders die Aufbauarbeit der jungen Republik. Ungeteiltes Lob zollt er dem damaligen Prunkstück von Ostberlin, der Stalinallee:

Hans Schmidt 1959

"Der entscheidene Schritt in den Massstab eines neuen Berlin bildet die im wichtigsten Abschnitt bereits ausgebaute, bewohnte und belebte Stalinallee. Man kann die überraschende Grösse und lebensfreudige Munterkeit dieser neuen Hauptstrasse nicht aus Bildern und Plänen ermessen. Erst die Wirklichkeit, die lichterfüllte Weite des Raumes, die freundliche Wärme der mit lichtgelber, unglasierter Keramik verkleideten Fassaden, das belebende Element der Ladenfronten, zeigt das eigentliche Neue, das hier in einem kühnen Anlauf geschaffen wurde." ... "Die Stalinallee zeigt, dass es richtig war, den grossen Schritt, den der neue sozialistische Bauherr von den Architekten erwartete, nach bestem Können zu tun." [1]

Die von Hermann Henselmann nach der stalinistischen Doktrin gestaltete Prunkstrasse ist für Hans Schmidt ein gutes Beispiel eines "nationalen Gesichtes der Architektur". Den Beweis dafür sucht er in den Ruinen der grossen historischen Bauten von Dresden und Potsdam und in deren "Urgewalt des Bauens". Mit einem an die frühe Arbeiterbewegung anklingenden Pathos ruft er die jungen Architekten zu neuen Aufgaben auf:

"Macht euch auf den Weg, ihr Städtebauer und jungen Architekten, und lernt von den Ruinen die verlorengegangene Würde und Heiterkeit der Baukunst, den Reichtum der menschlichen Schöpfung und die Mahnung zur Erhaltung des Friedens, von der letztlich die Erfüllung eurer Aufgabe abhängt."

Offensichtlich ist es Hans Schmidt auf seiner Reise von 1955 entgangen, dass die architektonische Parteidoktrin im Osten bereits in anderer Richtung zu schwingen beginnt. Nachdem Chruschtschow 1954 den Architekten in der Sowjetunion eine neue Richtung befohlen hatte, erklärt Ulbricht an der Baukonferenz von 1955 in Ostberlin die Senkung der Baukosten als wesentliche Aufgabe der Republik, und dies bedeutet die Umstellung des Bauens auf eine industrialisierte Produktion sowie die Absage an die sog. "nationalen Traditionen" im Stile der Stalinallee. Dass Hans Schmidt im Juni 1955 vom DDR-Minister für Bauwesen die Stelle des Chefarchitekten am neuen Institut für Typung in der Bauakademie angeboten wird, mag verschiedene Hintergründe haben. Massgeblich ist sicher Schmidts langjähriges Eintreten für die Industrialisierung und seine Erfahrung aus Moskau. Dabei spielt es auch eine Rolle, dass Schmidt als "neuer Mann" nicht durch die nun abgeworfene Architekturdoktrin der ersten 10 Republiksjahre belastet ist. Seine Anpassung an die stalinistische Architekturdoktrin in den Jahren 1940–55 ist für seine neue Funktion offenbar kein Hinderungsgrund.

So wird Hans Schmidt mit seinem Stellenantritt am 1.1.1956 zum Chefarchitekten eines Institutes mit 200 Mitarbeitern und leitet die neue Periode des industrialisierten, standardisierten Bauens in der DDR ein, eine Aufgabe, die für ihn die Erfüllung und Realisierung seiner städtebaulichen Theorien bedeutet. 1958 wird Schmidt zum Professor an der Bauakademie und zum Direktor des Institutes für Theorie und Geschichte der Baukunst ernannt, wobei er alle städtebaulichen Projekte der Republik zu beurteilen hat. 1963 verleiht ihm die Akademie die Ehrendoktorwürde und ernennt ihn, den 70jährigen zum Chefarchitekten des Institutes für Städtebau und Architektur. 1969 gibt er seine Ämter und Funktionen ab und kehrt mit 76 Jahren nach Basel zurück. Eine solche Karriere in den verschiedenen Funktionen müsste, besonders in einem sozialistischen Staat, mit grosser Machtfülle und massgebendem Einfluss verbunden sein, was jedoch im Falle von Hans Schmidt kaum zutrifft.

Der Städtebau der DDR aus der Sicht 1992

Im heutigen Zeitpunkt, drei Jahre nach dem Fall der Mauer und der Wiedervereinigung Deutschlands fällt es nicht leicht, die Leistung des ost-

1 Der Weg vom Kurfürstendamm zum Victoria-Luise-Platz am 9. 4. 44.
Aus: J. F. Geist, Das Berliner Mietshaus 1945–1989, München 1989

2 Hermann Henselmann, Stalinallee, Ausführungsentwurf zur Gestaltung des Strausberger Platzes (1952).
Aus: J. F. Geist, Das Berliner Mietshaus 1945–1989, München 1989

3 Stalinallee 1954, Block E-Nord von H. Hopp.
Klaus von Beyme, Städte aus Ruinen, München 1992

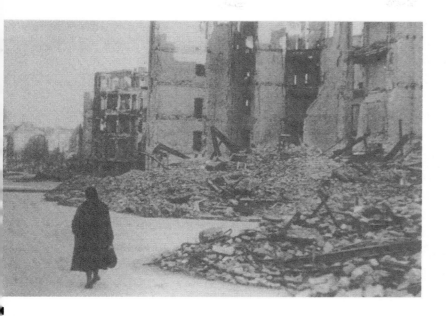

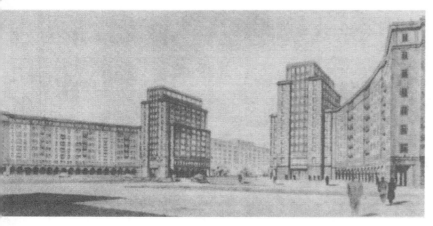

deutschen Städtebaus der letzten 40 Jahre zu beurteilen und damit auch die Arbeit von Hans Schmidt in Ost-Berlin einzuordnen. Mit der Gesamtwirtschaft der fünf neuen Bundesländer ist auch die industrialisierte Bauwirtschaft der ehemaligen DDR weitgehend am Ende. Die in den letzten 40 Jahren erstellten Wohnungsbauten befinden sich in einem sehr schlechten Zustand und die sog. Plattensiedlungen in Berlin, Rostock, Leipzig und Hoyerswerda sind heute ausserdem zum Begriff und Synonym von sozialer Desintegration und rechtsradikalen Demonstrationen geworden. In wie weit diese bedrückenden Ereignisse allein auf die politische und wirtschaftliche Situation oder auf die städtebauliche Lage zurückgeführt werden können, bleibt offen. Die Umstellung der neuen Bundesländer von der kommunistischen Planungsökonomie auf eine westliche Marktwirtschaft zeigt auch im Städtebau und im Bauwesen sehr unterschiedliche Resultate. Die radikale Wende in Politik und Wirtschaft hat nicht nur positive Folgen in diesem Bereich, sondern droht auch wesentliche Leistungen der vorangehenden Periode zu zerstören.

Wenn das Ende des realen Sozialismus in den ehemals kommunistisch bestimmten Ländern des Ostens noch keine generelle Liquidation der sozialistischen Idee bedeuten kann, dann müssen auch die Ideen des sozialistischen Städtebaus, wie sie von Hans Schmidt vertreten worden sind, heute in ihrem Grundgehalt und nicht allein im Blick auf den heutigen Zustand der Stadtanlagen beurteilt werden. Auch wenn gerade im Fall von Hans Schmidt eine Trennung von politischer Überzeugung und städtebaulichen Theorien schwer durchführbar ist, soll hier versucht werden, die städtebaulichen Absichten, Methoden und Leistungen in ihrem Grundgehalt zu beschreiben.

Die Formulierung der städtebaulichen Theorien

Mit seinen theoretischen Arbeiten am Institut für Typung und demjenigen für Theorie und Geschichte kann Hans Schmidt nicht an seine Tätigkeit der Kriegs- und Nachkriegsjahre in Basel anknüpfen. Hingegen setzt er dort wieder an, wo er am Ende der dreissiger Jahre aufgehört hat. Seine städtebaulichen Maximen sind wieder die offene Bauweise ohne strassenbegleitende Bauten, die Industrialisierung des ganzen Bauvorgangs und die Bestimmung der Architektur durch Funktion und Technik, wenn auch in den ersten Typenentwürfen noch klassizistische Formelemente nachklingen. Die ökonomischen Theorien des Marxismus-Leninismus unterstützen wieder neu seine städtebaulichen Vorstellungen und die bauwirtschaftliche Situation der DDR mit dem grossen Aufbaubedarf kommt seinen Ideen entgegen. Die Planung im grossen Massstab, die Vorbereitung von 5-Jahresprogrammen für

4 Stadtquartier in Plattenbauweise beim Alexanderplatz Berlin. Städtebaulicher Entwurf W. Dutschke (um 1960). Klaus von Beyme, Städte aus Ruinen, München 1992

5 Grossplattensiedlung Wolfen-Nord, Aufnahme 1993. Foto: Matthias Ebinger

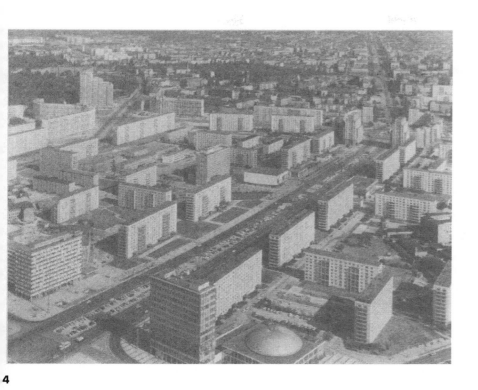

4

5

den Wohnungsbau und die Standardisierung der Bauindustrieprodukte entsprechen exakt seinen Theorien der zwanziger Jahre, die er in seinen Russlandjahren wider Erwarten nicht umsetzen konnte.

Seine theoretischen Schriften, die er von 1956 bis zu seinem Abschied in grosser Zahl und unablässiger Folge in der Zeitschrift "Deutsche Architektur" veröffentlicht, zeigen denn auch wenig neue Aspekte. Dies mögen einige Titel zeigen:

- Typenserien für den industrialisierten Wohnungsbau, 1956
- Die Beziehungen der Typisierung zur Architektur, 1956
- Architektur und Typenprojektierung, 1957
- Keine Furcht vor Monotonie, 1956
- Der sozialistische Wohnkomplex, 1958
- Industrialisierung und Städtebau, 1959
- Das industrielle Bauen und die neuen Mittel der künstlerischen Gestaltung, 1959
- Muss industrielles Bauen langweilig sein?, 1962
- Vom Typenprojekt zum Städtebau, 1960
- Baukastensystem und Architekten, 1963
- Möglichkeiten und Grenzen der Industrialisierung auf dem Gebiet der Architektur, 1964

Unermüdlich versucht Hans Schmidt zu beweisen, dass mit der Industrialisierung des Bauens und mit einer richtigen Typisierung der einzelnen Gebäude die Probleme der Ökonomie, der Architektur und des Städtebaus gelöst werden können. Er unterstützt seine Theorien durch Berichte über die verschiedenen Parteitage und Zentralkomiteesitzungen der SED in Ostberlin und der KPdSU in Moskau, in denen von den kommunistischen Führern Parolen zum Aufbau ausgegeben werden. Die Entwicklung der Architektur im Westen kommentiert er als "fruchtlosen Ästhetizismus und als kapitalistischen Irrweg".

Von grosser Bedeutung sind für Schmidt in diesen Jahren die Kongresse der UIA, Union international des Architectes, die für ihn die Nachfolge der CIAM, Congrès internationaux de l'Architecture moderne, aufgenommen haben. Aus westlicher Sicht hatten und haben die Tätigkeit und die Kongresse der UIA allerdings mehr offizielle Verbandsfunktionen und wenig Einfluss auf die Entwicklung der Architektur. Für Hans Schmidt bedeuten sie jedoch eine Kontaktmöglichkeit mit Kollegen des Auslandes und ausserdem ein Forum für seine Ideen der Industrialisierung. So besucht er 1958 den Kongress in Moskau, 1961 denjenigen in London und 1962 eine For-

6 "Das Baukastensystem beruht auf der Zerlegung des Bauwerks in einzelne Teile – Bauelemente –, die mit maschinellen Methoden vorgefertigt und in der Montagebauweise zum kompletten Bauwerk zusammengesetzt werden können. Dieses Prinzip, unmittelbar aus der Industrialisierung entstanden, zeigt sehr eindrücklich der im Jahre 1850 errichtete Bau des Kristallpalastes in London."
Aus: Hans Schmidt, Baukastensystem und Architektur, in: Deutsche Architektur 1962/3

7 Balkone aus Betonfertigteilen. Entwurf: Dipl. Arch. H. Schmidt (Institut für Typung).
Aus: Hans Schmidt, Architektur und Typenprojektierung, in Deutsche Architektur 1957/2

8 Typenhäuser an der Kensington Road (Anfang 19. Jahrhundert).
Aus: Hans Schmidt, Architektur und Typenprojektierung, in: Deutsche Architektur 1957/2

9 Amsterdam nach Cornelis Antonicz (1544), frühe Form der Typisierung.
Aus: Hans Schmidt, Architektur und Typenprojektierung, in Deutsche Architektur 1957/2

6

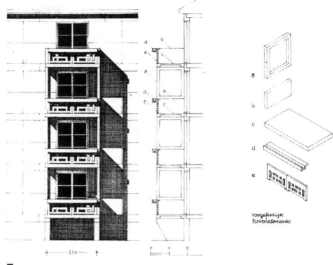

7

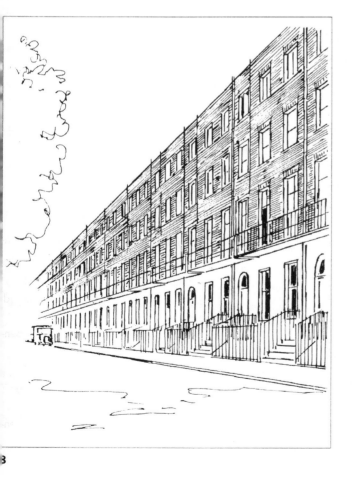

8

9

schungskommissionssitzung in Moskau. In seinen Berichten in der "Deutschen Architektur" kommentiert er diese Tagungen stets positiv. Am UIA-Kongress 1963 in Havanna hat sich Hans Schmidt die mehrstündige Rede Fidel Castros angehört aber keinen Bericht darüber in der DDR veröffentlicht.

Die Aufgabe, in seinem Institut die städtebaulichen Projekte für neue Städte und Neubauviertel zu überprüfen, veranlasst ihn zu verschiedenen Texten über städtebauliche Qualitäten, über die räumliche Ordnung der Stadt und über die Notwendigkeit einer Architekturkritik. Dabei bezieht er sich immer auf seine Prinzipien des industrialisierten Bauens und auf die offene Bauweise der Stadt. Er kritisiert jedoch in den einzelnen Fällen die Anordnung der Bauten innerhalb des Systems und eine Abweichung vom orthogonalen Raster. Auch die Anwendung der Plattenbauweise beim Wiederaufbau historischer Bezirke erklärt er als vertretbar und städtebaulich richtig.

Nach 1962 und auch im Zusammenhang mit seiner Beurteilungstätigkeit beschäftigt sich Schmidt wieder stärker mit der historischen Architektur und vor allem mit der städtebaulichen Raumwirkung in historischen Stadtteilen. Diese historischen Studien und ihre Umsetzung auf den heutigen Städtebau führen in seinem Institut 1968 zur Herausgabe des Buches "Strassen und Plätze, Beispiele zur Gestaltung städtebaulicher Räume". Das Buch umfasst eine Aufzeichnung und Analyse von gegen 60 Strassen- und Platzräumen aus allen Stadtbauperioden und aus allen Ländern. In seiner Einführung versucht Hans Schmidt aus der Analyse der Beispiele allgemeingültige Regeln für die räumliche Gestaltung von Strassen und Plätzen abzuleiten. Dabei geht es weniger um die Funktionen der städtischen Räume, sondern um deren Wahrnehmung und Wirkung, um Raumproportionen und um die baukünstlerische Gestaltung. In diesem Buch und in seinem letzten Werk über städtebauliche Theorien "Gestaltung und Umgestaltung der Stadt", 1969, ist Hans Schmidt zurückgekehrt zum historischen Städtebau und zur Baukunst, zu den beiden Elementen, die er in seiner Frühzeit als überholt und für den modernen Städtebau als unwesentlich oder sogar untauglich bezeichnet hatte.

Die städtebaulichen Projekte in der DDR

Trotz seiner hohen und einflussreichen Stellung in der Deutschen Bauakademie gelingt es Hans Schmidt in seiner Ost-Berliner-Zeit nicht, eigene städtebauliche Projekte zu realisieren. Dies kann auf verschiedene Gründe zurückgeführt werden. Zum einen ist sein Einfluss auf das Baugeschehen nicht so gross, wie seine Stellung vermuten lässt. Vor allem fehlen ihm die direk-

10-13 Skizzen von Hans Schmidt. Aus: Hans Schmidt, Die sozialistische Wandlung des Raumes, in: Deutsche Architektur 1958/10

10 Blick auf Moskau von der Plattform der Lomonossow-Universität

11 Moskau, Krasnopresnesker-Ufer gegenüber dem Hotel Ukraine mit Hochhaus am Platz des Aufstandes

12 Moskau, Südwestbezirk, Lenin-Prospekt

13 Moskau, Südwestbezirk, Inneres des Quartals Nr. 2

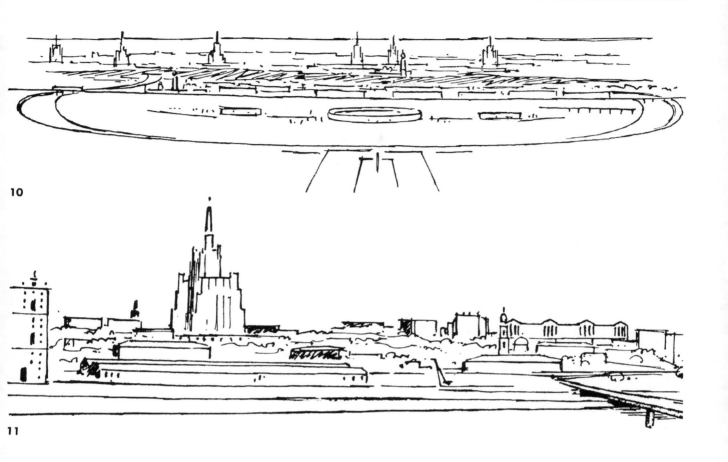

10

11

12

13

ten Beziehungen zur Parteispitze und zur Regierung, über die Hermann Henselmann verfügt und auch bei wechselnden Parteikonstellationen in grosse Aufträge umsetzt. Schmidt gilt als theorielastig. Dazu kommt, dass er durch seine Aufgabe als Beurteilungsinstanz für städtebauliche Projekte zum Kritiker in Person wird. Diese Funktion trägt nicht zu seiner Beliebtheit bei Kollegen und Planern der DDR bei, und von den Architekten der jüngeren Generation wird er als besserwisserisch und rechthaberisch empfunden. Wenn er zwecks Gutachten und Beratung in die verschiedenen Städte der Republik reist, wird er dort mit der nicht unbedingt geliebten Zentralgewalt identifiziert.

Am Anfang seiner Berlinerzeit nimmt er zusammen mit seinen Mitarbeitern an verschiedenen städtebaulichen Wettbewerben teil, jedoch ohne Erfolg. Später beschränkt sich seine Entwurfstätigkeit auf das Korrigieren der städtebaulichen Projekte anderer Entwurfskollektive und Baukombinate. Er gibt sich dabei grosse Mühe, überlegte und konstruktive Korrekturen vorzuschlagen. Er versucht mit den ungelenken und unproportionierten Plattenbauten eine logische Ordnung und eine räumliche Wirkung herzustellen. Stets belegt er die Korrekturen mit seinen, im Stil unverwechselbaren, perspektivischen Skizzen, in denen er die räumliche Wirkung nachweist.

Im architektonischen Bereich ist er ebenfalls korrigierend tätig und versucht die Grundriss- und Fassadengestaltung von einzelnen Bautypen wie z. B. eines Wohnhotels zu verbessern. Weil er jedoch von der absoluten Richtigkeit der Plattenbauweise überzeugt ist, kann und will er die architektonischen Grenzen dieser Bauweise nicht erkennen und seine Gegenentwürfe sind kaum überzeugender als das zu korrigierende Original.

Im Jahre 1965 schreibt Schmidt in der "Deutschen Architektur" einen Nachruf für den verstorbenen Le Corbusier. Der Nachruf zeigt seinen Respekt aber auch seine Vorbehalte, die er gegenüber dem "Künstlerarchitekten" Le Corbusier zeit seines Lebens zum Ausdruck gebracht hatte. Als wesentliche Leistung anerkennt Schmidt, dass Le Corbusier die Epoche der Modernen Architektur eingeleitet und die Bedeutung der industriellen Produktion frühzeitig erkannt habe. Hingegen bildet für Schmidt die Kapelle von Ronchamp einen Verrat am Rationalismus und eine "Liquidation des Funktionalismus", was er Le Corbusier über den Tod hinaus nicht verzeihen kann.

Anmerkung

[1] Aus: Deutsche Architektur, 1955/8.

Texte und Projekte 1955–1969

Aus: **DIE BEZIEHUNG DER TYPISIERUNG ZUR ARCHITEKTUR,** in:
Deutsche Architektur, 1956/7

Die Industrialisierung des Bauwesens, der Übergang zur industriellen Methode des Bauens ist ein Prozeß, bei dem mit vollem Recht die ökonomische, technische und organisatorische Notwendigkeit neuer Methoden im Bauwesen den ersten Platz einnimmt. Die Verhandlungen der Moskauer Baukonferenz vom Jahre 1954, der Baukonferenz, die im Jahre 1955 in der Deutschen Demokratischen Republik stattgefunden hat, und schließlich der Ministerratsbeschluß vom 21. April 1955 gehen in erster Linie von der ökonomischen Notwendigkeit des industrialisierten, billigeren Bauens aus.

Die Fragen der Architektur, genauer gesagt die Architekten, schienen dabei zunächst in eine negative Rolle gedrängt. Es mußte ihnen mit Recht vorgeworfen werden, sie stünden dem notwendigen Fortschritt im Bauwesen mit überholten Anschauungen und Methoden im Wege.

Es ist verständlich, daß daraus ein gewisses Durcheinander, eine Verwirrung unter den Architekten entstanden ist. Man schlägt sich an die Brust und bekennt, daß man sich bisher zu einseitig mit dem Künstlerischen befaßt habe, daß nunmehr das Technische, Funktionelle, Ökonomische im Vordergrund zu stehen habe. Es treten, wenn auch nicht gerade offen, Kollegen auf, die mit Schadenfreude feststellen, man habe eine falsche Theorie besessen, es gelte jetzt modern zu sein, wobei man an das modische Spielen denkt, das an den Entwürfen und Bauten in die Augen sticht, die im Westen entstehen. Andere Kollegen anerkennen zwar die Industrialisierung als ökonomische, technische Notwendigkeit. Gleichzeitig aber sprechen sie davon, die damit verbundene Typisierung schränke die Gestaltungsmöglichkeiten des Architekten ein, sie behindere die Berücksichtigung vielfältiger Funktionen, sie führe zur Gleichförmigkeit, zur Monotonie.

Es ist klar, daß die industriellen Baumethoden zu sehr strengen Gesetzen des räumlichen Aufbaus und des plastischen Ausdrucks führen müssen – Gesetzen, die auf einem unerbittlichen Kanon der Zahlen und Maße aufgebaut sind und uns zwingen, das nur Momentane, Willkürliche, Zufällige auszuscheiden.

Soll das aber dazu führen, daß wir das industrielle Bauen nur als aufgezwungene Notwendigkeit, als einengende Beschränkung empfinden, die wir höchstens durch von aussen herangeholte, aus der Sache selbst nicht hervorgehende sog. "gestalterische" Mittel mildern können? Das würde bedeuten, daß wir eine dem Wesen der Baukunst fremde Zweiteilung in Technik und Kunst zulassen und die Architekten in Konstrukteure und Dekorateure scheiden. Ein solcher Weg wäre nicht nur für die Architektur unannehmbar, er würde sich für die Durchführung der Industrialisierung als ebenso verhängnisvoll erweisen.

[...]

Das industrielle Bauen zwingt uns, von bestimmten Gesetzen der Ordnung, der Zahl, der Maße, des formalen Ausdrucks auszugehen. Es ist denkbar, daß das einfachste Ergebnis dieses Weges den Architekten nicht gleich auf den ersten Blick als schön befriedigt. Und doch ist es richtig, zunächst einmal auf diesem Wege vorzugehen, bevor wir unsere Zuflucht zu den verschiedenen Verschönerungsmitteln und "gestalterischen" Rezepten nehmen. Wir müssen dem Bauen, die verlorengegangene Gesetzmäßigkeit und Wahrheit wiedergeben und dabei etwas vorsichtig mit subjektiven Begriffen von Schönheit umgehen.
[...]

Aus: **MEINE AUFFASSUNG VON DEN AUFGABEN DER ARCHITEKTUR,**
(Manuskript, Berlin 1957). Archiv GTA, ETH Zürich, Nachlass Hans Schmidt

[...]

Mein siebenjähriger Aufenthalt in der Sowjetunion brachte die notwendige Auseinandersetzung zwischen den erworbenen funktionalistischen Auffassungen und den Problemen des ideellen, künstlerischen Ausdrucks einer sozialistischen Architektur. Diese Auseinandersetzung hat mir neue Einsichten in die Bedeutung der Architektur der Vergangenheit erschlossen und dazu geführt, dass ich nach meiner Rückkehr in die Schweiz immer mehr in Gegensatz zur Entwicklung der westlichen Architektur geriet, die sich bei allen grossen technischen Leistungen und scheinbaren formalen Kühnheiten, vom wahren Wesen einer echten Architektur immer weiter entfernt.
In meiner Arbeit in der DDR sehe ich die Möglichkeit, an der weiteren Entwicklung einer echten, von einer erstarkenden sozialistischen Gesellschaft getragenen Architektur mitzuarbeiten. Ich zögere nicht – es ergibt sich dies aus meinen bisherigen Auffassungen und Erfahrungen – in der Typisierung und Industrialisierung die entscheidende Grundlage einer sozialistischen Architektur und zwar nicht nur in technisch-materieller, sondern ebensosehr in künstlerisch-ideeller Beziehung zu sehen. Das bedeutet für den Architekten die nicht leichte Aufgabe, das wissenschaftlich-analytische Denken und die künstlerische Intuition in gleicher Weise zu beherrschen. Wenn er die Aufgabe zu lösen vermag, kann er ein richtiger Architekt genannt werden.

Aus: **INDUSTRIALISIERUNG UND STÄDTEBAU,** (Referat 1959) in: Hans Schmidt, Beiträge zur Architektur, 1924–1964, Basel 1965

[...]

Das industrielle Bauen stellt an die städtebauliche Planung ganz bestimmte Bedingungen.
Die ausschlaggebende dieser Bedingungen ist die Zusammenfassung der Bauaufgaben in einem bestimmten Komplex, der nach einem einheitlichen technologischen Prozeß im Taktverfahren ausgeführt werden kann. Mit dieser Bedin-

14 Wohnstrasse – Studienprojekt für einen Wohnkomplex in Grossblockbauweise, Institut für Typung.
Aus: Hans Schmidt, Architektur und Typenprojektierung, in: Deutsche Architektur 1957/2

15 Schemaentwurf eines Wohnkomplexes für 4500 Einwohner, Institut für Typung.
Aus: Hans Schmidt, Der sozialistische Wohnkomplex als Architektur, in: Deutsche Architektur 1958/6

16 Perspektivische Ansicht des Zentrums im Schema-Entwurf eines Wohnkomplexes

14

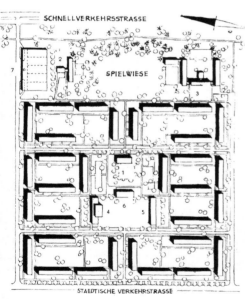

SCHNELLVERKEHRSSTRASSE

SPIELWIESE

STAEDTISCHE VERKEHRSTRASSE

Gesamtfläche	20,5 ha =	100 Prozent
Wohnbauland	12 0 ha =	59 Prozent
Bauland der Nachfolge- einrichtungen	5 0 ha =	24 Prozent
Verkehrsflächen (befahrbar)	0,6 ha =	3 Prozent
Öffentliche Grün- und Freiflächen	2,9 ha =	14 Prozent

Anzahl der Einwohner 4500
Einwohnerdichte 220 Ew/ha
Wohndichte 375 EW/ha
Geschoßflächendichte 0,75

15

16

gung unmittelbar verbunden ist die Forderung, daß nach Typenprojekten gebaut werden muß, die auf einheitlicher Technologie aufgebaut sind und einen reibungslosen Ablauf des Taktverfahrens ermöglichen. Für die Wohnungsbauten kommt die Forderung der möglichst gleichen Anzahl der Geschosse hinzu.

Aus diesem technisch bedingten System des Bauens ergeben sich notwendigerweise eine ganz bestimmte Ordnung und eine weitgehende Einheitlichkeit der Bebauung. Was bedeuten diese technisch geforderte Ordnung und Einheitlichkeit für die baukünstlerische Aufgabe des sozialistischen Städtebaus? Es ist klar, daß allein aus den Bedingungen des industriellen Bauens noch keine baukünstlerischen Grundsätze für den Städtebau abgeleitet werden können. Auf der anderen Seite wäre es ebenso falsch, diesen Bedingungen aus dem Wege gehen zu wollen und zu verkennen, daß sie eine wichtige Komponente des sozialistischen Städtebaus bilden.

Wir müssen davon ausgehen, daß Ordnung und Einheitlichkeit, Zusammenfassung zu grossen Komplexen, Anwendung der Typenprojektierung nicht nur technisch bedingte Forderungen darstellen. Der sozialistische Städtebau öffnet den Städtebauern den Weg, gestützt auf das sozialistische Bodenrecht und die sozialistische Bauwirtschaft, an die Stelle der Unordnung und Uneinheitlichkeit der kapitalistischen Stadt die Einheit und die Zusammenfassung zu setzen.

Bei der Lösung der baukünstlerischen Aufgaben, die sich hierbei stellen, werden die Städtebauer durch das industrielle Bauen keineswegs gehemmt. Im Gegenteil. Das Bauen in ganzen Komplexen, die einheitliche Ordnung der Bebauung und der Bauweise, die klare Tektonik der Baukörper und Fassaden, die einfachen, aus der Maßordnung hervorgehenden Maßbeziehungen – alle diese aus dem industriellen Bauen erwachsenden Forderungen sind geeignet, die baukünstlerischen Aufgaben des sozialistischen Städtebaus, der, ausgehend vom Wesen der sozialistischen Gesellschaft, nach Größe, Klarheit und Reichtum der Beziehungen strebt, wirksam zu unterstützen.

Die sozialistische Gesellschaft schafft, indem sie die Klassentrennung und die gesellschaftliche Isolierung des Menschen vom Menschen aufhebt, neue gesellschaftliche Bedürfnisse und Vorstellungen, neue Beziehungen zwischen den Menschen, ein neues Verhältnis zur Natur. Dieses Neue muß in der Planung unserer Wohnkomplexe und ihrer Zentren, in der Anlage der städtischen Straßen und zentralen Plätze, in der Beziehung der Siedlungen und Städte zur Landschaft seinen Ausdruck finden. Die Aufgabe, die dem Städtebauer damit gestellt wird, ist nicht nur eine funktionelle, technische. Die Geschichte der Stadtbaukunst zeigt, daß das Zueinander-in-Beziehung-setzen der städtebaulichen Räume, die dem Zusammenleben der Bewohner dienen, also die räumliche Komposition, eine elementare Aufgabe des Städtebaus darstellt.

Im Sozialismus wird die räumliche Komposition als wesentlicher, die Menschen miteinander verbindender Faktor zu einer wichtigen baukünstlerischen Qualität des Städtebaus. In ihr findet die gesellschaftliche Aufgabe des sozialistischen Städtebaus ihren stärksten Ausdruck.

[...]

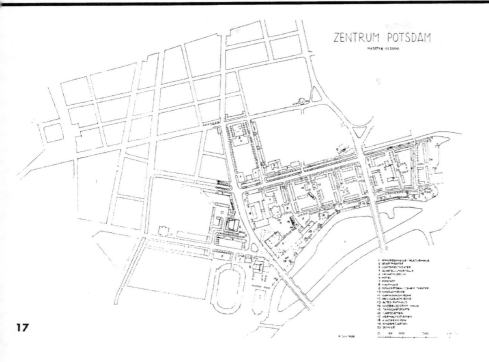

17

18

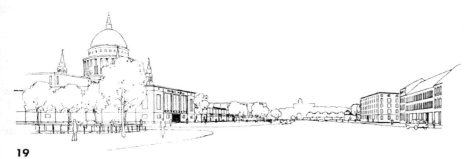

19

Aus: **KÜNSTLERISCHE PROBLEME DER STÄDTEBAULICHEN PLANUNG,**
(Manuskript 1960). Archiv GTA, ETH Zürich, Nachlass Hans Schmidt

[...]

Das wichtigste Mittel zur Schaffung vielgestaltiger und schöner Städte liegt in
der allseitig durchdachten harmonischen Komposition sowohl der Stadt als Gan-
zes als auch ihrer verschiedenen Teile. In der städtebaulichen Komposition müs-
sen die vielfältigen Funktionen der Stadt, ihrer Industrieanlagen, Verkehrsein-
richtungen, Wohngebiete, Zentren und Erholungsflächen baukünstlerisch als
räumliche und baukörperliche Ordnung sichtbar werden.
Die räumliche und baukörperliche Ordnung der Stadt, ihrer Zentren und Wohn-
gebiete erhält ihren besonderen und neuen baukünstlerischen Charakter durch
das Prinzip der offenen Bebauung. Dieses Prinzip, das vom allseitig freistehen-
den Baukörper ausgeht, hat nicht nur hygienische und bautechnologische Be-
deutung. Es hebt die bisher angewendete Randbebauung auf, die im Städtebau
des 19. Jahrhunderts zum bekannten Widerspruch zwischen der Korridorstraße
und dem für sich abgeschlossenen Blockinneren geführt hatte. Der städtebauli-
che Raum, der sich bei der geschlossenen Bebauung auf die Abfolge von
Straßen und Plätzen beschränkt hatte, wird zum offenen, durchgehenden Raum.

[...]

Aus: **MUß INDUSTRIELLES BAUEN LANGWEILIG SEIN?,** in: "National-
zeitung" Berlin 6/1992

[...]

Das industrielle Bauen ist, wie wir alle wissen, eine Notwendigkeit. Wird aber
jemand, der etwas Notwendiges tut, zuerst mit der Frage beginnen, ob das,
was dabei herauskommt, schön oder häßlich, interessant oder langweilig sei?
Gewiß, es gab solche Leute, und es gibt sie immer noch. Schon ehe das indu-
strielle Bauen richtig geboren war, warnten Architekten, Kunstschriftsteller und
andere Leute, es könne dabei nur etwas Langweiliges, Unmenschliches, Kunst-
widriges herauskommen. Häuser vom Fließband? Sie dachten an die muntere
Vielfalt der Giebel von Stralsund oder der Erker von Nürnberg. Städte von Gleit-
fertigern und Kränen gebaut? Sie dachten an die Maurer, Steinmetze und Zim-
merleute, die den Montagebrigaden den Platz räumen mußten.
Aber die Montagebrigaden und Rapidkräne ließen sich nicht aufhalten, sie ha-
ben begonnen, das Gesicht unserer Häuser und Städte zu verändern. Sind sie
nicht auch imstande, das zu verändern, was wir als langweilig begreifen?
[...]
Was unter den Bedingungen des industriellen Bauens möglich und richtig ist,
zeigt der Weg des Eisenbahnwaggons und des Automobils. Die Wohnung –
das ist unsere individuelle Umgebung. Daß sie typisiert ist, hindert niemanden
daran, sein Zuhause so einzurichten, wie es ihm entspricht, und wie das Auto-
mobil in bezug auf Geschmack und Bequemlichkeit der Einrichtung und Aus-

20-23 Wettbewerbsbeitrag für
die Neugestaltung des Zentrums von Ost-
Berlin (zusammen mit Bruno Flierl) 1959.
Quelle: Archiv GTA, ETH Zürich, Nachlass
Hans Schmidt

20 Vogelperspektive vom
Marx-Engels-Platz

21 Marx-Engels-Forum und Umgebung

22 Blick von "Unter den Linden" auf
das Marx-Engels-Forum

23 Blick vom Bahnhof Alexanderplatz
in das Kaufzentrum

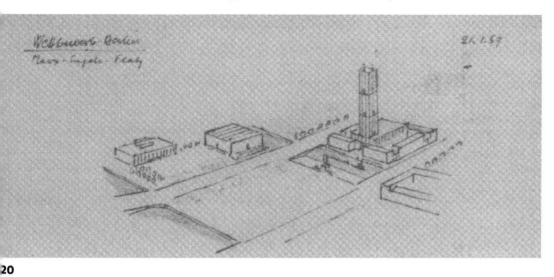

20

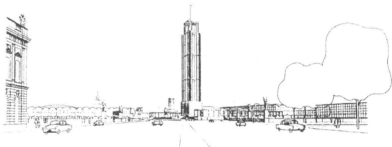

21

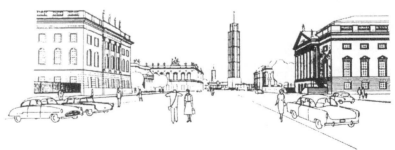

22

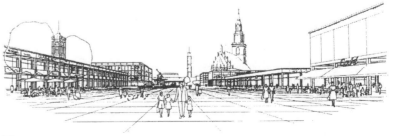

23

stattung beständig verbessert wird, so verhindert die Massenproduktion auch nicht, daß die Typen der Wohnungen – so wie das zum Beispiel bei den Wohnungsgrundrissen des Experimentalhauses P 2 am Fennpfuhl geschehen ist – ständig weiterentwickelt werden.

Das Haus aber, das mehrgeschossige Typenhaus unserer neuen Wohnviertel, geht den Weg des Eisenbahnwaggons. Hier wäre es unsinnig, vom Architekten zu verlangen, er solle die Individualität der Bewohner ausdrücken.

[...]

Es gibt aber noch einen anderen Grund. Wir bauen mit Typenhäusern ganze Wohnviertel, selbst neue Städte. Es könnte also sein, daß das Langweilige viel weniger an den Häusern liegt als daran, wie diese Wohngebiete angelegt sind. Wir wissen von den alten Städten und Dörfern, daß es nicht nur die einzelnen Häuser sind, die das Ganze interessant und lebendig machen. Ebenso wichtig ist die Art und Weise, wie das Ganze durch Straßen, Plätze, Promenaden, Grünzüge räumlich geordnet wird. Mit dieser Aufgabe, die für eine industriell gebaute Stadt genauso gilt wie für das alte Dresden oder Erfurt, kommen aber unsere Städtebauer offenbar noch nicht ganz zurecht. Die meisten von ihnen glauben, man könne der Langeweile dadurch entgehen, daß man die Häuser möglichst bunt in allen Richtungen aufstellt, so daß man vor lauter Häusern die Stadt nicht mehr sieht. Es ist, als hätten die Städtebauer, die die neuen Wohnviertel von Berlin, Dresden, Rostock entworfen haben, richtig Angst vor der Ordnung – vor Ausblicken, die, statt immer wieder durch Häuser verstellt, ins Grüne führen, vor Straßen, die den Blick ins Weite lenken, vor Alleen, die ein Wohngebiet in ähnlicher Weise ordnen würden, wie sie uns durch die Landschaft führen. Nichts spricht dagegen, diese Mittel der Stadtbaukunst auch beim industriellen Bauen anzuwenden. Auf diese Weise würden die industriell gebauten Häuserzeilen zu einem Ganzen zusammengefaßt, und durch bestimmte Kontraste würde bewirkt, daß wir das Gleichförmige nicht als langweilig, sondern als richtig empfinden.

Es kommt also darauf an, daß die Architekten und Städtebauer ihre Kunst immer besser verstehen lernen. Dann wird niemand mehr die Frage stellen, ob das industrielle Bauen langweilig sein müsse.

Aus: ÜBER DIE NOTWENDIGKEIT DER ARCHITEKTURKRITIK UND DER ARCHITEKTURTHEORIE, in: Deutsche Architektur, 1963/10

[...] Es geht in der sozialistischen Architektur, ohne daß damit die Bedeutung der Phantasie, der Intuition, der individuellen schöpferischen Leistung herabgesetzt wird, um mehr als die subjektive Konzeption. Es geht um eine objektive, umfassende Konzeption, hinter der nicht nur der einzelne Künstler, sondern die ganze Gesellschaft steht. Damit ändert sich auch der Charakter der Kritik. Sie wird von allgemein überzeugenden, objektiv belegbaren Kriterien ausgehen. Sie wird nicht mehr als subjektiv abgelehnt werden können oder sich mit unfruchtbarer Polemik begnügen.

24–25 Wettbewerbsentwurf Kollektiv H. Schmidt, Institut für Typung ca. 1956. Bebauung Wohnbezirk 3 Oberschöneweide, Berlin-Köpenick
Aus: Hans Schmidt, Der sozialistische Wohnkomplex als Architektur, in Deutsche Architektur 1958/6

24 Lagepläne Komplex I, Kottmeierstrasse (im Nordwesten) und Komplex III, Scharnweberstrasse (im Südosten)

25 Perspektivische Ansicht des Zentrums von Oberschöneweide

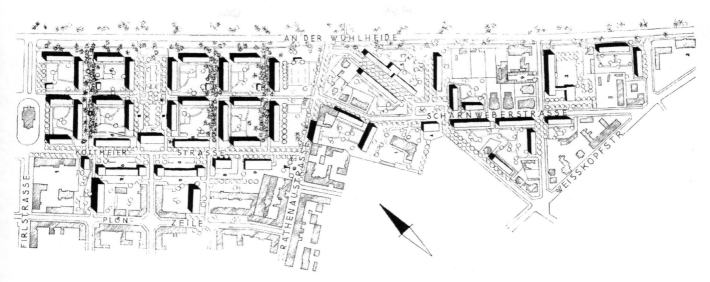

24

Bebauung Wohnbezirk 3 Oberschöneweide, Berlin-
Köpenick 1:5000

(Wettbewerbsentwurf Kollektiv H. Schmidt, Institut
für Typung)

Komplex I: Kottmeierstraße

Viergeschossige Bebauung

Das Zentrum des Wohnkomplexex ist zugleich Zentrum des Wohn-
bezirks und so gelegt, daß es die Beziehung zwischen der beste-
henden Altbebauung und der an der Wuhlheide liegenden Neube-
bauung herstellt.

Gesamtfläche (Neubauland)	14,5 ha	=100 Prozent
Wohnbauland	8,0 ha	= 55 Prozent
Bauland der Nachfolge-einrichtungen	2,0 ha	= 14 Prozent
Verkehrsflächen (befahrbar)	1,4 ha	= 10 Prozent
Öffentliche Grün- und Freiflächen	3,1 ha	= 21 Prozent

Anzahl der Einwohner 3000

Einwohnerdichte 207 EW/ha

Wohndichte 375 EW/ha

Komplex III: Scharnweberstraße

Dreigeschossige Bebauung zwischen zwei- und
dreigeschossiger Altbebauung

Gesamtfläche (Neubauland) 8,5 ha

Anzahl der Einwohner 1350

Einwohnerdichte 160 EW/ha

Wohndichte 330 EW/ha

25

Keine Architekturkritik ohne Architekturtheorie

Eine solche Architekturkritik setzt eine wissenschaftlich begründete Architektur-theorie voraus. Auf die Notwendigkeit, die Theorie der sozialistischen Architektur zu entwickeln, haben die 3. Baukonferenz der Deutschen Demokratischen Republik vom Mai 1959 sowie der Ministerratsbeschluß vom 4. Juni 1959 ausdrücklich hingewiesen, wobei der Deutschen Bauakademie die Aufgabe gestellt wird, gemeinsam mit dem Bund Deutscher Architekten und den Hoch- und Fachschulen des Bauwesens die theoretischen Grundlagen unserer Architektur und unseres Städtebaus zu klären und weiterzuentwickeln.

Wenn hier von den theoretischen Grundlagen der Architektur und des Städtebaus gesprochen wird, so ist darunter ein sehr breiter Bereich von Kenntnissen zu verstehen, die wir nach bestimmten Kriterien der Architektur ordnen müssen. Wir übernehmen zu diesem Zweck von der klassischen Architekturtheorie die bekannten Hauptkriterien: Funktion – Konstruktion – Schönheit, die – als Schema verstanden – für unsere Untersuchung immer noch brauchbar sind. Sie bezeichnen drei grundlegende Faktoren des Bauwerks:

- *Funktion – den materiellen oder ideellen Zweck, den das Bauwerk und seine Einrichtung zu erfüllen haben,*
- *Konstruktion – die materiell-technischen Mittel, die für die Errichtung und Dauerhaftigkeit des Bauwerkes aufgewendet werden,*
- *Schönheit – die ästhetisch wahrgenommene Form, die wir als schön empfinden.*

Praktisch gesprochen: Wir können ein Bauwerk danach beurteilen, ob es seinem Zweck entsprechend benutzbar ist, ob es die Anforderungen an Festigkeit, Widerstand gegen klimatische Einflüsse und so weiter erfüllt, und schließlich danach, ob es unserem Schönheitsempfinden entspricht. Zu diesem Schema sind nun allerdings einige notwendige Bemerkungen zu machen.

Zunächst müssen wir feststellen, daß die Kriterien nicht gleichwertig nebeneinanderstehen. Die Anforderungen an die Funktion und Konstruktion müssen in jedem Falle erfüllt sein. Es ist aber denkbar, daß ein durchaus zweckmäßiges und solides Bauwerk unserem Schönheitsempfinden widerspricht, ohne daß darunter sein Gebrauchswert leidet. Undenkbar wäre jedoch ein zwar schönes, zugleich aber unzweckmäßiges und unsolide gebautes Bauwerk. Die drei Kategorien besitzen also im Sinne der Architektur unterschiedliche Wertigkeit.

Damit hängt ein weiterer, für die Architekturkritik sehr wichtiger Umstand zusammen. Die Kriterien der Funktion und der Konstruktion lassen sich weitgehend objektiv erfassen. Sie lassen sich exakt messen, vergleichen, in Zahlenwerten (Kennziffern, Parametern und so weiter) ausdrücken. Für das Kriterium der Schönheit trifft dies nicht oder zumindest nicht in diesem Maße zu. Es muß darum auch besonders behandelt werden.

Eine letzte Bemerkung gilt der Ökonomie. Sie darf als Faktor der Architektur auf keinen Fall beiseite gelassen werden. Aber es erscheint uns nicht notwendig, sie zu einem selbständigen Kriterium zu machen. Sie muß vielmehr als Prinzip des Maximums an Leistung oder Nutzen bei einem Minimum von Aufwand, also als

26–27 Zentrum von Halberstadt. Aus: Hans Schmidt, Halberstadt – Baukünstlerische Probleme des Wiederaufbaus und der Umgestaltung von Stadtzentren, in: Deutsche Architektur 1962/2

26 Bebauungsplan 1959, Entwurfsbüro für Gebiets-, Stadt- und Dorfplanung Magdeburg, Gruppe Halberstadt

27 Überarbeitung und Korrektur des Bebauungsplanes durch das Institut von Hans Schmidt 1961

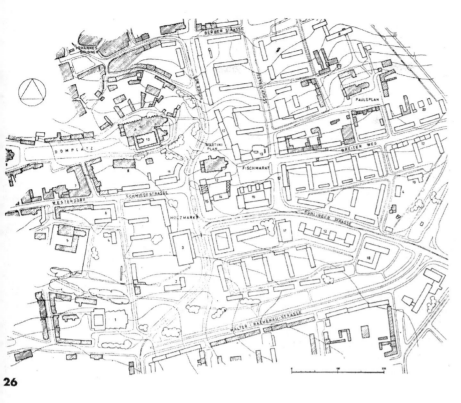

1 Theater
2 Café
3 Kulturhaus
4 Kindergarten
5 Andreaskirche (Ruine)
6 Fernmeldeamt
7 Post
8 Schule
9 Liebfrauenkirche
10 Dom
11 Hotel
12 Läden
13 Warenhaus
14 Deutsche Versicherungsgesellschaft
15 Rat der Stadt
16 Konsum-Kaufhof
17 Kino
18 Poliklinik
19 Kinderkrippe
20 Garagen
21 Handwerkerhof

26

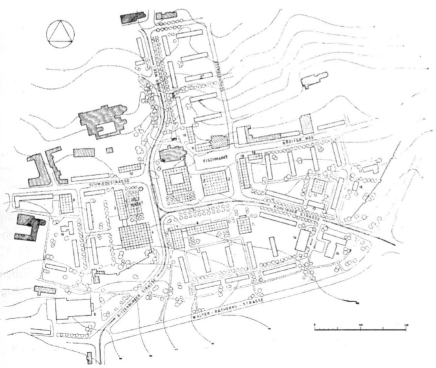

1 Rathaus
2 Kaufhaus
3 Klubhaus der Jugend
4 Kulturhaus
5 Gaststätte
6 Hotel
7 Kino
8 Theater
9 Fernmeldeamt
10 Café
11 Bürogebäude
12 Kaufhalle
13 Klubgaststätte
14 Garage
15 Poliklinik
16 Kindergarten
17 Kinderkrippe
18 Läden

27

Arbeitsproduktivität bei jeder unserer drei Kriterien in entsprechender Form wirksam werden – bei der Funktion als rationellste Nutzung der Flächen und Volumen, bei der Konstruktion als rationellste Anwendung des Materials und der technologischen Verfahren, bei der Schönheit als bewußt angewandtes Kunstgesetz.

[...]

Aus: **DIE RÄUMLICHE ORDNUNG DER STADT,** in: Deutsche Architektur 1965/2

[...]

Wenn wir Städte bauen, so bauen wir zugleich Räume. Die wichtigste ästhetische Forderung, die wir an diese Räume, Straßen und Plätze oder an die einfachen Freiflächen zwischen den Gebäuden stellen müssen, ist die Einheit und Klarheit des Raumeindruckes. Die Praxis des Städtebaus der Deutschen Demokratischen Republik hat eine Reihe von Beispielen aufzuweisen, wo solche einheitlichen, klaren räumlichen Eindrücke entstanden sind. Nicht umsonst ist die Magistrale von Eisenhüttenstadt das Lieblingsobjekt der Fotografen geworden. Ein Blick aus der Querachse des wesentlichen Teils der Karl-Marx-Allee in Berlin zeigt, daß ein einheitlicher Raumeindruck auch aus einer sehr lebendigen Vielfalt von Gebäuden entstehen kann (siehe "Deutsche Architektur", Heft 7, 1964 S. 433). Durch das einfache Motiv des gleichzeitigen Fassens mehrerer Gebäude und durch den Ausblick auf die dahinterliegenden Massen des Kinos und des Hotels kommt trotz des Reichtums der Massen ein einheitlicher Raumeindruck zustande.

Viel häufiger ist es aber immer noch der Fall, daß ein solcher Raumeindruck nicht zustande kommt, daß der Raum auseinanderfällt. Die Fotografen, die nach eindrucksvollen Motiven suchen, sind ratlos. Die Bewohner sprechen vom fehlenden städtischen Charakter oder von Eintönigkeit. Die Städtebauer versuchen meistens, dieser Monotonie dadurch zu entgehen, daß sie die Wohnblocks in möglichst vielfachem Wechsel aufstellen. Auf diesem Prinzip sind die Bebauungspläne der Neustadt Hoyerswerda, die Südstadt Rostock, der Berliner Wohngebiete und vieler anderer Städte aufgebaut. Es handelt sich eigentlich immer um dasselbe. Die Vielfalt des Planes, die uns im Ergebnis erfreuen sollte, führt zu einer Verwirrung. Statt räumlich klarer Eindrücke gibt es unverständliche Bruchstücke. Die Häuser, die die Räume fassen sollten, geraten durcheinander, fallen räumlich auseinander so wie etwa eine Flotte im Sturm. Den Grund für die Erscheinung müssen wir in der Tatsache suchen, die wir an den Anfang unserer Überlegungen gestellt haben. Viele Städtebauer haben es verlernt, räumlich einfach zu denken. Sind die Modelle schuld? Städte müssen unter den räumlichen Bedingungen und dem Maßstab der Wirklichkeit erdacht und erbaut werden. Das braucht ein großes Maß von Vorstellungskraft und künstlerische Erfahrung. Das Modell, so wertvoll es als Mittel der Darstellung sein kann, ist nicht imstande, die Vorstellungskraft und die künstlerischen Erfahrungen zu ersetzen, die nur aus der Wirklichkeit gewonnen werden können.

28–30 Städtebauliche Auseinandersetzung über die Stellung der Hochhäuser am Elbufer in Dresden. Handskizzen von Hans Schmidt.
Aus: Hans Schmidt, Die räumliche Ordnung der Stadt, in: Deutsche Architektur 1965/2

28 Lageplan der Altstadt

29 Hochhäuser an der Elbe

30 Blick von der Brücke der Einheit

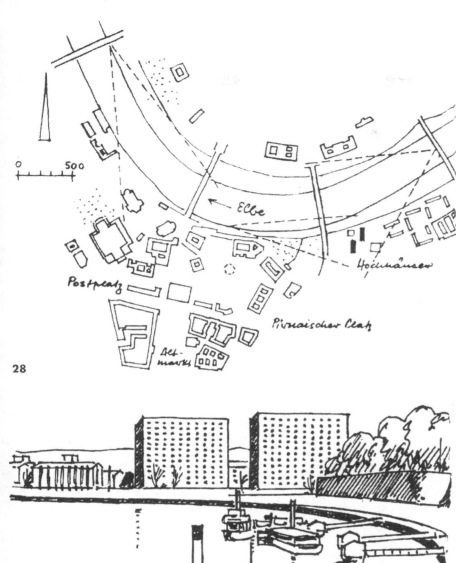

0 500

Elbe

Hochhäuser

Postplatz

Pirnaischer Platz

Altmarkt

28

29

30

Aus: **DAS PROBLEM DER FORM IN DER ARCHITEKTURTHEORIE,** in:
Deutsche Architektur 1967/12

[...]

Die Entwicklung und Wandlung des ästhetischen Sinnes

Aus dem ästhetischen Sehen bildet sich der "ästhetische Sinn" als ein Produkt
der menschlichen Entwicklung. Karl Marx sagt darüber in den "Ökonomisch-
philosophischen Manuskripten" (1844): "Erst durch den gegenständlich entfal-
teten Reichtum des menschlichen Wesens wird der Reichtum der subjektiven
menschlichen Sinnlichkeit, wird ein musikalisches Ohr, ein Auge für die Schön-
heit der Form, kurz werden erst menschlicher Genüsse fähige Sinne, Sinne, wel-
che als menschliche Wesenskräfte sich betätigen, teils erst ausgebildet, teils erst
erzeugt."

Der ästhetische Sinn des einzelnen Menschen und der Gesellschaft entwickelt
und verändert sich in der Auseinandersetzung mit der sich entwickelnden und
verändernden Umwelt. Blicken wir auf die rund hundert Jahre unserer eigenen
Vergangenheit zurück, so werden wir feststellen, daß diese Umwelt durch Tech-
nik und industrielle Produktion in einem Maße verändert worden ist – und dau-
ernd weiter verändert wird –, die einer eigentlichen Umwälzung gleichkommt.
Aber all dieses Neue – Autostraßen, Hochbahnen, Flughäfen, Kraftwerke,
Hochhäuser und so weiter – verändert die Umwelt nicht nur praktisch-nützlich,
sondern auch visuell-ästhetisch. Bezeichnend ist, daß in derselben Zeit neue und
wichtige visuelle Kommunikationsmittel, wie das Plakat, die Packung, die Leucht-
schrift, die Verkehrssignale, überhaupt erst geschaffen wurden.

Dem veränderten ästhetischen Sinn entsprechen neue ästhetische Mittel. Das
Neue besteht darin, daß die Mittel der visuellen Wirkung – Form, Farbe, Licht –,
die bisher die Funktion des Beschreibenden, Erzählenden, Ausschmückenden
hatten, heute im Sinne des Direkten, Elementaren, Schlagenden verwendet wer-
den.

[...]

31–32 Wohnstadt Schwedt/Oder.
Aus: Hans Schmidt, Städtebau unterwegs,
in: Deutsche Architektur 1963/5

31 Bestandsplan der Stadt Schwedt mit
Eintragung des Entwurfs II von Professor
Selmanagic

32 Überarbeitung und Korrektur des
Bebauungsplanes durch das Institut von
Hans Schmidt

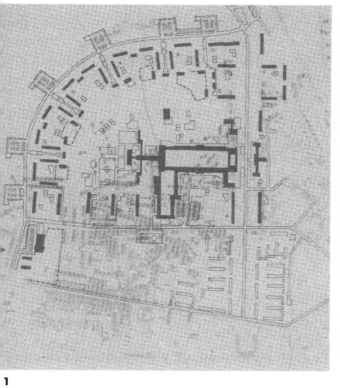

1

32

Der Funktionalismus
im Lebenswerk von Hans Schmidt

Rückkehr in die Schweiz

In seinem 77 Altersjahr kehrt Hans Schmidt im Sommer 1969 aus Ost-Berlin nach Basel zurück. Es ist die Zeit der Studentenunruhen an den Universitäten der Schweiz und des Auslandes. Als Sozialist aus dem Osten und als einer der letzten Zeugen aus der Zeit des Neuen Bauens erfährt Hans Schmidt hier eine unerwartete Aktualität seiner Person. Die früheren Vorbehalte gegenüber dem Kommunisten und Moskauhörigen sind zum mindesten bei der jungen Generation weggefallen und auch die älteren Kollegen empfangen den alten Schmidt mit Freude in ihrem Kreis. Sofort beschäftigt er sich wieder mit den architektonischen und städtebaulichen Fragen der Schweiz und seiner Vaterstadt Basel. Er wird durch die rebellierenden Studenten zu Vorträgen an die Hochschulen geholt und schreibt Stellungnahmen zu den strittigen Fragen der Architektenausbildung. Er empfiehlt den Studierenden, Gesellschaftswissenschaften als Grundlage des Architekturstudiums einzuführen, das Bauen auf dem Bauplatz oder in der Werkstatt werkmässig zu erfahren, die industriellen Baumethoden mit Vorfertigung und Standardisierung zu studieren und an Stelle von Vorlesungen mehr Kolloquien und Disputationen durchzuführen. Die Studierenden finden in Hans Schmidt einen Zeugen der früheren Avantgarde und einen Mitkämpfer in ihrer aktuellen Rebellion.

Hans Schmidt im Bergell 1972

In seinem Haus am Nonnenweg in Basel ordnet Hans Schmidt seine umfangreiche Bibliothek und insbesondere die Sammlung seiner eigenen Schriften aus 50 Jahren Theoriediskussion. Er verfasst Beiträge über städtebauliche Fragen, z. B. "Städtebau – Notwendigkeit und Utopie", "Umweltschutz und Raumplanung" und plant eine "Geschichte der Architektur". In den Kreisen seiner früheren Parteigenossen hält er Vorträge über die städtebaulichen Probleme Basels und er nimmt wieder an den Monatsversammlungen des Basler BSA teil.

Im Juni 1972 führt der schweizerische BSA seine Jahresversammlung während dreier Tage an verschiedenen Orten des Bergells durch. Hans Schmidt ist aktiv dabei, frischt alte Freundschaften mit Kollegen anderer Kantone auf, marschiert auf den Wanderwegen von Dorf zu Dorf und tanzt mit Begeisterung an der Abendveranstaltung in den Grotti von Bondo. In

der Folge eines Spazierganges hinauf nach Soglio erleidet er bei der Vespermahlzeit im Garten des Palazzo del Salis mitten unter seinen Kollegen eine Herzschwäche und stirbt am nächsten Tag im Spital von Soglio.

Die Verteidigung des Funktionalismus

Das Ende der 60er Jahre, in denen Schmidt nach Basel zurückkehrt, ist nicht nur die Zeit der Studentenunruhen. Im gleichen Zeitraum werden von verschiedenen Seiten her die Grundlagen der Architektur und insbesondere der Funktionalismus als Richtschnur alles Gestaltens in Frage gestellt. Venturi veröffentlicht sein "Complexity and Contradiction in Architecture", Alexander Mitscherlich kritisiert die "Unwirtlichkeit unserer Städte". Drei Mitarbeiter des Sigmund Freud Institutes Frankfurt, H. Berndt, A. Lorenzer und K. Horn analysieren als Soziologen und Psychologen den modernen Städtebau in ihrem Buch "Architektur als Ideologie" und erteilen dem Funktionalismus eine Absage als "ästhetische Kunstrichtung".

Hans Schmidt ist offensichtlich über diese neuen Tendenzen der Architekturkritik bestens im Bilde und Ende 1970 holt er zu einer vehementen Verteidigungsrede für den, für seinen Funktionalismus als Grundlage der Neuen Architektur aus. In seinem Artikel im Novemberheft des WERK "Der Funktionalismus am Pranger" weist er zuerst detailliert die Entstehung des Begriffes bei Adolf Behne 1923 und bei A. Sartoris 1932 nach und kommt dann auf die diesbezüglichen Auseinandersetzungen bei der CIAM-Gründung in La Sarraz 1928 zu sprechen.

"An der Gründerversammlung der CIAM in La Sarraz (1928) kam es zu einer Auseinandersetzung zwischen der Mehrheit der Teilnehmer und Le Corbusier, der eine Festlegung auf die von ihm aufgestellten 'Fünf Punkte zu einer neuen Architektur' beabsichtigte. Statt dessen wurde die bekannte Erklärung von La Sarraz ausgearbeitet und angenommen. Die vier Punkte (Allgemeine Wirtschaftlichkeit – Stadt- und Landesplanung – Architektur und öffentliche Meinung – Architektur und Beziehung zum Staat) umfassende Erklärung zeigt deutlich, dass man sich nicht auf eine bestimmte ästhetische Doktrin festgelegt hatte.

Ihren Höhepunkt erreichte die Arbeit der CIAM mit dem vierten, im Jahre 1933 an Bord der 'Patris II' abgehaltenen Kongress, aus dem die berühmt gewordene 'Charta von Athen' hervorging. Als Diskussionsmaterial diente dem Kongress eine Ausstellung von dreiunddreissig einheitlich dargestellten und analysierten Stadtplänen, wobei als Thema zum ersten Male der Begriff 'Die funktionelle Stadt' gebraucht wurde. Die Charta von Athen wurde erst im Jahre 1943, versehen mit einem ausführlichen

1

1 Titelblatt "ABC – Beiträge zum Bauen", Serie 2 Nr. 4 (1927/28)
2 Titelblatt "Charte d'Athènes" (1943)

Kommentar, durch die Gruppe CIAM-France als Broschüre veröffentlicht. Eine deutsche Ausgabe erschien erst 1962 bei Rowohlt. Das umfangreiche Material der Ausstellung wurde niemals veröffentlicht. Dagegen erhielt der spanische Delegierte J. L. Sert den Auftrag, die Ergebnisse des vierten Kongresses in einer grösseren Buchveröffentlichung zusammenzufassen, die 1944 unter dem Titel 'Can our cities survive?' in Cambridge (USA) erschienen ist."

Nach einer Schilderung der CIAM-Entwicklung während und nach dem zweiten Weltkrieg kommt Schmidt nochmals auf La Sarraz zurück:

"Gewiss hatten die Architekten, die sich um die Fahne der Neuen Architektur scharten, ihre eigenen, mitunter sogar sehr unterschiedlichen Vorstellungen vom künstlerischen Gesicht dieser Architektur. Aber in einem Punkt waren sie sich einig: die Erneuerung musste bei den gesellschaftlichen und technisch-ökonomischen Grundlagen einsetzen. Mit ihnen beschäftigen sich die Erklärung von La Sarraz, die Charta von Athen und die 15 Kapitel des Buches 'Can our cities survive?'. Von den 95 Punkten der Charta befasst sich ein einziger mit der architektonischen Form: Im Punkt 70 wird die Anwendung der Stilformen der Vergangenheit bei Neubauten im Sanierungsgebiet historischer Städte grundsätzlich abgelehnt. Im übrigen wird man in allen genannten Dokumenten vergeblich nach Vorschriften im Sinne einer 'ästhetischen Kunstrichtung' suchen."

Zur Ästhetik des Funktionalismus äussert er sich dann folgendermassen:

"Der ästhetische Sinn des einzelnen Menschen und der Gesellschaft entwickelt und verändert sich in der Auseinandersetzung mit der sich entwickelnden und verändernden Umwelt. Diese Umwelt ist durch Technik und industrielle Produktion in einem Masse verändert worden, das einer eigentlichen Umwälzung gleichkommt. Aber all dieses Neue – Autostrassen, Hochbahnen, Flughäfen, Kraftwerke, Hochhäuser – verändert die Umwelt nicht nur praktisch-nützlich, sondern auch visuell-ästhetisch. Bezeichnend ist, dass gleichzeitig neue visuelle Kommunikationsmittel wie das Plakat, die Packung, die Leuchtschrift, die Verkehrssignale überhaupt erst geschaffen wurden. Auch die moderne Kunst hat, auf ihrem Wege von den Nachimpresionisten bis zu den Abstrakten, ihre künstlerischen Mittel – Farbe, Form, Material – im Sinne eines neuen ästhetischen Sehens verändert und damit selbst Einfluss auf die formale Entwicklung der Architektur genommen.

Wir haben es also mit einer neuen Ästhetik zu tun, die sich bezeichnenderweise aus der Sphäre des Zweckhaften aus der materiellen Produktion, entwickelt hat und nicht, wie die Frankfurter Soziologen und Psychologen annehmen, aus einer menschenfeindlichen Ideologie des 'Funktionalismus' abgeleitet werden kann. Die Annahme einer Ästhetik des Zweckhaften bedeutet nun allerdings nicht, dass – im Sinne des bekannten

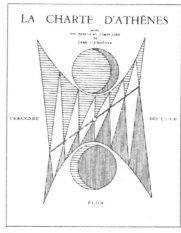

2

Satzes 'Was zweckmässig ist, ist auch schön' – keine ästhetischen Probleme mehr bestünden".

Am Schluss des Artikels begründet er die Bedeutung des Funktionalismus für den modernen Städtebau:

"Auf dem Gebiet des Städtebaus, mit dem sich die Frankfurter Untersuchungen zur Hauptsache beschäftigen, stellen sich solche ästhetischen Probleme wie die Konsequenzen des standardisierten industriellen Bauens, die architektonisch-räumliche Ordnung unter den Bedingungen der offenen Bebauung und des heutigen Verkehrs, die Rolle von Strassen und Plätzen, die Bedeutung der Orientierung, die Beziehung zwischen Stadt beziehungsweise Siedlung und Landschaft. Es handelt sich dabei um Probleme der Wahrnehmung und Beurteilung der sichtbaren Umwelt durch den Menschen, die untersucht werden und zu konkreten Kriterien führen müssten. An diesen Fragen geht die Arbeit der Frankfurter Soziologen und Psychologen vorbei. Erwähnt werden zwar die sehr interessanten Untersuchungen von Kevin Lynch, der als erster die Bewohner einer Stadt nach ihren Reaktionen befragt hat; aber über die weiteren Perspektiven der Wahrnehmungspsychologie, die sich vor allem in englischen und amerikanischen Untersuchungen für das Umweltproblem abzeichnen, werden wir nicht unterrichtet."

3 Titelblatt "Can our cities survive?" (1944)

Auch wenn Hans Schmidt in seinem letzten veröffentlichten Text den Funktionalismus in erster Linie gegenüber den Zweifeln und Angriffen der Frankfurter Psychologen und Soziologen verteidigt, zeigt sich doch darin, dass für ihn Funktionalismus nicht nur ein entwicklungsgeschichtlicher Begriff bedeutet, sondern dass er darin die wesentliche Grundlage der neuen Architektur und eines richtigen Städtebaus sieht.

Als rationalistischer Mensch kann er nur rational begründbare Elemente und Fakten für sein Schaffen akzeptieren. Die Architekturgeschichte interpretiert er nach rationalistischen Aspekten und eine Ästhetik kann sich für ihn nur aus der Funktion der Objekte, seien es nun Architektur, Städtebau oder Kunst, ableiten lassen.

In seinem bewegten Leben ist Hans Schmidt in seiner absoluten, rationalistischen Einstellung mehrfach mit seiner Umgebung, mit dem Sozialismus und mit sich selbst in Konflikt geraten. Das Verlassen der funktionalistischen Prinzipien zu Beginn der 40er Jahre, seine Hinwendung zu klassizistischer Architektur und zu monumentalem Städtebau können nicht allein mit seiner Treue zur sowjetischen Parteidoktrin erklärt werden. Offensichtlich suchte Hans Schmidt in der klassischen Architektur eine historisch begründete Typisierung der Architekturelemente und damit eine grössere Verbindlichkeit der funktionalistischen Architektursprache zu erreichen.

Trotzdem kann Hans Schmidt mit seiner klassizistischen Periode nicht als früher Vorläufer der postmodernen Architektur betrachtet und für diese Be-

wegung vereinnahmt werden, wie dies teilweise geschehen ist. Denn gerade die Beliebigkeit, mit der die Protagonisten der postmodernen Architektur in den Fundus der historischen Bauformen gegriffen haben, würde dem systematischen Denken und Handeln von Hans Schmidt zutiefst widersprechen.

In den frühen 20er Jahren hat Hans Schmidt seine Architektur und seine Städtebautheorie auf einem Funktionalismus aufgebaut, der gleichzeitig rational und gesellschaftlich begründet ist. Die Ästhetik und die Baukunst waren für ihn nur aus diesem rationalen Funktionalismus ableitbar. Darin zeigt sich auch der Gegensatz zu Le Corbusier, dem er seit dem 1. CIAM-Kongress das Abweichen von den funktionalistischen Prinzipien zu Gunsten einer künstlerischen Architektur immer wieder vorgeworfen hat.

Hans Schmidt war in seinem Denken geprägt von der Zeit des Neuen Bauens und von dessen funktionalistischen Grundlagen. Er selbst wiederum hat die Architektur und den Städtebau des Neuen Bauens geprägt und durch sein ganzes Lebenswerk weitergetragen. Die Stadt des Neuen Bauens in ihrer gesellschaftlichen, ökonomischen und architektonischen Relevanz zu verwirklichen, erachtete er als seine Lebensaufgabe.

Anhang

Verzeichnis der abgebildeten Projekte und Planungen von Hans Schmidt

Die meisten Planzeichnungen sind verkleinert wiedergegeben. Die teilweise eingetragenen Verhältniszahlen entsprechen daher nicht dem Planmassstab.

Warschau

Skizze zum Bericht über den Generalplan der Stadt Warschau (1947) *S. 92*

Zollikon

Ortsplanung – Bebauungsvorschlag (1943) *S. 91*

Zürich

Neubühl, Siedlung in Wollishofen-Zürich – Lageplan (1928–1932) *S. 43*
Eierbrecht – städtebauliche Studie (1943) *S. 87*

Made in United States
Troutdale, OR
11/13/2024

24743039R10080